D0598105

MAJESTIC HOLLYWOOD

The Greatest Films of 1939

MARK A. VIEIRA

RUNNING PRESS
PHILADELPHIA · LONDON

To my father, who took me to see *Gone With the Wind* in 1967.
To my mother, who let me read her copy of *Gone With the Wind* in 1969.
To Ron Haver, who ran David O. Selznick's print of *Gone With the Wind* for me in 1975.

© 2013 by Mark A. Vieira
Published by Running Press,
A Member of the Perseus Books Group

All rights reserved under the Pan-American and International Copyright Conventions

Printed in China

This book may not be reproduced in whole or in part, in any form or by any means, electronic or mechanical,
including photocopying, recording, or by any information storage and retrieval system now known or hereafter
invented, without written permission from the publisher.

Books published by Running Press are available at special discounts for bulk purchases in the United States
by corporations, institutions, and other organizations. For more information, please contact the Special
Markets Department at the Perseus Books Group, 2300 Chestnut Street, Suite 200, Philadelphia, PA 19103,
or call (800) 810-4145, ext. 5000, or e-mail special.markets@perseusbooks.com.

ISBN 978-0-7624-5156-2
Library of Congress Control Number: 2013945945

E-book ISBN 978-0-7624-5164-7

9 8 7 6 5 4 3 2 1
Digit on the right indicates the number of this printing

Cover design by Dan Cantada
Interior design by Susan Van Horn
Edited by Cindy De La Hoz
Typography: Neutra text, Yellowtail, and MeyerTwo

Running Press Book Publishers
2300 Chestnut Street
Philadelphia, PA 19103-4371

Visit us on the web!
www.runningpress.com

CONTENTS

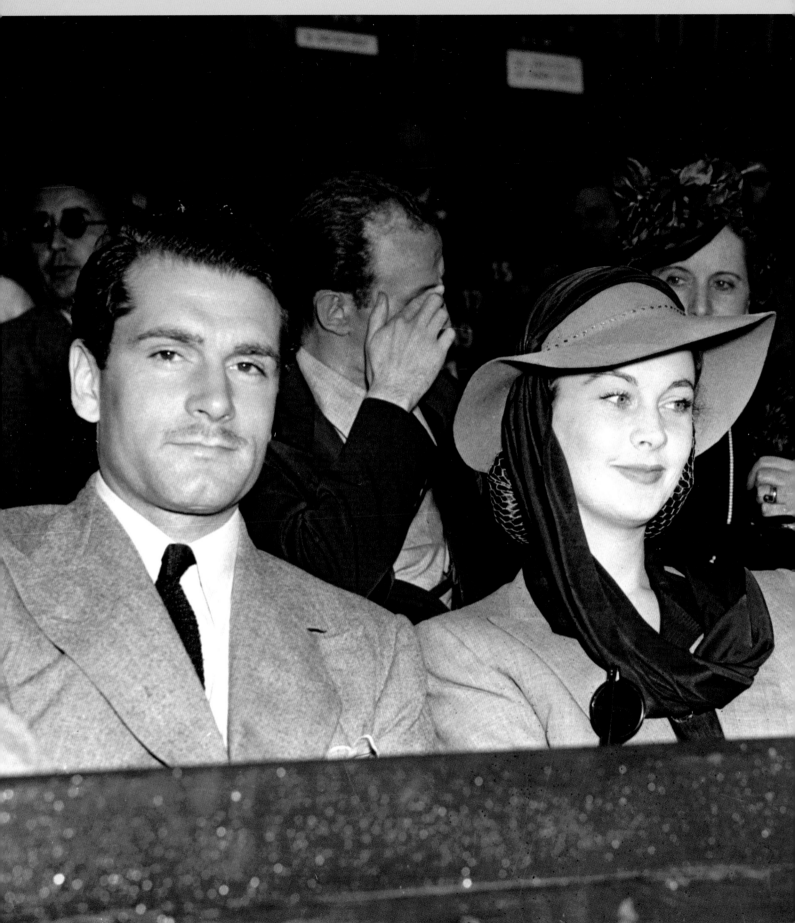

INTRODUCTION

Nineteen thirty-nine was a watershed year. The Great Depression was barely over, but America was again feeling the chill winds of change. Politics, economics, and art braced for war. There was a lull before the storm, and Hollywood, as if expecting to be judged by posterity, produced a portfolio of classics. What year before or since has yielded as many masterpieces? How many calendars have glistened with releases like *Gunga Din*, *The Hunchback of Notre Dame*, *Only Angels Have Wings*, *Destry Rides Again*, *Beau Geste*, *Son of Frankenstein*, *The Women*, *Drums Along the Mohawk*, *Union Pacific*, *The Wizard of Oz*, *Stagecoach*, *Ninotchka*, *Of Mice and Men*, and, of course, *Gone With the Wind*? In 1939, every week was a cinematic cornucopia. This volume showcases fifty classics from that majestic year.

We are fortunate that these films, and the photos that heralded their releases, have survived the decades. These films were magical experiences. Their production created equally magical images. Whether scene stills, behind-the-scenes shots, or portrait art, these images are as enchanting and powerful as the films they were meant to publicize. The histories of these films include anecdotes from the artists who made them: directors William Wellman and John Ford; cinematographers Arthur Miller and Lee Garmes; actors Judy Garland, Henry Fonda, and Olivia de Havilland. Their stories are here, transporting the reader to an era when Hollywood trusted the intelligence of its audience and presented insightful, sensitive films like *Wuthering Heights*, *Goodbye Mr. Chips*, and *Midnight*.

In 1989, a number of commercial and critical entities decided that 1939 was special; after all, it had yielded two perennial moneymakers, *The Wizard of Oz* and *Gone With the Wind*. The litany of other titles was sufficient to convince any skeptic, so no one asked what caused this outpouring of excellence.

If one looks at Hollywood in 1938, certain clues emerge. America was a short five years removed from the Great Depression. There had been a mini-boom in 1936, which was followed by a slight slump in 1937. Box office improved markedly in 1938, which in itself would allow for bigger and better films, but there were other factors. Labor disputes which took place between writers and producers in 1936 had been settled; screenwriters were better treated and paid. Studios could afford to cultivate staff writers and attract celebrity authors of hit plays and bestselling novels. Big prices were paid for big properties.

In July 1938 the Justice Department's antitrust division filed a lawsuit against Hollywood's eight major studios. Owners of independent theaters claimed that the studios' block booking was denying them first-run films. *United States v. Paramount Pictures et al.* said that the eight major studios were violating the Sherman Antitrust Act by forcing these independent theaters to take blocks of inferior films. It was only a matter of time before the five

Left: Three stars of prominent 1939 films were caught in a candid racetrack photo: (l. to r.) Laurence Olivier (*Wuthering Heights*); Vivien Leigh (*Gone With the Wind*); and Claire Trevor (*Stagecoach*)

"major majors" (Metro-Goldwyn-Mayer, Paramount, Twentieth Century-Fox, Warner Bros., and RKO Radio) would be stripped of their monopolistic imperatives, so they began thinking in terms of bigger productions, which they need not offer to independent exhibitors. Making B pictures could be left to the "major minors" (United Artists, Universal, and Columbia) and independent producers.

Seeking to boost morale, the Motion Picture Producers and Distributors of America (MPPDA) launched a campaign called "Motion Pictures' Greatest Year." If that was truly to be so, the campaign had to not only ballyhoo big films but also calm unease about world conditions. In March 1938, Germany annexed Austria, one instance of the unchallenged spread of fascism in Europe. Foreign distribution accounted for a third of Hollywood's box-office revenue. Stars such as Greta Garbo and Marlene Dietrich had their largest following in Europe. A European war could totally deprive Hollywood of this market. "Bunds, pacts, pogroms and blockades are throttling the release of American pictures in Europe," wrote Edwin Schallert in the *Los Angeles Times*. "Step by step the market in Central Europe is being reduced. Germany and Austria have gone into oblivion. Even if pictures can be sold, there is no remuneration to be derived through direct channels." One solution would be a release schedule full of big-budget films. These could earn big returns in Europe before the inevitable loss of that market. These films could also enjoy longer "play outs" in the United States, because they would play as high-priced road shows before going into general release.

There were 18,000 theaters in America. Weekly attendance had held at sixty million since 1934, down from the record-breaking ninety million of 1929. What a movie fan paid at any given theater was determined by the Exhibitors' Price-and-Time-Fixing Plan. The A pictures opened in movie palaces like the Loew's State in downtown Los Angeles or the Pantages in Hollywood. Because of their opulent settings and deluxe presentation, these theaters charged fifty cents general admission, and sixty-five cents for loges. After twenty-one days, an A picture moved to a forty-cent neighborhood theater. After forty-two days, the picture moved to a thirty-cent theater; after sixty-three days, to a twenty-five-cent theater; after ninety-six days to a twenty-cent theater; and, after 126 days, to a fifteen-cent theater, which was probably on skid row.

A film's status as a hit or a flop was decided in the first week of its release at the big theaters, which could accommodate thousands of moviegoers. If a film was a bona fide hit, it was held over for a second week. A blockbuster might stay three and four weeks. This was the kind of film that could solve both the antitrust and foreign market problems. "Twentieth Century-Fox will not curtail production because of possible European losses," said sales manager Herman Wobber. "The company will seek to recapture business through bigger pictures, and subjects that will have appeal for markets such as South America."

One by one, the studios joined the bandwagon, planning big for 1939. "Production is up about twenty to thirty percent," reported Schallert in November 1938. "There is substance to the scope of the new undertakings. Warner Bros. intends to spread $4 million more than usual over ten features to ensure their eminence as world attractions. RKO Radio proposes to augment its investments by a third. Universal is also operating on a new financial basis, and at United Artists, Samuel Goldwyn's *Wuthering Heights*, very pretentious, is getting under way." M-G-M had already begun *The Wizard of Oz*, and Paramount was preparing *Beau Geste*.

There was one more reason for big projects on studio slates. "The golden jubilee of the motion-picture industry will be celebrated next year," wrote Schallert. "It is the fiftieth anniversary, according to the best accounts, of the first projection of photographs that moved on a screen. In 1889, in the laboratory of Thomas Alva Edison, came the achievement for which William Kennedy Laurie Dickson gained credit as well, being an assistant to the great inventor."

There would also be a twenty-fifth anniversary in 1939, since 1914 was the year of Cecil B. DeMille and Jesse Lasky's *The Squaw Man*, which was credited with bringing the film industry from New York to Hollywood. "Studio plans indicate increased budgets," said Schallert, "which suggest that Hollywood is looking forward to banner box-office results in this jubilee year." Although these anniversaries received less play when 1939 arrived, they contributed to the sense of an important year, and there were indeed films that looked to the historic past, such as *Hollywood Cavalcade*, *The Roaring Twenties*, and *The Story of Alexander Graham Bell*. There had been films like this before but there had never been so many planned for one calendar year. There was something in the air.

We can still enjoy the films of 1939. Thanks to studio preservation programs and to independent archives, most of these films survive and are available in high-quality formats such as DVD, Blu-ray, and HD streaming. If you look at a 1939 film on DVD or on Turner Classic

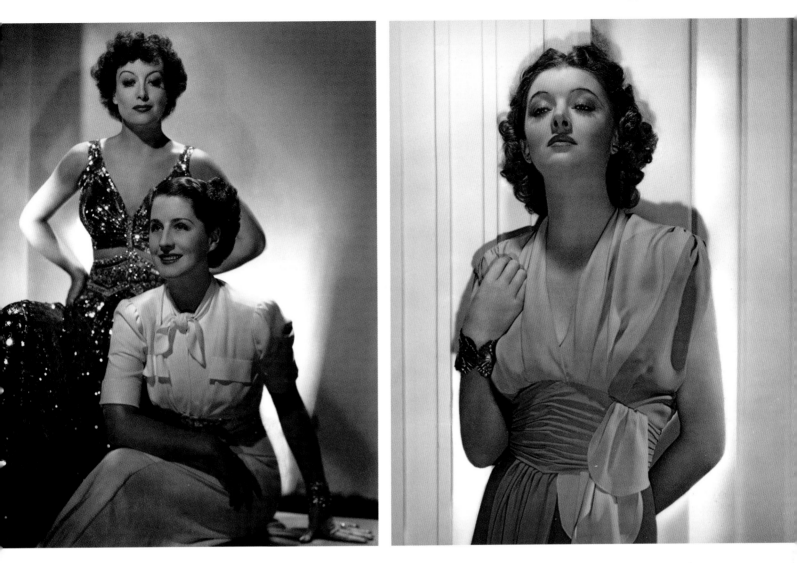

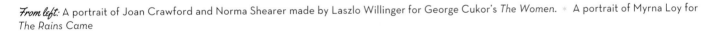

From left: A portrait of Joan Crawford and Norma Shearer made by Laszlo Willinger for George Cukor's *The Women.* ✴ A portrait of Myrna Loy for *The Rains Came*

Movies, what will this book add to your experience? In addition to production highlights, it can help you see the film in its original context. It will give you an idea of what it was like to see the film in a fifty-cent theater with a first-week audience. The film critic of 1939 was not treated to a private screening in a plush studio theater. He had to see the film in the theater as it opened. This is to our advantage, since the critic usually reported audience reaction. How often have you watched a classic film and wondered: "How did *that* scene go over when people first saw it?" Fortunately,

many of the contemporary reviews tell us if the audience was laughing with a scene or at it.

Hedda Hopper has gained a reputation as a power-hungry destroyer of careers, but the notorious gossip columnist also served a unique function when she gathered material for her column. Unlike Louella Parsons or any other columnist, Hopper had worked in the Hollywood film industry almost from the beginning. She knew personnel at every level of the business. She was a fan herself. She collected fine-art prints of Garbo portraits made by Clarence

Sinclair Bull. Hopper's reports on the films of 1939 have a special immediacy, although there are accounts of visits to movie sets by other journalists.

As author of this book I have attempted, above all, to convey accurate information about the making of these films. I did not see it as my job to critique them, deconstruct them, or warn you that they are "dated." My job is to transport you to a special time and place, where the artists who were making big films for the end of a tumultuous decade ended it with an array of cinematic art. *Majestic Hollywood* celebrates that art.

SON OF FRANKENSTEIN

RELEASED JANUARY 13, 1939

"Bullets. Crude bullets in his heart but he still lives."

THE STORY

When the son of the scientist who created the infamous Monster tries to clear his father's name, he comes up against the Monster and the crazy man who is manipulating him.

Opposite: An unusual portrait of Bela Lugosi, Boris Karloff, and Basil Rathbone by Ray Jones for *Son of Frankenstein*

PRODUCTION HIGHLIGHTS

The first big hit of 1939 was not a romance, a historical epic, or a musical. It was a horror film. Why was a scary movie being released three weeks after Christmas? It was a question of timing—and desperation. Universal Pictures needed a hit, no matter what the subject. In 1931 the studio had made cinematic history (and a lot of money) with Tod Browning's *Dracula*, which starred Bela Lugosi as an undead vampire, and James Whale's *Frankenstein*, which starred Boris Karloff as a reanimated corpse. A so-called "horror cycle" followed, but in 1936 it was forced to a standstill by the British Board of Film Censors. Fearful of losing the British market, Universal conceded. Two bad years followed. By 1938 the company was a million dollars in the red.

In August of that year, the Wilshire Regina Theatre in Beverly Hills booked a "daring" revival: *Dracula*, *Frankenstein*, and, oddly enough, *Son of Kong*. The startling success of this horror bill spread to numerous big cities. "It is the comeback of horror," said Lugosi. "And I come back." It looked as if he would, when Universal quickly and happily put *Son of Frankenstein* into production, casting the Hungarian actor with not only Karloff but also Basil Rathbone, the highest-paid supporting actor in films. This was no slapdash follow-up. It was a prestige production written by Willis Cooper of the radio show *Lights Out* and directed by the imaginative Rowland V. Lee, who envisioned a Gothic ensemble piece that would give Lugosi as showy a part as Karloff's. In this sequel to both *Frankenstein* and the 1935 *Bride of Frankenstein*, Wolf von Frankenstein (Rathbone) tries to distance his family name from the long-dead Frankenstein Monster but instead becomes obsessed with reviving the creature, assisted by a broken-necked hunchback named Ygor (Lugosi).

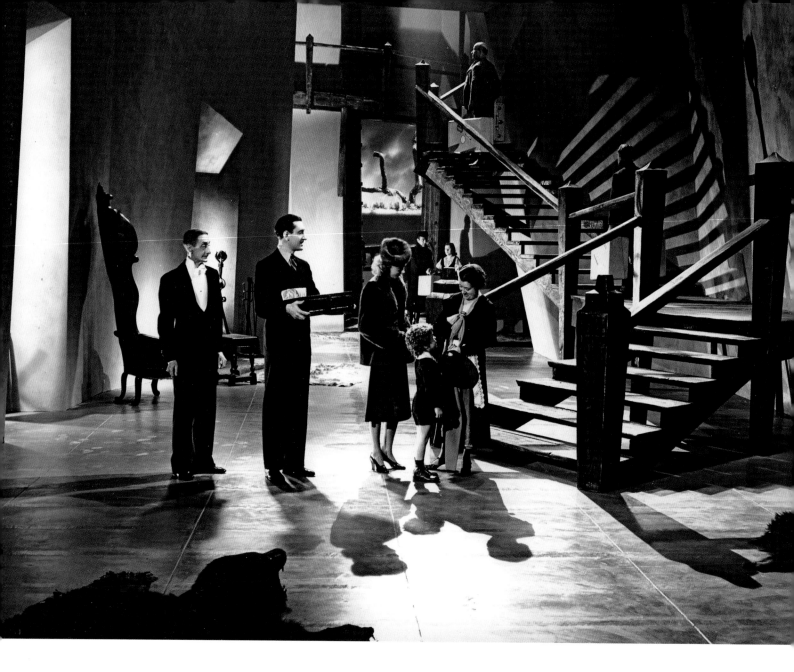

There is a long-standing Hollywood rule that says never to start a film without a finished script, but Lee, like the character in the scenario, became obsessed with the possibilities of the Frankenstein sequel. He threw out Cooper's first script, which was in fact a bit florid, and, even as the film was about to start shooting, continued to write and rewrite. This would have been fine if there were a flexible release date, but the studio was so needy that it had booked the film for Friday, January 13, 1939. Lee was supposed to start on October 17 with a budget of $250,000 and a projected schedule of thirty days. Instead, he started on November 9, still rewriting. He never stopped tinkering with the film. "Mr. Lee did some of his rewriting on the set," recalled Josephine Hutchinson, who played Elsa von Frankenstein. "We actors spent a lot of time in separate corners, pounding new lines into our heads." As Lee fell behind schedule and costs mounted, Universal executives tried to cut corners elsewhere. Karloff felt that Lee and Universal had altered the Monster's character too much. "I didn't like it," said Karloff. "They changed his clothes completely, wrapped him up in furs, and he became just nothing."

The movie-going public did not agree. *Son of Frankenstein* broke attendance records in Boston, Los Angeles, and even in England, where the horror ban was lifted. "Movie producers attribute the public's current thirst for terror to the war scares of unsettled Europe," wrote *Look* magazine. "Quick to take their cue, they have started a race to produce blood chillers on a more lavish and fantastic scale than they have ever attempted." In 1939 Hollywood, everything was more lavish and fantastic.

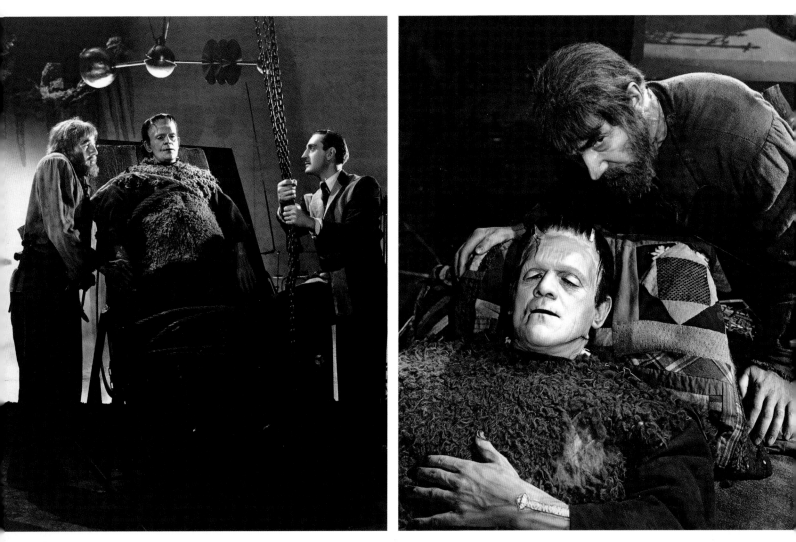

Opposite: Edgar Norton, Basil Rathbone, Josephine Hutchinson, Donnie Dunagan, and Emma Dunn in a scene from Rowland V. Lee's *Son of Frankenstein*
Above from left: Bela Lugosi, Boris Karloff, and Basil Rathbone * Bela Lugosi and Boris Karloff

Critical Reaction

"Yes . . . Ooh-hoo-hoo-hoo! And a couple more Ooh-hoos, it was surely Friday
the thirteenth, yesterday at R.K.O.-Hillstreet and Pantages Hollywood theaters.
Son of Frankenstein is a first-class successor to the original *Frankenstein*. Of
course due allowance must be made for the fact that it is pretty high keyed at
times, in the playing and it evoked laughter and other distracting outbursts from
the audience." **—EDWIN SCHALLERT, *LOS ANGELES TIMES***

"The Rivoli, after its brief popularity with *The Beachcomber*, once again has a
lemon on its hands. *Son of Frankenstein* is seemingly regarded as the laugh riot
of the year by everyone who comes to see it. Its calculated horrors chill no one
except subnormal moviegoers, and that trade does not patronize so high-priced
a theater." **—*LOS ANGELES TIMES* (NEW YORK CORRESPONDENT)**

IDIOT'S DELIGHT

RELEASED JANUARY 27, 1939

"Must you always be in Omaha?"

THE STORY

When a second-rate vaudevillian is stranded with his troupe at a posh hotel on the border of two hostile countries, he recognizes a Russian countess as an old flame—just as war is declared.

PRODUCTION HIGHLIGHTS

When M-G-M paid $125,000 to Robert Sherwood for his play *Idiot's Delight* in December 1936, there was enthusiasm all around. The Broadway hit starred Alfred Lunt and Lynn Fontanne, the First Couple of the American Stage. Clark Gable, the studio's biggest star, and director Clarence Brown, were so eager to make the film that they consulted with the Lunts. "Idiot's delight" is a slang term for solitaire, which Sherwood used to symbolize God's apparent indifference to the horrors of war. *Idiot's Delight* was prophetic. While M-G-M was adapting the play, Italy became so menacing that the studio received a warning from the Production Code Administration (PCA).

"This play contains numerous diatribes against militarism, fascism, and the munitions ring," Joseph I. Breen wrote to M-G-M. "A film of *Idiot's Delight* would be banned abroad and cause reprisals against the American company distributing it." The Italian government issued a threat. If M-G-M tried to release the film in Europe, *all* their pictures would be banned—in both Italy and Germany, and there would be "trouble." As previously noted, overseas audiences accounted for at least a third of every film's box office. M-G-M could not jeopardize a huge market for the sake of one film.

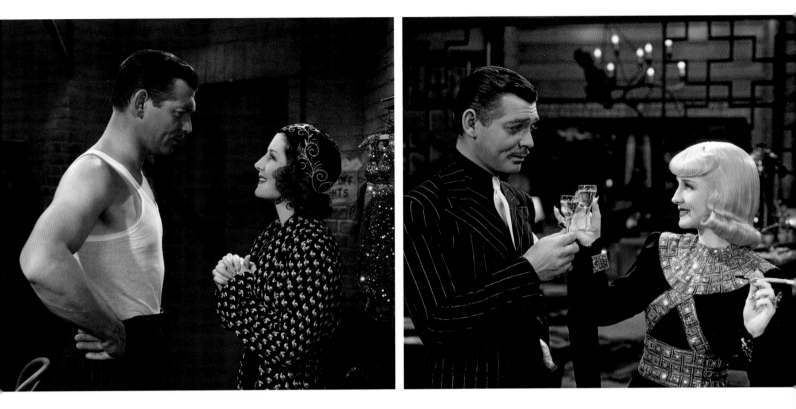

Above from left: Clark Gable and Norma Shearer in a scene from Clarence Brown's *Idiot's Delight* ∗ Clark Gable and Norma Shearer *Opposite:* A portrait of Norma Shearer made by Laszlo Willinger for *Idiot's Delight* *Overleaf:* Edward Arnold and Norma Shearer

Hunt Stromberg, who was producing *Idiot's Delight*, attempted to placate Italy. He hired Sherwood to rework the story. "We elected to build up the love story rather than the propaganda," Stromberg told the *Los Angeles Times*. "We detailed the leading characters' first meeting in America, which was only referred to in the dialogue in the play." More to the point, the story was moved from Italy to an unnamed country where Esperanto was the native tongue. In June 1938 Breen traveled to Naples to get the script approved. He was told by Italian representatives that M-G-M had to change the film's title. Angry telegrams came from M-G-M. Breen got the run-around from Benito Mussolini's government, but the script—still anti-war—was finally approved.

When Gable read the new *Idiot's Delight* script, though, it was not politics that concerned him. "I let out a squawk that must have been heard from one end of the San Fernando Valley to the other," said Gable. "They not only had me doing a song-and-dance act but also a vaudeville routine as a chorus boy!"

A play making the transition to a film is customarily "opened up." This film had a new ending added, and belatedly. A preview audience wrote that the characters should be united in a happy ending after the near-fatal air raid, so Stromberg had Brown shoot an alternate ending.

By the time *Idiot's Delight* was released, Italian approval was a moot point. "Hollywood is in revolt against mandates issued in Italy," wrote Edwin Schallert on January 22, 1939. "No Hollywood film will be shown to the Mussolini-ruled population." The reason? "The Italian government has begun impounding exhibition profits." There were sufficient profits to justify the pains Stromberg had taken with *Idiot's Delight*. The film did well, in spite of reviewers who made invidious comparisons to the Lunts. The most pointed review came from *Commonweal* magazine: "This is a strong and bitter condemnation of a civilization tottering on the brink of war." By the time *Idiot's Delight* had finished playing its engagements, the world was no longer on the brink. It was at war.

Critical Reaction

"Gable, tongue in cheek, is really excellent. Here, at last, is an intelligent film that was not made in England."

—PHILIP K. SCHEUER,
LOS ANGELES TIMES

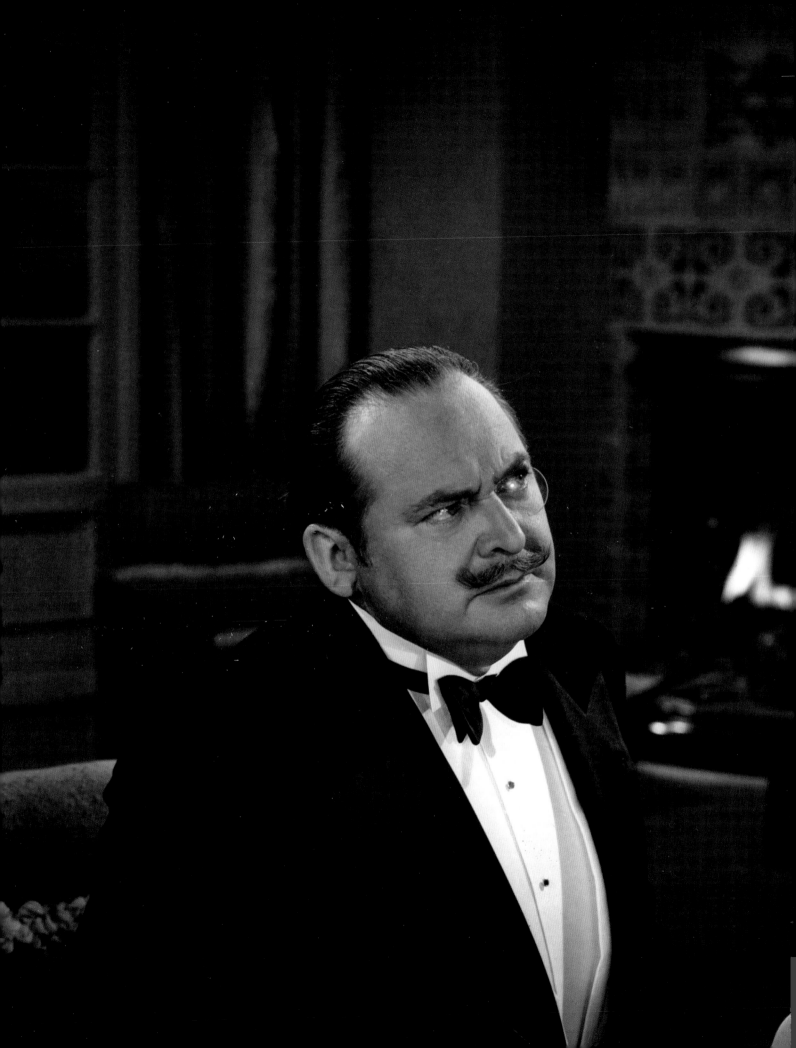

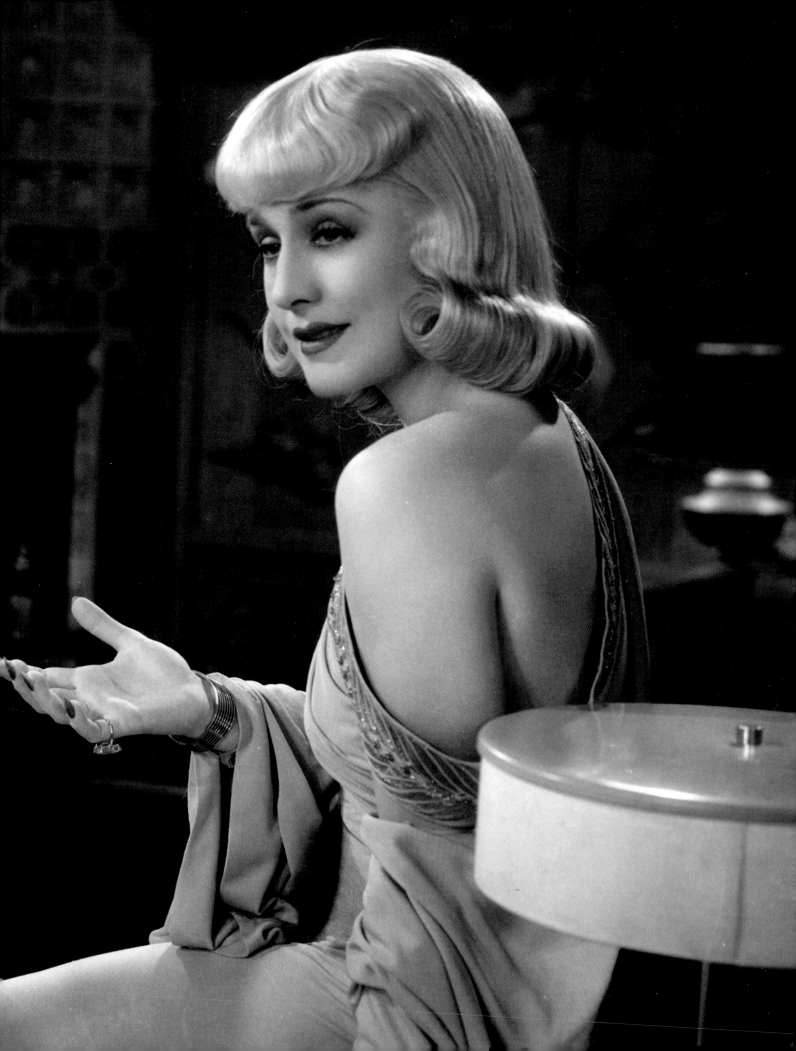

JESSE JAMES

RELEASED JANUARY 27, 1939

"If you don't know what this is, folks, it's a holdup."

THE STORY

Two brothers become outlaws after their family is destroyed by ruthless businessmen.

PRODUCTION HIGHLIGHTS

Twentieth Century-Fox's first entry in the 1939 lineup of bigger and better pictures was Henry King's *Jesse James*. Jo Frances James, granddaughter of the fabled outlaw, was peddling a manuscript based on his life, and Fox screenwriter Nunnally Johnson was intrigued with the exploits of the bank robber and his brother Frank, so production chief Darryl F. Zanuck decided to film the first large-scale Technicolor western.

Zanuck did not need to send a film company across country to achieve pictorial effects. The Twentieth Century-Fox backlot in West Los Angeles boasted every kind of setting, domestic and exotic. King, who specialized in Americana, insisted that *Jesse James* be shot in real locales, so he flew thousands of miles scouting locations before he settled on Pineville, Missouri. He was thrilled by the location. "There was a courthouse in the middle of the town square that was the most beautiful old red brick I've ever seen in my life," said King. "It had been there since the Civil War."

In August 1938 he built a $20,000 street there and began filming Tyrone Power as Jesse and Henry Fonda as Frank. Both actors were big enough stars to carry a film but neither felt that he had been given a sufficiently challenging role. Their first obstacle in *Jesse James* was to concentrate while being watched by 5,000 residents of Pineville, most of whom were exceedingly polite; crew members were invited to stay in neighboring homes, free of charge. When actor John Carradine arrived to portray the treacherous Bob Ford, he beguiled throngs of onlookers with a recitation of Shakespeare, but he first made his intentions clear. "I am here for a sole purpose," said Carradine. "To kill Jesse James."

When King's film began arriving in Los Angeles, it was late and not enough. "I appreciate your desire for an authentic location," wrote Zanuck, "but at the rate we are going, this picture will never break even, no matter how successful it is. I fully realize how you have been molested and hampered by crowds and other difficulties, but the fact remains we are now six days behind schedule with no prospects of improvement. In the history of our industry there has never been a successful location trip that lasted longer than two weeks." Zanuck pulled the *Jesse James* company back to the Twentieth lot, where more sets were built and the film was successfully completed, even though King fell ill shortly after resuming work on the lot. The film ended up costing $1.6 million. It also fictionalized the cold-blooded Jesse

Opposite: Tyrone Power in a scene from *Jesse James* *Right:* Nancy Kelly and Tyrone Power

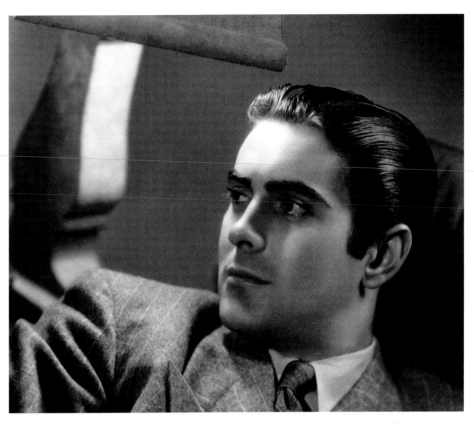

Opposite: Henry Fonda and Tyrone Power in a scene from Henry King's *Jesse James* *Above:* A portrait of Tyrone Power by Frank Powolny

James to the point that Tyrone Power was portraying a folk hero. "About the only connection that film had with fact," said Jo Frances James, "was that there was once a man named Jesse James, and he did ride a horse."

Jesse James grossed $3 million, which made it Twentieth Century-Fox's most profitable picture of 1939, and one of the year's top five. It established Power as a dramatic star and Fonda as a western star. "It turned out that Frank James was the part most moviegoers remembered," said Fonda. "He was more of a character." For John Carradine *Jesse James* was a mixed blessing, as he discovered while standing outside a theater that was running it. "Did you shoot Jesse?" a boy asked him. When Carradine admitted he had, the child kicked him in the shin.

Critical Reaction

"Historians may be thoroughly irked over much that happens during the unspooling of *Jesse James*. My friends who know the James history tell me there is much that is particularly false in this picture's attempts to point up the brothers as defenders of the downtrodden, but the public who is interested in entertainment will find this a rip-roaring melodrama."

—EDWIN SCHALLERT, *LOS ANGELES TIMES*

THEY MADE ME A CRIMINAL

RELEASED JANUARY 28, 1939

"Regenerate, ya dope!"

THE STORY

A champion boxer fleeing a murder rap hides out in the sticks with an old lady and a house full of kids.

Below: Ann Sheridan, John Garfield, and Barbara Pepper *Opposite:* A George Hurrell portrait of John Garfield

PRODUCTION HIGHLIGHTS

In 1939, as in every other year, making new stars was as important as making hit movies. John Garfield had made his Hollywood debut several months earlier, in Michael Curtiz's *Four Daughters*. The young New Yorker's raw energy immediately set him apart from the male up-and-comers being groomed for leading-man roles. Heaps of fan mail were dumped at the studio. John Garfield was a star. Warner Bros. allowed him to renegotiate his contract, granting him the unusual privilege of time off for theatrical productions. "Warner Bros. is giving Garfield a buildup seldom accorded a newcomer," wrote Read Kendall in the *Los Angeles Times*.

The buildup was not so magnanimous as to include a tailor-made script. First Warners rushed him into a B picture, *Blackwell's Island*, and then chose to recycle a plot that had served Douglas Fairbanks Jr. five years earlier. *The Life of Jimmy Dolan* became *They Made Me a Criminal*. In the earlier film, the kids in the story had been played by Mickey Rooney and some *Our Gang* alumni. In 1938 Warners had under contract the boys who had shot to fame, both on stage and screen, in Sidney Kingsley's *Dead End*. Billy Halop, Bobby Jordan, Leo Gorcey, Huntz Hall, Gabriel Dell, and Bernard Punsly were known as the Dead End Kids. This would be their third Warners feature.

The director assigned to *They Made Me a Criminal* was Busby Berkeley. Garfield was concerned that Berkeley's talents lay solely in his ability to mount dance routines. The famed choreographer's talent was considerable. Starting with *Whoopee!* for Samuel Goldwyn Pictures in 1930, Berkeley had elevated the musical number into an art form. Films like *Footlight Parade* and *Gold Diggers of 1935* were huge hits because of him, but the musical film, especially the "backstage" variety, could not last as a vogue forever. When the cycle began to slow, Berkeley had to, and, indeed wanted to, direct non-musical features. *They Made Me a Criminal* would be his eleventh straight drama, but this did not inspire Garfield's confidence. He doubted that Berkeley could give him the kind of direction that he needed, the kind he'd gotten at the Group Theatre in New York. He soon saw that Berkeley was as meticulous with characterization as he was with design.

Working with Berkeley was the Chinese American cinematographer James Wong Howe, one of Hollywood's finest. Berkeley and Howe collaborated on a boxing

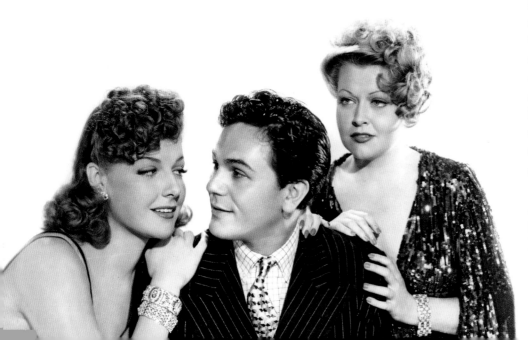

scene, applying to it the same principles that Berkeley used to film dance numbers. It was choreographed so well that when they were shooting it at the Jeffries Barn, a Burbank boxing gym, bystanders wandered in and watched the match, thinking that it was real. The hideout scenes were shot in Palm Desert in the heat of August. "It was so hot in the date groves that we had to stop shooting by noontime," recalled Berkeley. "There were times when the heat was so intense it melted the film in the camera." These problems slowed shooting and the studio sent threatening memos, which Berkeley dismissed.

They Made Me a Criminal confirmed Garfield's stardom. Years later, Garfield had softened his attitude toward the studio. "I was suspended only eleven times," Garfield said later. "I served my time and I took it like a sport." He was not bitter or resentful toward Warners. "They taught me the business and they made me a star. They took their chances with a cocky kid from the east who still talked out of the corner of his mouth. I appreciate all that."

Critical Reaction

"It is always Mr. Garfield, with his sublime self-confidence and the unhandsome attractiveness of his greasy, round, gamin face, who carries the show along." —BOSLEY CROWTHER, *THE NEW YORK TIMES*

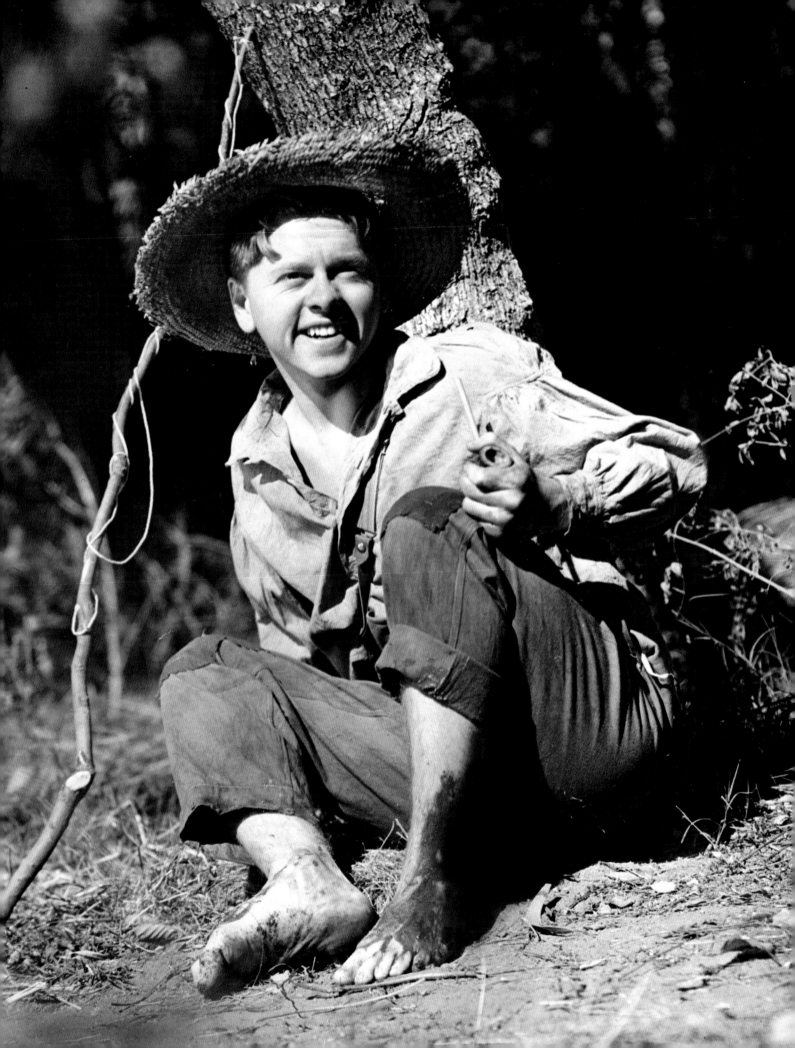

FEBRUARY

THE ADVENTURES OF HUCKLEBERRY FINN

RELEASED FEBRUARY 10, 1939

"Human beings make enough of a mess of their own lives without messing another human being's."

THE STORY

A boy and a slave escape an oppressive environment by taking a raft onto the Mississippi River.

Opposite: A portrait of Mickey Rooney by Bud Graybill for Richard Thorpe's *The Adventures of Huckleberry Finn*

PRODUCTION HIGHLIGHTS

When a studio filmed a literary classic in the 1930s, it was assumed that the film cost substantially less because there was no writer to pay. This was not the case with Mark Twain. Paramount Pictures had to pay the Samuel Clemens estate in order to film *The Adventures of Huckleberry Finn* in 1931. Likewise, M-G-M had to pay Paramount in April 1938 for rights to Twain's 1885 novel. David O. Selznick's *The Adventures of Tom Sawyer* was still in theaters. Why would the bigger studio want to make another Mark Twain film so soon? There were a number of reasons: Paramount's 1930 version of *Tom Sawyer* was one of the ten top-grossing films of the decade. Selznick's *Sawyer* was doing well, despite its cost overruns. People loved Tom and Huck. Making such a film would also give M-G-M a 1939 vehicle for a new star.

Mickey Rooney was edging out Clark Gable as America's number-one box-office attraction. Rooney, who stood five foot two, was prodigiously talented and equally energetic. He could act, sing, dance, and play almost every musical instrument but the violin. His portrayal of Andy Hardy in the *Hardy Family* series drew all the attention, so it became the *Andy Hardy* series. Along with the Jeanette MacDonald-Nelson Eddy musicals, and the *Tarzan* series, the *Hardy* series was making Louis B. Mayer the highest-paid executive in America. Mayer showed his gratitude by giving Rooney a $15,000 bonus on his eighteenth birthday, September 23, 1938. The Mark Twain assignment followed.

The Adventures of Huckleberry Finn was aptly named since the film did not include the character of Tom Sawyer, but

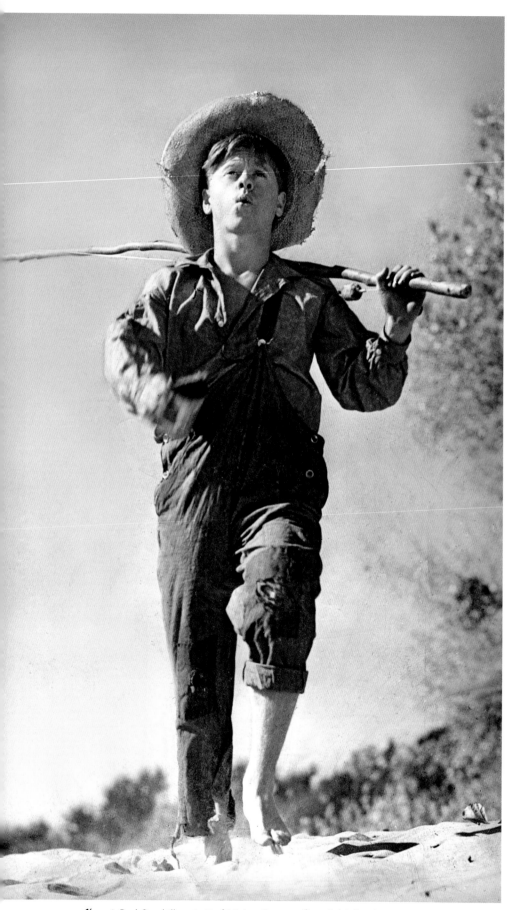

the adventures did include the runaway slave Jim, who was more than capably played by the African-American actor Rex Ingram. "I'm savin' up enough money to buy myself," Jim says with happy self-confidence. The onscreen rapport between Jim and Huck echoed that displayed by Hattie McDaniel and Jean Harlow in *China Seas* and *Saratoga*. Such scenes were usually cut to appease audiences in the South, who refused to watch interracial fraternizing, but these scenes were integral to the plot and could not be removed without affecting continuity. M-G-M was one of the few studios strong—or courageous—enough to cast a proud African American in a self-possessed role and stand by the material through its exhibition. Thus Jim is not an inferior along for the ride but a guide and mentor to Huck Finn.

Critical Reaction

"Huck has progressed ideologically since his last two cinema incarnations. Now, it appears, he is a convinced abolitionist, and not only persuades the Widow Douglass to free Rex Ingram but also makes a little speech allowing how it ain't right for one human being to own another. Surely we can all applaud this sentiment without feeling compelled to endorse the socially conscious Huck who gives it utterance. The next thing you know, they'll be using Master Finn to promote 'Votes for Women.'"

—FRANK S. NUGENT, *THE NEW YORK TIMES*

Above: A Bud Graybill portrait of Mickey Rooney *Opposite:* Mickey Rooney and William Frawley

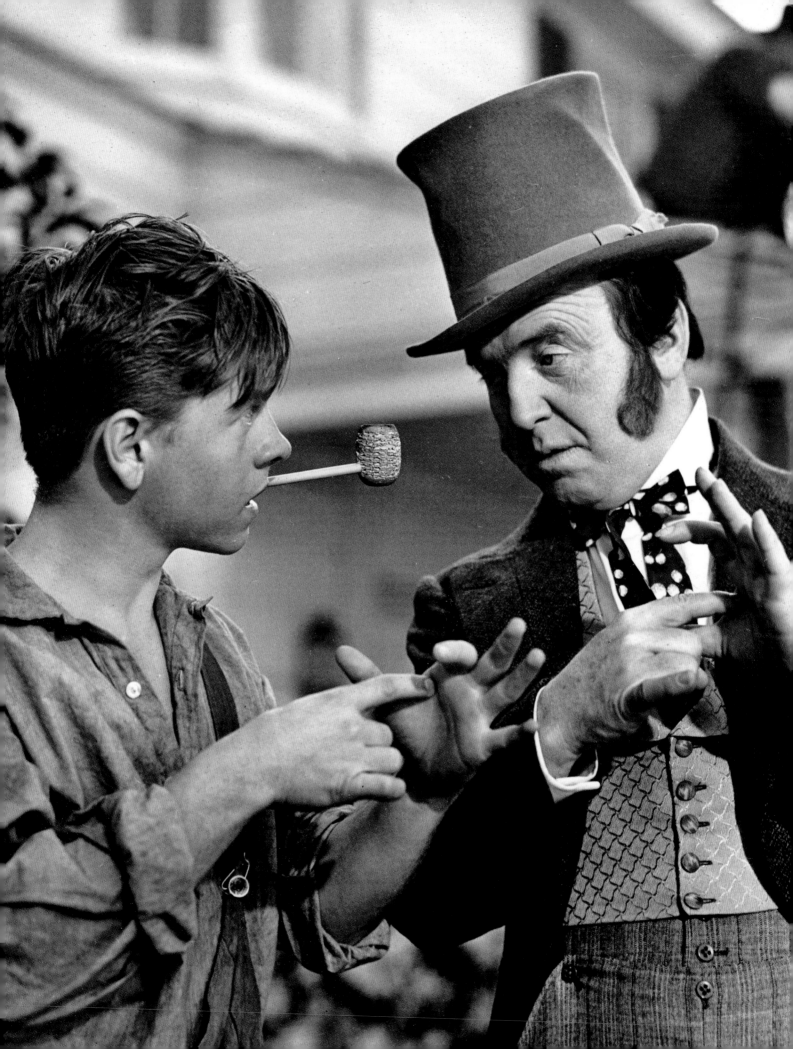

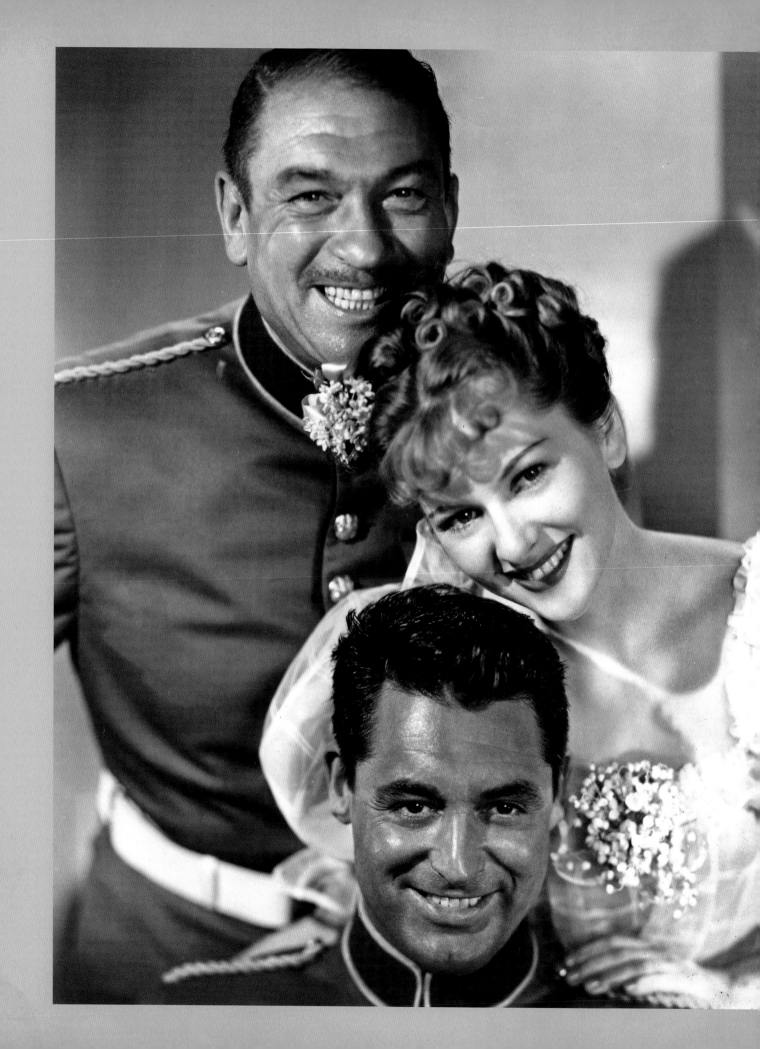

GUNGA DIN

RELEASED FEBRUARY 17, 1939

"You're a better man than I am, Gunga Din."

THE STORY

When three British soldiers are caught by the members of a murderous East Indian cult, their only hope of rescue is a despised water bearer.

Opposite: A portrait of Victor McLaglen, Joan Fontaine, and Cary Grant made for George Stevens's *Gunga Din*

PRODUCTION HIGHLIGHTS

How did a nineteenth-century poem become a 1939 blockbuster? Rudyard Kipling wrote *Gunga Din* in 1892. The Nobel Prize winner died in 1936, and his widow entertained offers from numerous producers. One of these was Edward Small of the independent company Reliance Pictures, who purchased the rights to *Gunga Din* for £5,000. When he joined RKO Radio Pictures, that company acquired the property, which was little more than a poem about a Bhisti who dies trying to emulate the British soldiers he serves. (The Bhishti were regimental water bearers in colonial India.)

RKO executives thought enough of Kipling's poem to assign the project to director Howard Hawks, who had made *Twentieth Century* (1934), the first screwball comedy, which was in turn written by Hollywood's most prestigious and prolific screenwriting team, Ben Hecht and Charles MacArthur. Their greatest achievement was the sensationally successful Broadway play *The Front Page*. Starting in September 1936, Hawks worked with Hecht and MacArthur on the *Gunga Din* screenplay. It soon acquired elements from Kipling's novel *Soldiers Three* and, not surprisingly, *The Front Page*. This was not what RKO had in mind, and it made casting difficult, so the project languished

for a year while Hawks made *Bringing Up Baby*. He fell forty days behind schedule on that film and went 40 percent over budget—much of which was overtime paid to Cary Grant and Katharine Hepburn, not to mention himself.

Producer Pandro S. Berman reactivated *Gunga Din* in early 1938. "Hawks was both slow and difficult," said Berman. "He would go so much over budget that I would be in trouble. So I went with George Stevens, who up to that time had made pictures quite reasonably." *Gunga Din* was budgeted at $1.4 million, the highest ever for an RKO film, and scheduled for a December 1938 release. Stevens was known for the very profitable *Swing Time*, which starred Fred Astaire and Ginger Rogers, RKO's real moneymakers. "Stevens also had experience shooting and directing silent comedies," recalled Douglas Fairbanks Jr. "This was an invaluable background for a film that would consist of movement on a large and exciting scale." Stevens began reworking the script with Joel Sayre and Fred Guiol; Hecht and MacArthur had made it too much like their *Front Page*. "Most of it took place in offices," recalled Stevens. "I wanted an outdoor film." The wisecracking soldiers began to resemble the three Musketeers.

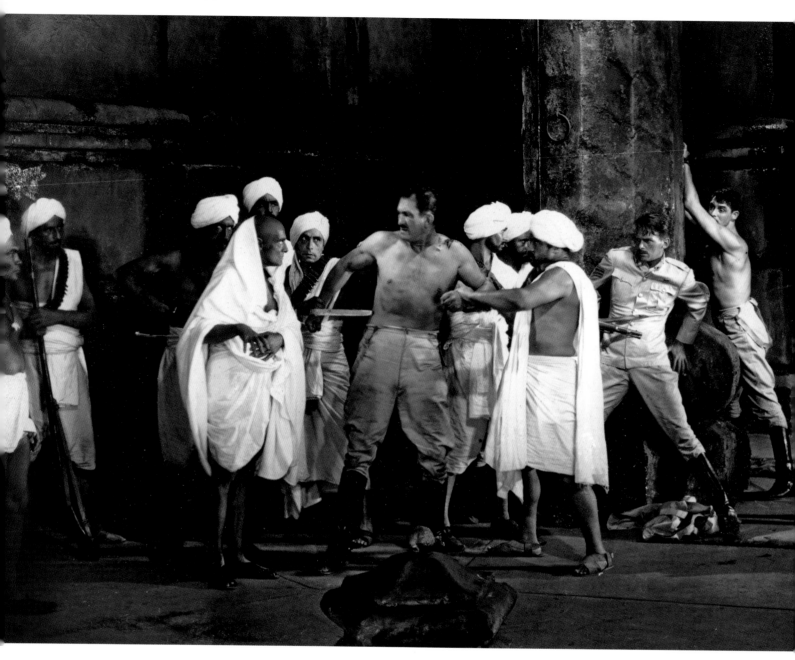

Gunga Din was not the typical RKO film. Casting was a problem. Cary Grant, who had nonexclusive contracts with both RKO and Columbia Pictures, was approached by Berman, and then urged freelancer Douglas Fairbanks Jr. to sign on as the second of the Musketeers. The third was the British actor Victor McLaglen, the veteran star and former boxer who had worked at every studio in Hollywood without wearing out his welcome. To play Gunga Din, Berman auditioned the teenage East Indian actor Sabu but could

not hire him because of his contractual obligations to Alexander Korda. Instead, Berman hired Sam Jaffe, who had just played the wizened Lama in *Lost Horizon*. Jaffe was forty-seven, seemingly too old to be a native water bearer. "I knew nothing about Hindus," said Jaffe. "I had recently seen Sabu in Korda's *Elephant Boy*. I tried to emulate what I remembered from that one performance. I tried to approach the character a little bit in the dialect Sabu had. You must go back to a source occasionally, and this was a source for me."

RKO had a ranch in the San Fernando Valley, but not even the use of painted glass or matte shots (the technique used to extend the perimeters of a scene) could transform it into the Khyber Pass. Using an airplane, Stevens found a location near Mount Whitney, 230 miles northeast of Los Angeles. To create a believable Indian setting, he had to build three large structures and move a thousand people to the location. This aspect of the production was deemed newsworthy, especially when nature turned on

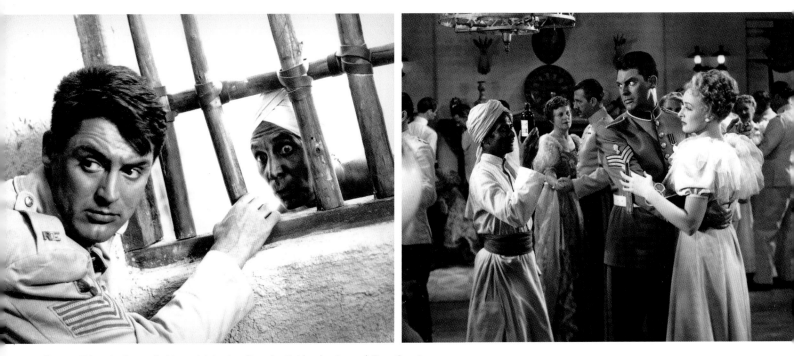

Opposite: Eduardo Ciannelli, Victor McLaglen, Douglas Fairbanks, Jr., and Cary Grant
Above from left: Cary Grant and Sam Jaffe ✳ Cary Grant and Ann Evers

its visitors. There was intense heat, then sandstorms, and a fire that destroyed sets. Berman had allotted a six-week schedule for the location but did not know that Stevens was still rewriting. "When we got to Lone Pine," recalled Stevens, "the script wasn't finished. I remember sitting in the back of a truck writing dialogue while soldiers were being drilled on the parade ground nearby."

Still, Stevens gained the confidence of his actors. "He was a kindly, able man, very bright," said Jaffe. "On the battlefield, he had to be a general, to know everything." Fairbanks also found Stevens an inspiring leader. "George Stevens was quite unlike the conventional, overassertive director," wrote Fairbanks. "Unlike tyrannical directors such as C. B. DeMille and Fritz Lang, he made his team feel they were trusted partners rather than hired puppets. One's first impression was that he was vague, dreamy, and inefficient, but this was a mask behind which his brain ticked at the

speed of light." Stevens's brain may have been moving fast, but the production was not. When it approached eight weeks, Berman had to drive to Lone Pine and order the company back to Hollywood.

Gunga Din had been budgeted for sixty-four days of filming. Stevens ended up shooting 104 days, pushing the film's cost to $1.9 million. The film started off unsteadily in some markets. "Despite the record-breaking crowds and the wonderful reviews," recalled Fairbanks, "many cynical New Yorkers greeted our Kiplingesque virtues and heroics with embarrassing guffaws and loud sneers." Fairbanks saw the film in a different context. "The picture's theme glorified the British 'Tommy' fighting courageously against heavy odds," wrote Fairbanks. "It was not only an enormous hit—it broke every record at Radio City Music Hall—but also an effective goodwill boost toward the British at that uncertain time in international affairs."

Critical Reaction

"There has probably never been a moment in the world's history when more exciting things were going on than in 1939. That Hollywood can supply no better salute to 1939 than a $2-million rehash of Rudyard Kipling and brown Indians in bed sheets is a sad reflection on its state of mind."

—*TIME*

"Stevens strikes exactly the right key for devil-may-care adventure. The battle scenes are wows. The climax is worthy of D. W. Griffith."

—PHILIP K. SCHEUER,
LOS ANGELES TIMES

YOU CAN'T CHEAT AN HONEST MAN

RELEASED FEBRUARY 18, 1939

"I'd rather have two girls at twenty-one each than one girl at forty-two."

THE STORY

A bombastic mountebank uses all manner of persiflage and chicanery to cheat people until it's time to save his daughter from marrying a horrible man.

Right: Constance Moore and W.C. Fields in George Marshall's *You Can't Cheat an Honest Man*

PRODUCTION HIGHLIGHTS

W. C. Fields had been off the screen for more than a year when Universal Pictures offered him a contract. He would be paid $100,000 and his comic brilliance would not be dimmed by an interfering producer—or writer. "The only time these writers do anything good," said Fields, "is when they write their relatives asking for a job." In 1938 Fields was looking for a job, and Universal was the only studio willing to put up with him. Fields was the quintessential misanthrope, avowedly hostile to women, children, and dogs. He insisted on writing his own weird stories. And he refused to take direction. Director Mitchell Leisen called him "the most obstinate, ornery son of a bitch I ever tried to work with." Yet no writer could concoct better one-liners than W. C. Fields. His off-kilter universe was the vision of a genius, and each of his films was a journey into that universe. The plot was usually slight, an

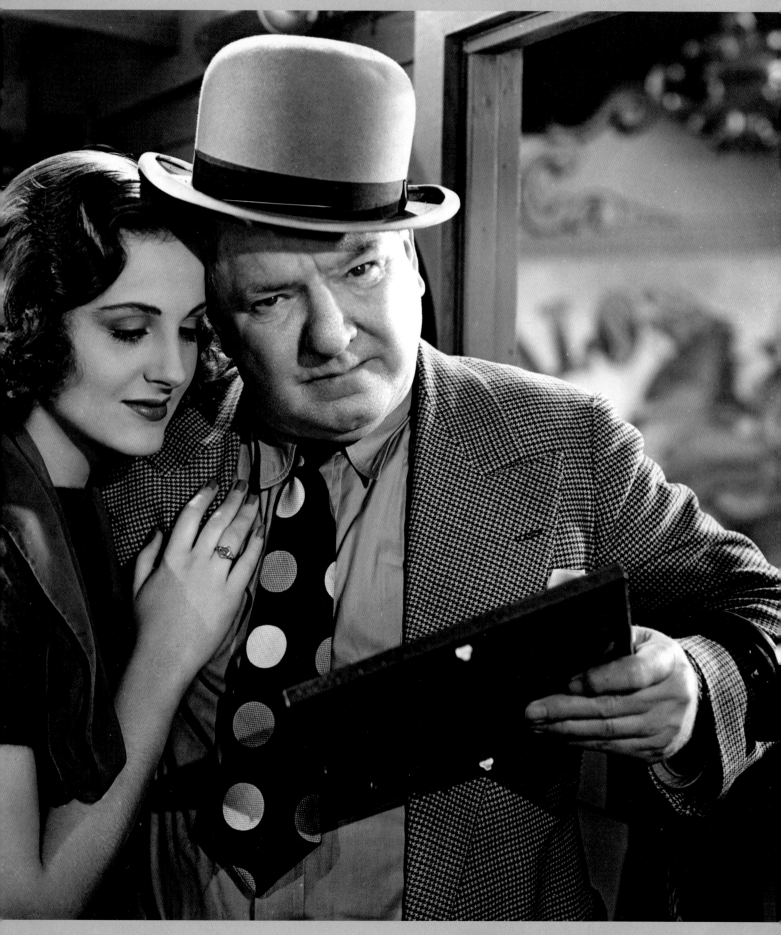

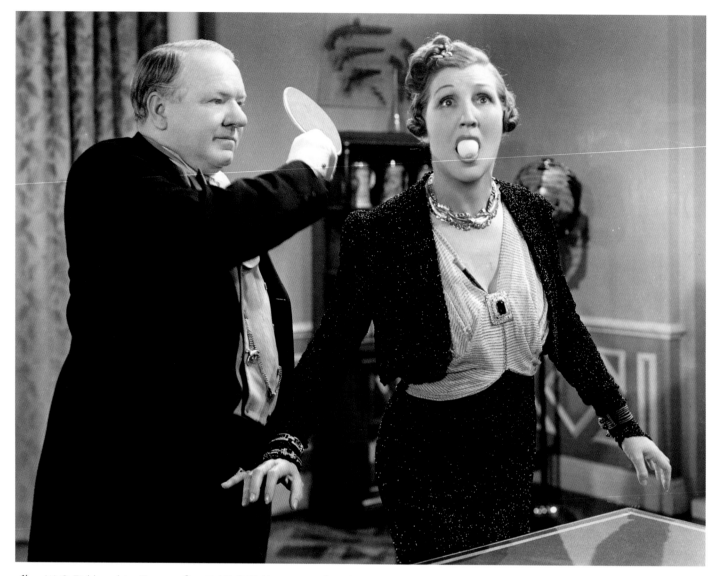

Above: W. C. Fields and Jan Duggan *Opposite:* W. C. Fields in a scene from *You Can't Cheat an Honest Man*

excuse for a series of episodes in which Fields did battle with women, children, dogs, and reality. These episodes—and Fields—were very funny.

Field was paid $25,000 for the outline of *You Can't Cheat an Honest Man*. He claimed to have written it on the back of an envelope. This may have been true, since seven writers failed to turn it into a screenplay, and the film started shooting without a script. No one was worrying. In addition to Fields, the project had ventriloquist Edgar Bergen and his savvy dummy, Charlie McCarthy, stars of *The Chase and Sanborn Hour*. Fields was a regular guest on the radio show, where he sparred

with McCarthy, who was supposed to be his errant son. Putting their feud on the screen was a great idea. Their routine would be even funnier if it could be seen.

Fields had not been making films because of ill health. Years of drinking had caught up with him. While he was recovering from a number of ailments, he had tried to stop drinking. By the time he was filming *You Can't Cheat an Honest Man*, he was drinking again. It was no secret. "Bill Fields takes two ounces of sherry an hour," wrote Hedda Hopper in her syndicated column. "But he says he's getting sick of these sissy drinks. As soon as the picture closes, he's going to do something

big about it." The regimen did nothing for Fields's temperament.

There were clashes, first with the screenwriters who were trying to force some continuity on his script, and then with director George Marshall. To placate Fields, Universal brought in the veteran comedy director Eddie Cline, but only to direct Fields's scenes. Next Fields turned a baleful eye on a certain dummy. "Edgar Bergen would use Charlie McCarthy to confront Fields," recalled Constance Moore, who was playing Fields's daughter. "And Fields would take great offense. So there would be this little creature attacking Fields. The

illusion was such—and things grew to such proportions—that Fields finally struck Charlie—the dummy—from the set." In spite of discord and discontinuity, *You Can't Cheat an Honest Man* finished only three days behind schedule. It was previewed six days later, and released on schedule less than two weeks later. The box-office returns of *You Can't Cheat an Honest Man* were disappointing. The film could not compete with more substantial February releases.

Critical Reaction

"Larson E. Whipsnade is a blusterer who bullies for the sake of bullying and not to conceal a tender heart. We want no part of him. He is something created by the radio, the result of nagging and being nagged by a pert ventriloquist's dummy. Too, his sequences have a mutilated look, are quite pointless, or trail off into bored slapstick. It is all most disappointing!"

—FRANK S. NUGENT,
THE NEW YORK TIMES

"If you are at all story-minded, stay away from this one. Outside of its reminiscent-of-variety-theater airs, it is virtually meaningless. As a freak attraction, it has its points. I enjoyed it."

—PHILIP K. SCHEUER, *LOS ANGELES TIMES*

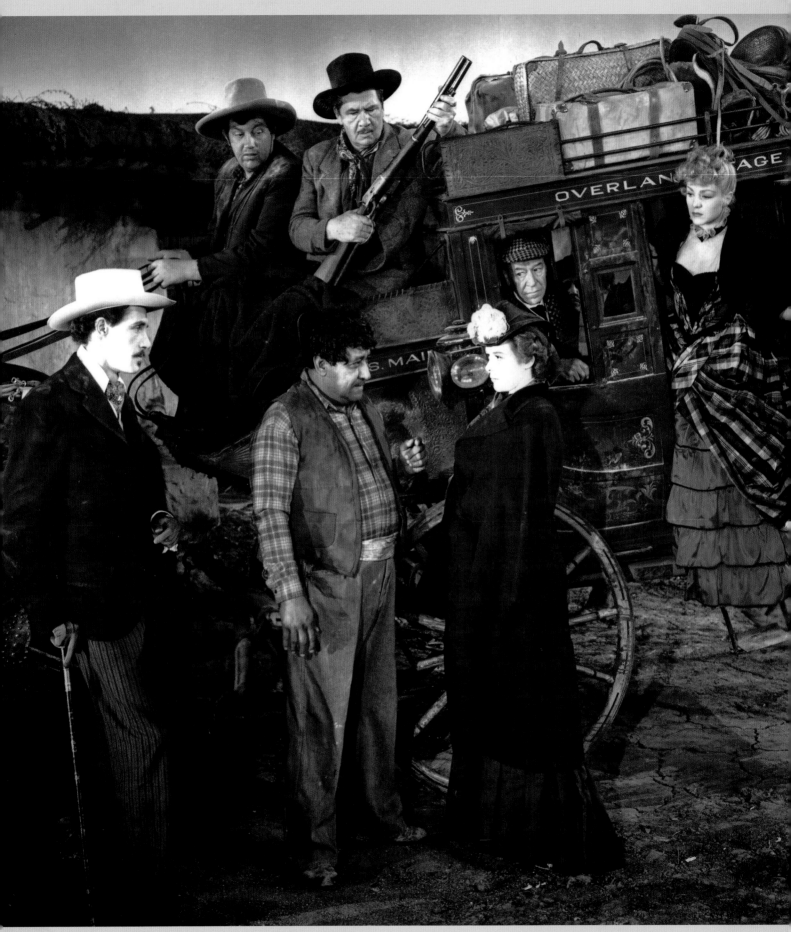

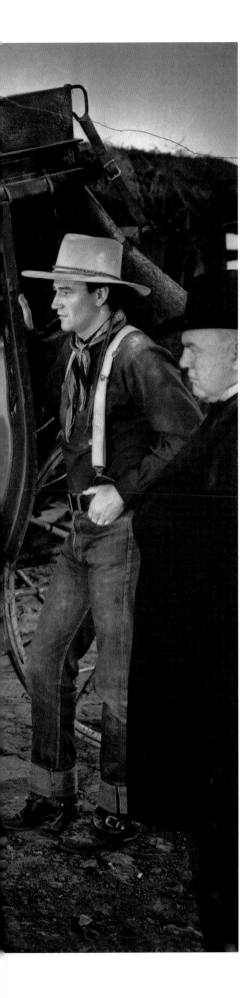

STAGECOACH

RELEASED MARCH 3, 1939

"Well, I guess you can't break out of prison and into society in the same week."

THE STORY

A group of misfits traveling by stagecoach fights to survive prejudice, Indian attacks, and each other.

Left: John Carradine, Andy Devine, George Bancroft, Soledad Jiménez, Louise Platt, Donald Meek, Thomas Mitchell, Claire Trevor, and John Wayne in a scene from John Ford's *Stagecoach*

PRODUCTION HIGHLIGHTS

In the spring of 1937, director John Ford was making *The Hurricane* for Samuel Goldwyn but had a "pet project" in mind. His son, Pat, had recommended a short story in *Collier's* magazine, *The Stage to Lordsburg* by Ernest Haycox. In it, a group of outcasts rides a stagecoach through Indian country, and each member of the group makes a personal journey from confusion to enlightenment. Ford thought it would make a big-budget western. No one else did. "Nobody was making westerns," recalled Ford. "They were a drug on the market." Well, not exactly; if a star could be cast, there was a chance to make one. There were Tyrone Power (*Jesse James*) and Robert Taylor (*Stand Up and Fight*). But a star vehicle was not Ford's concept. After paying a measly $7,500 for the story, he and producer Merian C. Cooper went to David O. Selznick. Selznick considered Ford "one of the greatest directors in the

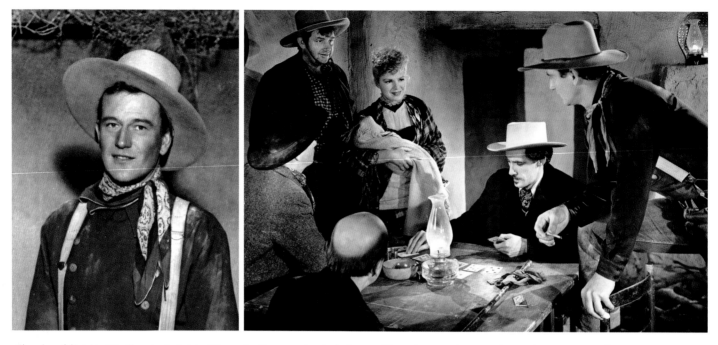

Above from left: A Ned Scott portrait of John Wayne for *Stagecoach* ◦ Andy Devine, Claire Trevor, John Carradine, and John Wayne *Opposite:* Donald Meek, John Wayne, Andy Devine, Claire Trevor, George Bancroft, Louise Platt, Tim Holt, Francis Ford, John Carradine, Berton Churchill, and Thomas Mitchell

world" but thought he should be shooting a literary classic, not a short story. "We argued that this was a classic western with classic characters," said Cooper. Selznick did not want it unless it starred Gary Cooper and Marlene Dietrich. Ford then spent a year knocking on doors. When he met with independent producer Walter Wanger, the project was called *Stage-coach*, with a script by Dudley Nichols. The leads were the B-western actor John Wayne and the B-picture actress Claire Trevor. "Let's do it," said Wanger. "Knock it out."

On October 31, 1938, Ford was on location in Utah's Monument Valley, an isolated area of the Navajo Nation Reservation. The awe-inspiring landscape of sandstone buttes and cloud-laden skies would provide a backdrop for the stagecoach's journey. Ford had discovered the site when the owner of a trading post drove to Hollywood with photographs. The majestic, breathtaking images he captured would do much to tell his story. "The real star of my westerns has always been the land," said Ford. "Monument Valley has rivers, mountains, plains,

desert, everything the land can offer. I consider this the most complete, beautiful, and peaceful place on earth."

Why was Ford's leading man an actor who was working in routine westerns? John Wayne was under contract to Republic Pictures, but had been a friend of Ford's for years, always hoping that Ford would elevate him to feature-film roles. Ford put him off but secretly planned to use him, even if it meant bucking the establishment. "The backers don't want him," said Ford in 1938. "The producer doesn't want him. I want him." A screen test with Trevor showed Wayne's potential.

Ford started working with Wayne in November 1938, and he used the same technique that Josef von Sternberg had to make Dietrich a star—lighting, angles, and camera movement. Then he drilled him and browbeat him. "Jack Ford was tough on Duke Wayne," recalled Trevor. "He was trying to take away Duke's bad habits. You can't help having bad habits when you've only made B pictures. I felt sorry for Duke because he wanted to succeed so badly." Ford would yell at

Wayne in front of cast and crew alike, calling him a "big oaf" and a "dumb bastard." Wayne took his medicine. "Ford knew what he was doing," said Wayne. "He knew I was ashamed of being a B-western cowboy." One day Ford grabbed Wayne's face and said, "What are you doing with your chin? You don't act with your mouth or your chin! You act with your eyes! I want to see it in your eyes!" In one scene, the sound recordist complained about Wayne's delivery of a line. Ford scratched out the line and said to Wayne, "Just raise your eyebrows and wrinkle your forehead." This was Ford's way, telling the story with images, not with dialogue, and making a star in the process.

Ford completed *Stagecoach* in forty-seven days, only four days behind schedule, but almost $15,000 under budget—something that rarely happened in Hollywood. As Wanger began publicizing the film, he said, "It was Ford who worked with Dudley Nichols in creating a fine script. John Wayne was Ford's idea. Please do everything in your power to see that the picture is known as John Ford's

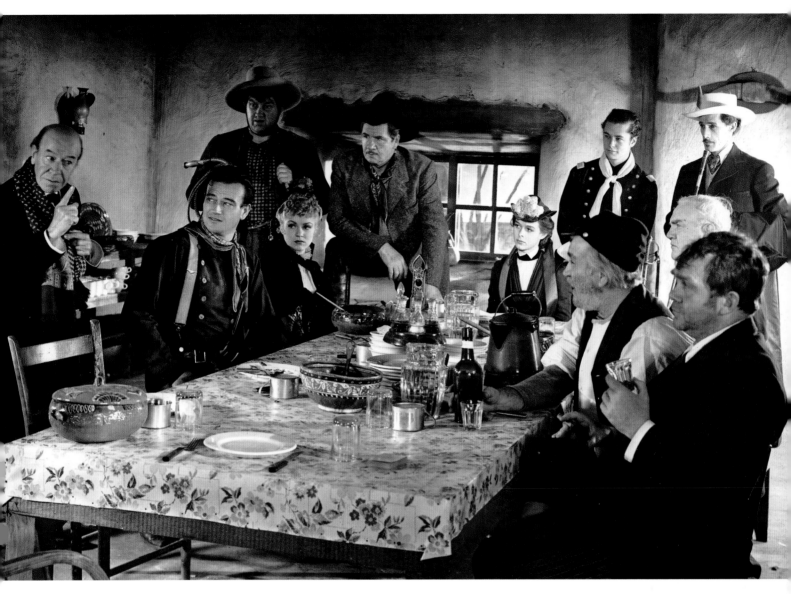

achievement." *Stagecoach* was pre-viewed at the Fox Westwood Theatre on February 2, 1939, to an audience of mostly college students—a tough audience. Wayne was taken aback by their reaction. "They yelled and screamed and stood up and cheered," he recalled. "But they were quiet at the right time, too," recalled Trevor. "Ford had them mesmerized."

Wanger wisely made sure that *Stagecoach* opened at Radio City Music Hall, where a huge screen would serve its grand images. The film grossed $1 million and sent John Wayne on the road to becoming the most popular star that Hollywood had ever known.

Critical Reaction

"In one superbly expansive gesture, John Ford has swept aside ten years of arti-fice and talkie compromise. He has made a motion picture that sings a song of camera. It moves, and how beautifully it moves, skirting the sky-reaching mesas of Monument Valley, beneath the piled-up cloud banks which every photographer dreams about."
 —FRANK S. NUGENT, *THE NEW YORK TIMES*

"This film has that symphonic feel which has belonged to most great motion pic-tures of the past. The feel is filmic as well as musical: a dominant theme, repre-sented by the coach-in-motion, surrounded by the minor motifs of the characters whom it carries."
 —PHILIP K. SCHEUER, *LOS ANGELES TIMES*

THE LITTLE PRINCESS

RELEASED MARCH 17, 1939

"Let's pretend we're back in India, and I'm going away with the troops for a few days."

THE STORY

When a little girl is orphaned by her father's death in the Boer War, she is forced to become a kitchen maid.

PRODUCTION HIGHLIGHTS

In 1938 Shirley Temple was the highest-grossing star in Hollywood. This was verified by the Quigley Poll of exhibitors, which showed that she had been number one for four years in a row. She was ten years old. Or was she? Darryl F. Zanuck, head of Twentieth Century-Fox, decided it might be wise to subtract a year from her age, to postpone the inevitable arrival of "that awkward age." Twentieth was roaring forward on a profit of $7.3 million from 1937, and Temple was a huge moneymaker, but Hollywood was an insecure place. "Popularity polls did little to reassure those uneasy with my growth," wrote Temple. "Although still at the top for a fourth consecutive year, I was closely trailed by Clark Gable and Sonja Henie. Mickey Rooney was fourth, catapulted from the deep hundred mark. The pack was closing fast on my heels."

One sign of Temple's prominence was an offer that came from M-G-M. At the urging of executive producer Mervyn LeRoy and associate producer Arthur Freed, Louis B. Mayer was going to film *The Wizard of Oz*. LeRoy and Freed were convinced that an M-G-M contract player named Judy Garland should have the lead role of Dorothy Gale, but they were outvoted. "The M-G-M brass was

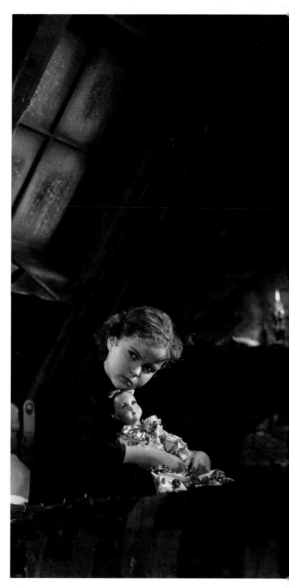

Opposite: A portrait of Shirley Temple made for Walter Lang's *The Little Princess* *Right:* Shirley Temple in a scene from the film

39

unanimous," wrote LeRoy. "They wanted Shirley Temple. I had nothing against her, but I had seen my 'Dorothy' in a low-budget Twentieth musical called *Pigskin Parade*. Judy Garland had the quality I wanted for Dorothy." M-G-M sent arranger and composer Roger Edens to make a vocal test of Temple. "Her vocal limitations are insurmountable," reported Edens. This was a moot point. Zanuck was unwilling to loan out his number one star.

This left Shirley Temple available for a new film, but to the annoyance of her mother, Gertrude Temple, no project was ready. "Mother expressed the opinion," wrote Temple, "that recent scripts were forcing me into rigid, stereotyped roles inappropriate to my growth. Typecasting in her view was one of the most persistent and destructive artistic traps." Gertrude pointed to the variety of roles played by Mary Pickford. This was something that everyone at Twentieth could understand, since one of Temple's earlier successes had been based on Pickford's *Poor Little Rich Girl*. Gertrude knew what was best for her daughter's image. "Shirley was the instrument on which her mother played," said Allan Dwan, who had directed two of her recent films. "Shirley was always on the job and ready," recalled Dwan. "She knew all her 'words'—as she called her dialogue—and her songs and dances, too. So it was simple working with her." A number of properties were considered, all Victorian romances. "For a second time," wrote Temple, "I was to be reincarnated in Mary Pickford's image."

The Little Princess was loosely based on a 1905 novel by Frances Hodgson Burnett, who was best known for *Little Lord Fauntleroy*. The princess of the title is a rich child whose father's death strips her

Above: Shirley Temple and director Walter Lang on the set of *The Little Princess*

of both money and social standing, but she survives the persecution of a cruel schoolmistress through a friendship with a lonely old bachelor. "The production budget was a cheering $1.3 million," wrote Temple. "Six times the cost of my first film and enough for a blockbuster." This was the first Shirley Temple movie to be made in Technicolor. This was a dubious

idea, because the process required high levels of light (one thousand "foot-candles"). Could a child work in that glare and heat? Zanuck called cinematographer Arthur Miller into his office. "We'd like to do a picture with Shirley in color," Zanuck said to Miller. "Is that possible?"

"A kid can't stand that kind of light," said Miller. He had an idea, though. He

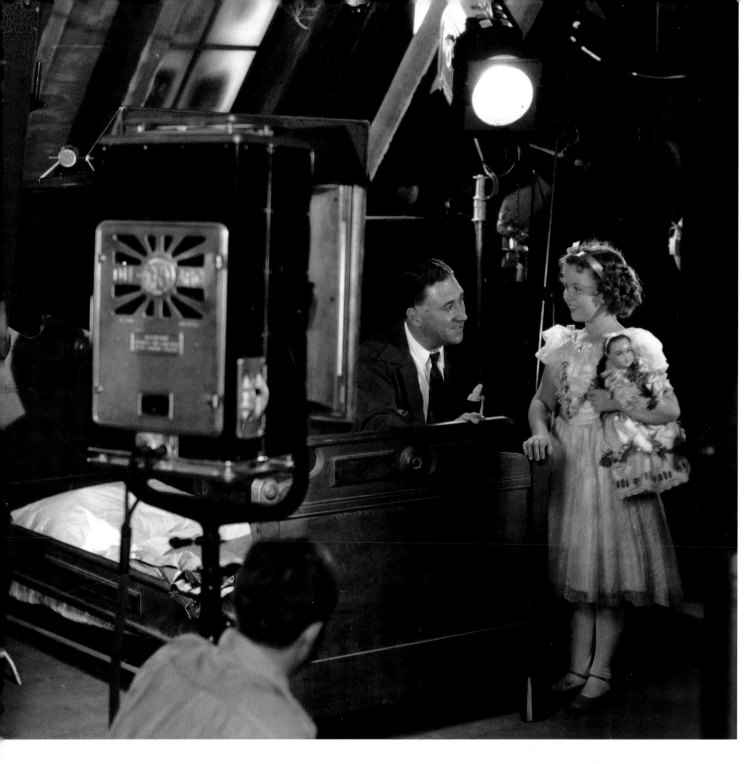

made a test using five hundred "foot-candles" instead of the standard one thousand and sent it to the Technicolor lab. No one could tell the difference. Half the light meant half the discomfort.

Under Walter Lang's direction, *The Little Princess* started shooting in September 1938 and enjoyed a spectacular premiere at Grauman's Chinese Theatre on March 17, 1939. Stars in the audience included Hedy Lamarr, Joan Crawford, Tyrone Power, Annabella, Douglas Fairbanks, and Sylvia Ashley Fairbanks. Zanuck told the Temples that *The Little Princess* was "by far the best picture she has ever made." For once hyperbole and truth were in tune.

Critical Reaction

"There was no question about the responsiveness of the audience to *The Little Princess* last night, practically from the initial reel. Plenty of tears were shed."

—EDWIN SCHALLERT, *LOS ANGELES TIMES*

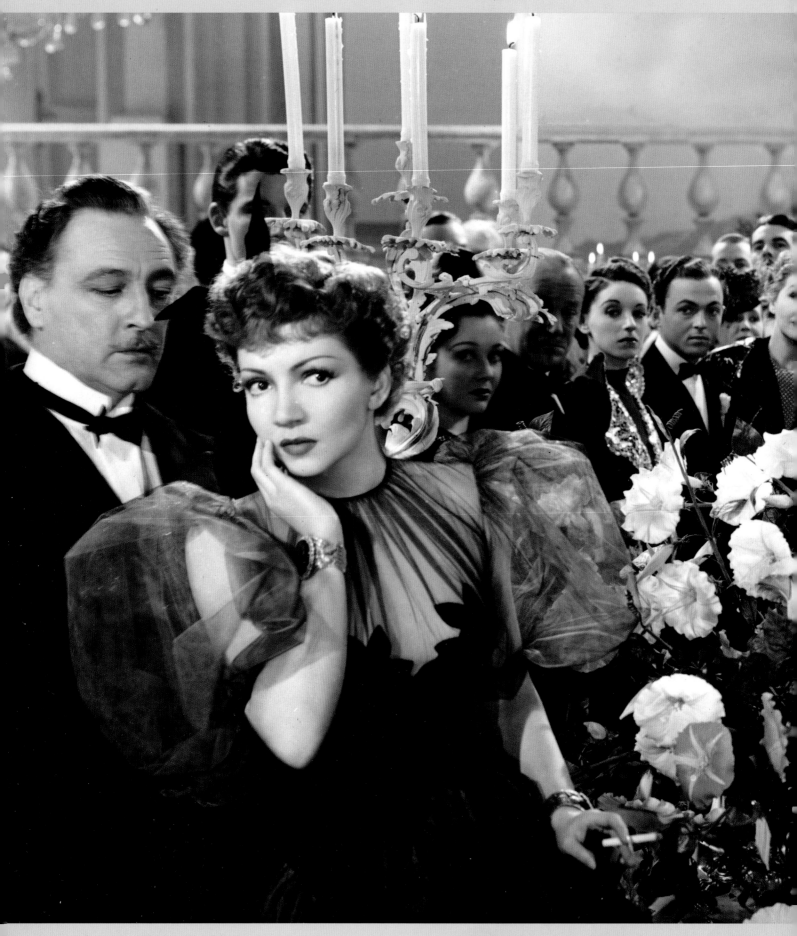

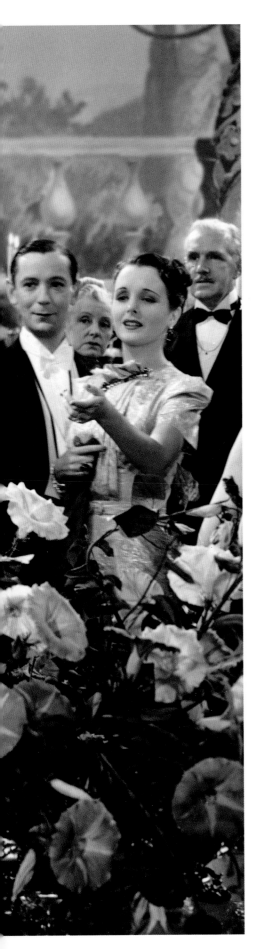

MIDNIGHT

RELEASED MARCH 24, 1939

"Don't forget, every Cinderella has her midnight."

THE STORY

An American show-girl arrives in Paris with nothing but a gold lamé gown. A cab-driver offers her shelter, but she runs away and crashes a private party, where a rich man offers her a more intriguing arrangement.

Opposite: John Barrymore, Claudette Colbert, Elaine Barrie, Billy Daniels, Hedda Hopper, Rex O'Malley, and Mary Astor in a scene from Mitchell Leisen's *Midnight*
Right: John Barrymore and Claudette Colbert

PRODUCTION HIGHLIGHTS

In 1938 Claudette Colbert earned $301,944 and became Hollywood's highest-paid star. Although her last two films (*Bluebeard's Eighth Wife* and *Zaza*) were not major hits, her earning power was undiminished. That was not true of her peers. Marlene Dietrich had fallen out of favor after Paramount paid playwright Edwin Justus Mayer $34,000 to write a film for her called *Careless Rapture*. The project was offered to Colbert, who had story approval. She liked it. Producer Arthur Hornblow assigned Paramount contract writers Charles Brackett and Billy Wilder to rework the script. When they gave it a Cinderella slant, it was retitled *Midnight*.

Mitchell Leisen was, after Cecil B. DeMille and Ernst Lubitsch, Paramount's most consistently profitable director. Having served as DeMille's art director, costume designer, and assistant director, Leisen brought a sense of design to his films that the average director could not. Producers appreciated him. "Arthur Hornblow wanted to make this a very special picture," said Leisen. "He loved the script and we threw money at it like drunken sailors." Leisen was also respected by actors. "Mitch was not a 'Svengali' director," said Colbert. "He never imposed his will on any player that I can recall. He left the acting to the actors; they presumably knew their jobs. Obviously he would suggest perhaps a little more or a little less, but he knew exactly when it was right."

A comedy has to be anchored in reality. "Eve Peabody was a very interesting character," said Leisen. "You see, there's a little bit of good and a little bit of bad in all of us. A lot of poor girls want to get rich." Leisen worked daily in Hornblow's office with Brackett and Wilder, crafting Eve's story scene by scene. At times Leisen felt that Wilder was more interested in cynical wit than in the truth of the character. "Billy, you have this guy doing something that is completely inconsistent," Leisen would say. "You suddenly introduce a completely different emotional setup for this character, and it can't be. It has to follow a definite emotional pattern." Wilder felt that Leisen was preoccupied with visual effects, especially costume details. Worse, Leisen would eliminate sections of dialogue on which Wilder had lavished time and care. "Billy would scream if you changed one line of his dialogue," said Leisen. "I used to say, 'Listen, this isn't Racine. It's not Shakespeare. If the actors can't say it, we must give them something they *can* say.'"

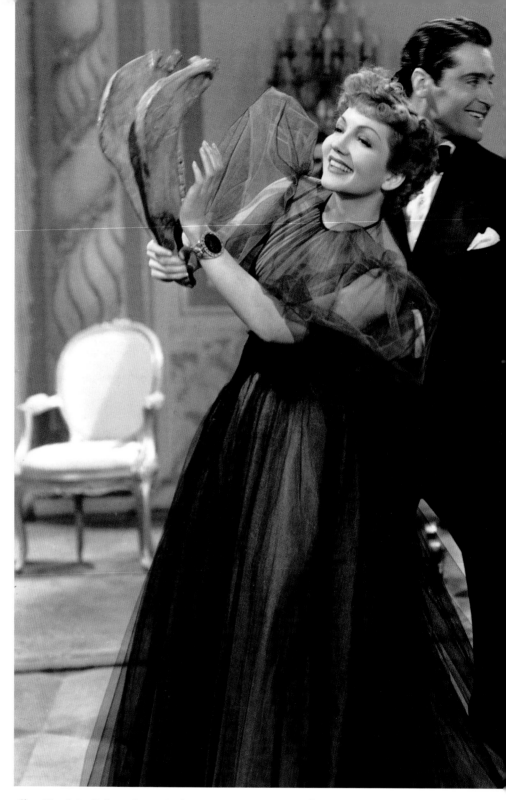

Above: Claudette Colbert, Francis Lederer, Mary Astor, Rex O'Malley, Elaine Barrie, Lionel Pape, Hedda Hopper, Billy Daniels, and John Barrymore in a scene from Mitchell Leisen's *Midnight*

John Barrymore had been America's greatest Hamlet, a matinee idol in silent films, and a star of the talkies. At fifty-seven he was a wreck, a sad caricature of his former grandeur, married to a gold digger named Elaine Barrie. "I had to give his wife a part in the picture just to keep him sober," recalled Leisen. "She was on the set every minute and watched him like a hawk." Barrymore was able to put aside his self-destructive behavior long enough to earn money to pay debts, but he could not (or would not) memorize dialogue. Directors had to write his lines

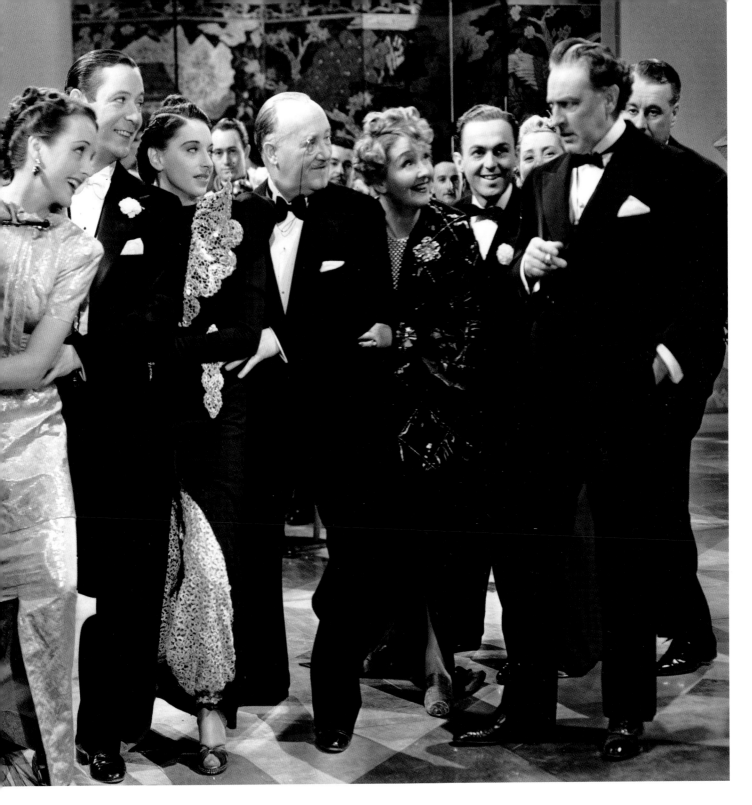

on chalkboards, which crew members held off camera. "Why should I fill my mind up with this shit just to forget it the next morning?" he asked Leisen. Whether reading or mugging, Barrymore stole the show. "Barrymore's reactions were great," said Leisen. "Every time Rex O'Malley said a line, Barrymore gave him a look that was something else again."

An industry preview on March 9 could have been a tense evening but turned into a "theaterful of completely contented film fans," according to *Motion Picture Daily*, which called *Midnight* "the best light comedy ever caught by a camera."

Critical Reaction

"To most reviewers *Midnight* is a brilliant picture. The story idea is genuinely comic, the happiest inspiration of its kind since *It Happened One Night*."

—NORBERT LUSK, *LOS ANGELES TIMES*

THE STORY OF VERNON AND IRENE CASTLE

RELEASED MARCH 31, 1939

"You are a beautiful dancer! But you're so smug and conceited that you can't see any further than your funny nose!"

THE STORY

A young married couple struggling for success as a dancing team finds a savvy older lady to manage them, just as the Great War breaks out.

Opposite: A portrait of Ginger Rogers and Fred Astaire made for H. C. Potter's *The Story of Vernon and Irene Castle*

PRODUCTION HIGHLIGHTS

Fred Astaire and Ginger Rogers were a unique entity in 1938, a singing-acting-dancing team. With eight hits since 1933, they had saved RKO from closing its doors. What makes a great team? Poise, beauty, timing, and sincerity. Astaire and Rogers had it all. "The chemistry between them was strictly an accident," recalled choreographer Hermes Pan. "Nobody could have foreseen it. I think Ginger realized more than Fred that they had a professional chemistry that the public responded to. He was a little tired of being known as part of a team. It was he who wanted to break away, but the public demanded them together. It was impossible to split. It would have been like divorcing your wife."

Twenty-five years earlier, there had been another famous dance team, Vernon and Irene Castle. They revolutionized ballroom dancing with the Foxtrot, the Castle Walk, and the Tango. The Castles were happily married, but their partnership ended tragically. Being British, Vernon had enlisted with the Royal Flying Corps, flown missions, and been awarded the Croix de Guerre, but after returning to the States, he was training pilots. It was during a training flight that a stalled engine caused his death. Irene Castle wrote two books about her life with Vernon, and in 1938 was hired as a consultant by RKO for its production of *The Story of Vernon and Irene Castle*.

Allan Scott had written six Astaire-Rogers films. He began this project with the usual enthusiasm but soon found his work being monitored, and not only by the PCA. "Irene Castle wanted everything done exactly to her specifications," said Scott. "She was very imperious, a pain in the ass. When she began to tell me how to write, I left for New York, to do a play." The script was finished by Richard Sherman. Castle also stationed herself on the set. "Irene had something to say about everything," wrote Ginger Rogers. "She not only wanted me to dye my hair but also to chop it off to the short bob which she claimed to have originated." The producer, Pandro Berman,

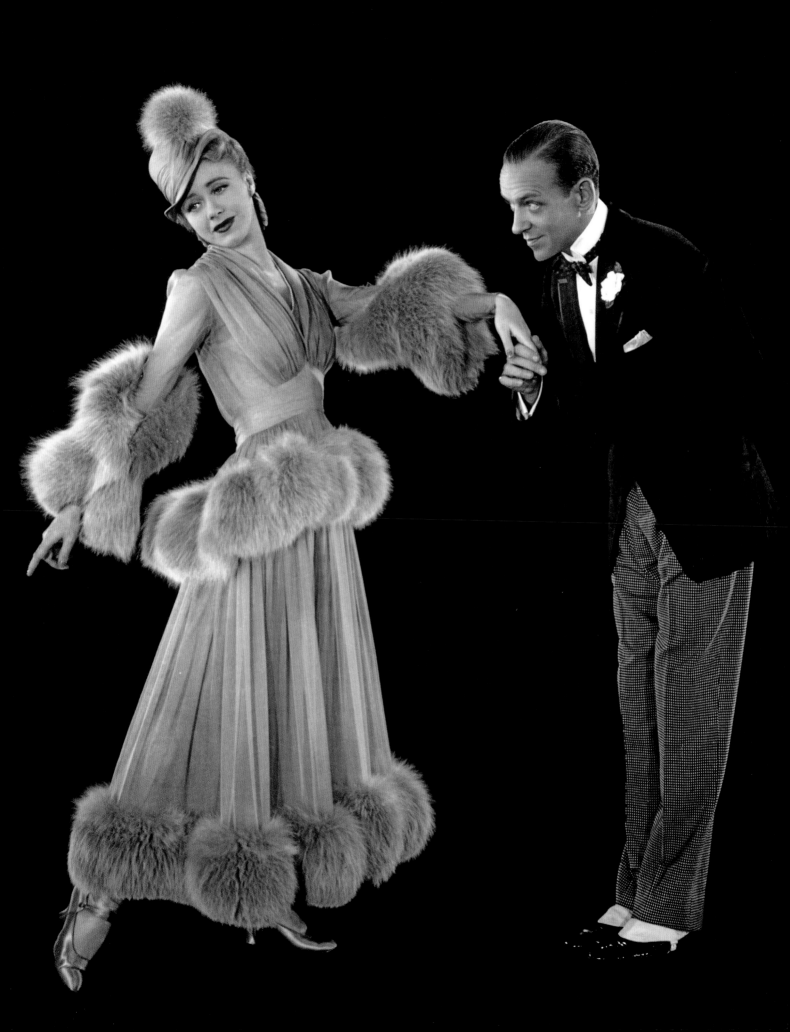

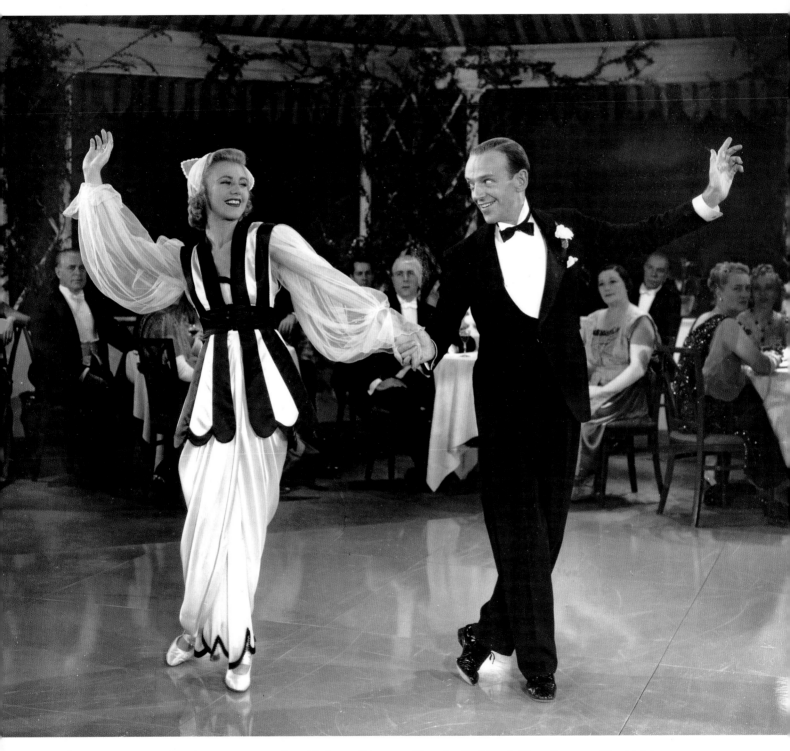

Above: Ginger Rogers and Fred Astaire in a scene from *The Story of Vernon and Irene Castle* *Opposite:* Ginger Rogers and Fred Astaire

arranged a compromise in which a wig is shown being cut.

During the filming, it was suspected that this might be the last Astaire-Rogers project. Their previous film, *Carefree*, had not performed as well as expected; plus Astaire wanted other partners, and Rogers wanted dramatic roles. When the day came to shoot their last dance, "The Missouri Waltz," the soundstage became crowded with visitors from other stages, departments, and even studios. "It even got to me," recalled Rogers. "I sort of teared up as we were dancing our last waltz together."

Critical Reaction

"Astaire and Rogers have been so closely identified with light comedy in the past that finding them otherwise employed is practically as disconcerting as it would be if Walt Disney were to throw Mickey to the lions and let Minnie Mouse be devoured by a non-regurgitative giant. (The comparison may be far-fetched and undignified, but it's the first that occurs.) We feel guilty about seeming to lend approval of type-casting. But somehow Astaire and Rogers have come to mean one thing to us. We prefer their happy endings. Besides, isn't tragedy for brunettes?"

—FRANK S. NUGENT, *THE NEW YORK TIMES*

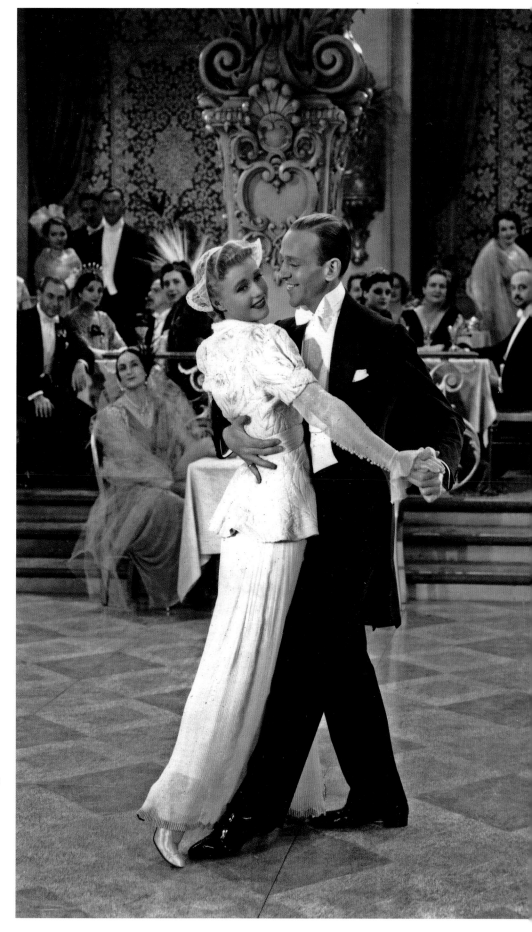

Left: Irene Dunne and Charles Boyer in a scene
from Leo McCarey's *Love Affair*

APRIL

1939

LOVE AFFAIR

RELEASED APRIL 7, 1939

"The things we like best are either illegal, immoral, or fattening."

THE STORY

A man and woman meet on a transatlantic voyage and fall in love, but they have to disentangle themselves from their respective engagements. When they dock in New York, they promise to meet in six months at the Empire State Building.

PRODUCTION HIGHLIGHTS

Leo McCarey had just produced and directed one of the greatest screwball comedies, *The Awful Truth*. He had also crystallized Cary Grant's screen persona, although whether that persona was based on his own (as he later claimed), we may never know. From then on, Grant was a star. And McCarey won a Best Director Academy Award. His next film was tailored to the talents of *The Awful Truth*'s nominal star, Irene Dunne, who was an accomplished singer. But this film was not a comedy, even though it had its wry moments. It was an unapologetic romance, crafted by McCarey from a Mildred Cram story with assistance from the veteran screenwriter Donald Ogden Stewart and future director Delmer Daves.

The first script, which was called *Love Match*, was rejected by the PCA on grounds that an illicit romance was not punished. Several versions later,

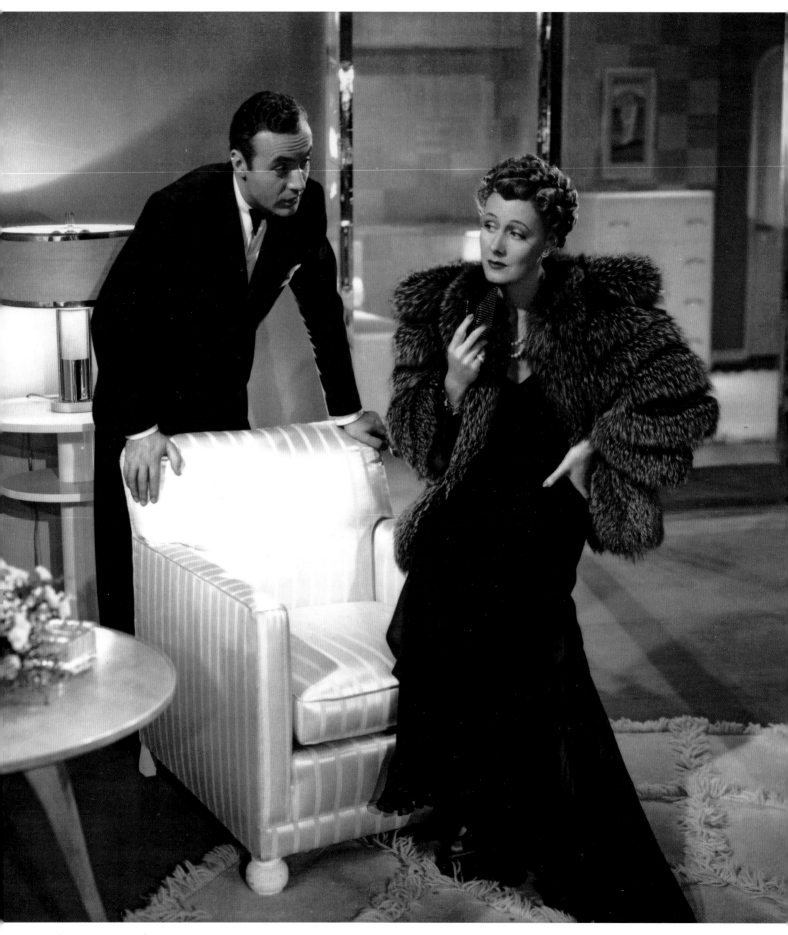

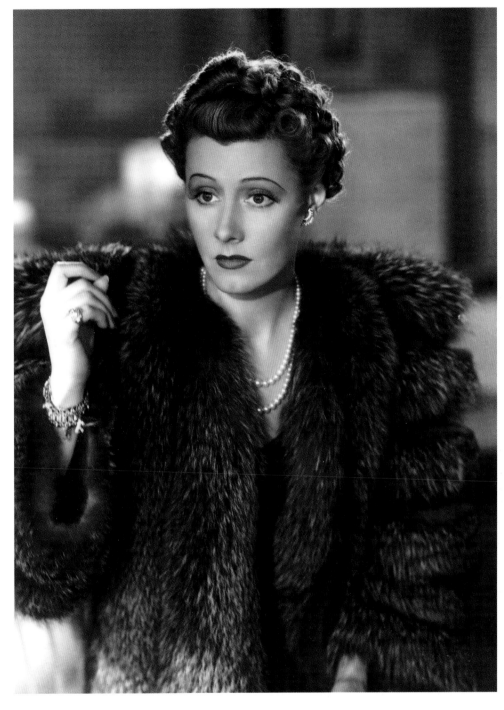

the script was approved and went into production as *Love Affair*, although there were rewrites on the set and much ad-libbing, which Dunne and her costar, Charles Boyer, did their best to cope with. "If they gave me dialogue on the set," said Dunne, "I'd ask to be excused for ten minutes so's I could find out why I was saying what I had to say, what relation it had to the character, and what she was thinking while she said it. As a result, the performance looks natural. But nobody realizes the amount of effort you've put in."

Even though McCarey tried actors' patience with rewrites, he was in every other respect sensitive to their needs. The film's love scenes were shot on a closed set. Maria Ouspenskaya, who herself taught acting, said that McCarey "created an atmosphere of work that was inspirational. Every person connected with the film, but everyone—actors, cameramen, and electricians—loved their work and did not want to break away from that atmosphere." The warmth carried over into the finished film. When RKO took *Love Affair* to a sneak preview in Pomona, 176 preview cards carried the words "marvelous," "very good," or "splendid."

Opposite: Charles Boyer and Irene Dunne in a scene from Leo McCarey's *Love Affair Right:* Irene Dunne

Critical Reaction

"*Love Affair* achieves a sustained mood and feeling rare in factory-made U.S. films."
—LIFE

"This picture is looking at life and looking at living in its best and finest sense. And it may also be said that this is one of those rare films which can be seen not only once, but may be revisited, perhaps even several times, and bring new delight on each re-observation." **—EDWIN SCHALLERT, *LOS ANGELES TIMES***

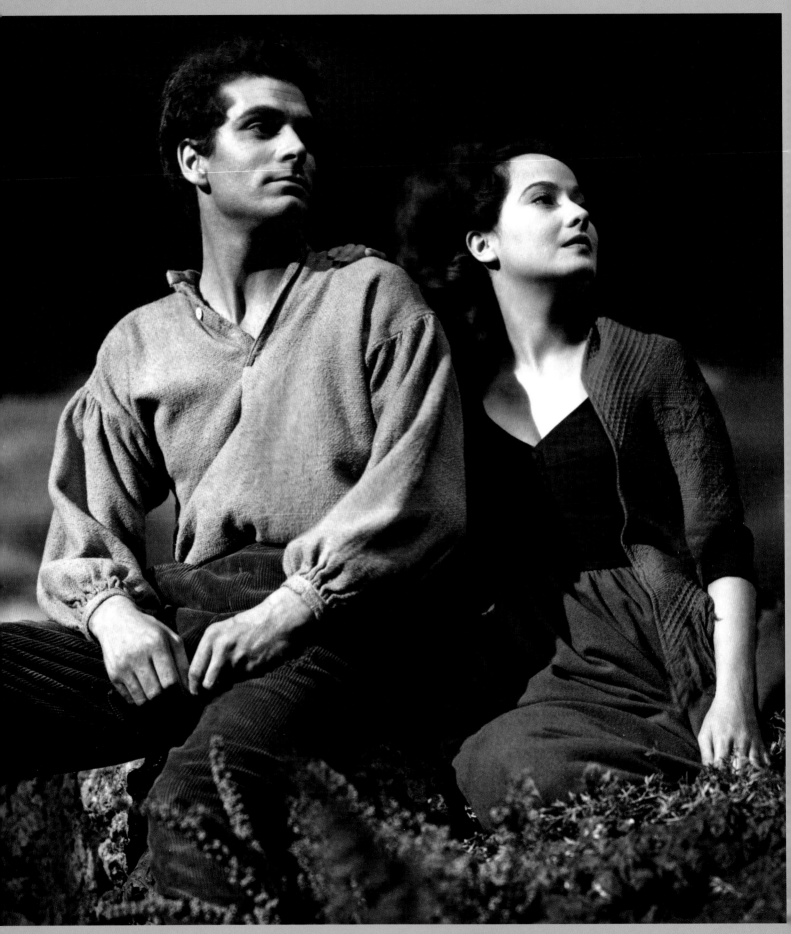

WUTHERING HEIGHTS

RELEASED APRIL 7, 1939

"Heathcliff, make the world stop right here. Make everything stop and stand still and never move again. Make the moors never change, and you and I never change."

THE STORY

An orphan boy brought to a home on the moors grows up to love the lady of the house, but she yearns for social approval and fears the intensity of their passion.

Opposite: Laurence Olivier and Merle Oberon in a scene from William Wyler's *Wuthering Heights*

PRODUCTION HIGHLIGHTS

"There was an excitement and generosity of spirit in Hollywood," wrote actor David Niven, "and a minimum of jealousy and pettiness. Everyone felt that he or she was pioneering a wonderful entertainment medium." Playwrights Ben Hecht and Charles MacArthur genuinely loved working together, which may have made them Hollywood's greatest writing team. "We wrote *Wuthering Heights* in eight days at Alexander Woollcott's island home in Vermont," recalled Hecht. "And our hooligan antics didn't ruin Emily Brontë's delicate love story." They wrote the script for producer Walter Wanger, who wanted it for Sylvia Sidney, but when Warner Bros. director William Wyler grew interested in directing it, Wanger tried to sell it to Jack Warner as a Bette Davis vehicle. Meanwhile, Samuel Goldwyn wanted it for Merle Oberon, so Wanger sold it to him.

Hecht suggested that Wyler cast Laurence Olivier as the wild "gypsy" Heathcliff. The British actor did not want to co-star with Oberon but rather with Vivien Leigh, his lady love. Leigh naturally wanted to play the passionate Cathy, but Wyler told her that Goldwyn had bought *Wuthering Heights* for Oberon. Wyler

reminded Leigh that she was unknown to American audiences and should be grateful to get the secondary role of Isabella, which was the best she could expect as a newcomer to Hollywood. (Of course, she proved him wrong a few months later.) The part of Isabella was given to another newcomer, the Irish actress Geraldine Fitzgerald. Meanwhile, Oberon wanted David Niven, whom she was dating, in the film, and he was cast as Edgar Linton.

Olivier grudgingly agreed to work without Leigh, and made no secret of his disdain for Hollywood and for movies in general. In 1933 he had been ready to play opposite Greta Garbo in *Queen Christina* when the star froze up and refused to work with him. "Larry came back to Hollywood with this chip on his shoulder because Garbo had rejected him," said Merle Oberon, "and now he was the big acknowledged Shakespearean actor. He started the picture very 'big.' His performance was really for the stage. His makeup was too much, and his acting was too much." When Wyler told Olivier he was overacting, he declaimed to the entire cast and crew: "I suppose this anemic little medium can't take great acting." The soundstage was rocked with

laughter. "I thought Willy Wyler would never stop laughing," recalled Olivier. "He was right. I was a fool." Olivier may or may not have been a fool, but Wyler was an undisputed taskmaster. He subjected Olivier, Oberon, Niven, and Fitzgerald to take after take, without ever explaining why the shot was being redone. Only Olivier stood up to him. "For God's sake," said Olivier, "I did it standing up. I did it sitting down. I did it fast. I did it slow. I did it with a smile. I did it with a smirk. I did it scratching my ear. I did it with my back to the camera. How do you want me to do it?"

"Just do it better," replied Wyler.

Wyler wore everyone down. Oberon and Olivier both fell ill. Olivier continued to fight Wyler. Eventually the impossible happened. Olivier and Wyler learned to communicate, perhaps as a joint defense against Goldwyn, who was the only producer willing to film an Emily Brontë novel, but who was tactless, abrasive, and obtuse. "Will you look at his ugly face?" he said about Olivier. "His performance is rotten. He's stagey. Look at him. He's filthy." Wyler countered that Heathcliff was a stable boy in the scene. Goldwyn wandered off, threatening to shut down production. Wyler had nightmares that he was arguing with Goldwyn but got through the film. The producer did have the last word. A preview audience in Riverside disliked the sad ending, which showed Heathcliff lying dead in the snow. Goldwyn thought up a ghostly reunion of the lovers. Even though Wyler hated it, and refused to shoot it, Goldwyn made it and added it to the film. It pleased the next preview audience.

Critical Reaction

"The story has reached the screen through the agency of Ben Hecht and Charles MacArthur, as un-Brontian a pair of infidels as ever danced a rigadoon upon a classicist's grave. But be assured: as Alexander Woollcott was saying last week, 'They've done right by our Emily.' It isn't a faithful transcription, but it is a faithful adaptation, which goes straight to the heart of the book, explores its shadows and draws dramatic fire from the savage flints of scene and character hidden there."

—FRANK S. NUGENT, *THE NEW YORK TIMES*

Above: Merle Oberon and Laurence Olivier in a scene from *Wuthering Heights*

"This book shocked its readers by revealing a heroine consumed by passion and made a deep break in the theory that woman was to be loved but was not capable of showing intense passion. That wasn't considered ladylike in those days. They tried to make you believe that children came by remote control. This is difficult stuff to portray, especially in our scrambled world of today, when every nation is at every other nation's throat. To be able to live for two hours with a story that takes you completely out of yourself, so that you forget your daily struggles—then you've got a picture." **—HEDDA HOPPER**

DODGE CITY

RELEASED APRIL 8, 1939

*"There's no law west of Chicago . . .
and west of Dodge City, no God."*

THE STORY

An Irish cowboy
unjustly blamed for the
death of a renegade
joins a crusade to save
a frontier city from a
murderous gang, and to
restore his favor with
the woman he loves.

PRODUCTION HIGHLIGHTS

In early 1939, the big-budget westerns were galloping into town. Twentieth had *Jesse James*. United Artists had *Stagecoach*. M-G-M had *Stand Up and Fight*. Warner Bros. and Paramount were readying their own epics. The smell of gunsmoke was in the air. "Americans enjoy movies based on fact," declared *Life* magazine. "Hollywood's current preoccupation with history springs from a nationwide resurgence in patriotism, which in turn comes from its revulsion at events taking place in Europe." What better way to affirm American values than by watching good defeat evil on a huge canvas? "There was a difference between the average western and a big spectacular," recalled Errol Flynn. "A western was generally batted off very quickly, at a certain price. The big spectaculars were made with an enormous budget and created in a very different manner. The studio spared no expense, because they paid off in a big way." Flynn had become a star in epics like *The Charge of the Light Brigade*. But he was Tasmanian, not American. How could he portray a cowboy? "Putting me in cowboy pictures seemed to me the most ridiculous miscasting," he wrote. "Often, in these pictures, I had to alibi my accent, which was still a bit too English for the American ear. But Jack Warner knew what the public wanted."

Dodge City had the requisite love story, in which Flynn must redeem himself in the eyes of Olivia de Havilland. It had director Michael Curtiz, who had directed Flynn's swashbuckling hits. It had a big budget, because of Technicolor and several impressive set pieces. One of the most impressive was a massive brawl in the Gay Lady Saloon. It required 150 stunt men, five days, and cost $112,500. Every angle, every violent detail, every brutal fall was choreographed, lit, and colored for maximum effect. The sequence lasted only four minutes but looked like a small war.

While *Dodge City* was being shot, Warner Bros. received a buffalo skin inscribed with a petition for the film's premiere to be held in Dodge City, Kansas. Although Warners had never premiered a film outside Hollywood, there were precedents. In 1933 the company had sent a cross-country train to ballyhoo the musical *42nd Street*. In 1938 M-G-M had premiered the film *Boys Town* in Omaha, Nebraska. In short order,

Opposite: Errol Flynn and Olivia de Havilland in Michael Curtiz's *Dodge City*

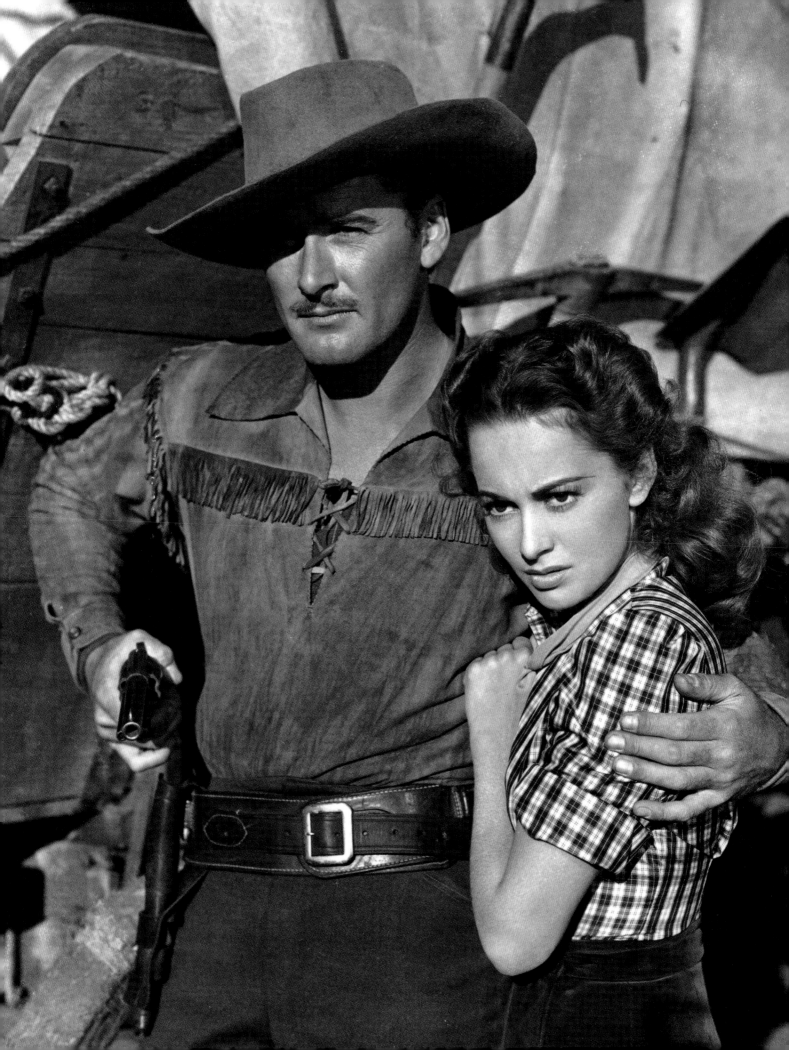

Above: Guinn Williams, Alan Hale, and Errol Flynn *Opposite:* Errol Flynn, Olivia de Havilland, and Alan Hale in *Dodge City*

the Warners publicity department and the Dodge City government dreamed up the "Dodge City Special," a sixteen-coach train chartered from the Santa Fe Railroad Company. Twenty stars were aboard, including Jane Wyman, John Payne, Humphrey Bogart, Ann Sheridan, and, of course, Errol Flynn. The Special arrived in Dodge City on April 1, 1939, where 60,000 people were waiting to greet it. *Dodge City* was the first 1939 feature to use what *Variety* called a "revolutionary method of exploitation." This method would be used again before the year ended. The entire country was alerted to *Dodge City*, and, despite some cynical reviews, it was a resounding hit.

Critical Reaction

"Critics were thrilled by *Stagecoach,* amused by *The Oklahoma Kid,* but *Dodge City* impressed them not at all. They find Errol Flynn out of place against the background of the old West."

—LOS ANGELES TIMES (NEW YORK CORRESPONDENT)

THE STORY OF ALEXANDER GRAHAM BELL

RELEASED APRIL 14, 1939

"Mr. Watson, come here. I want you."

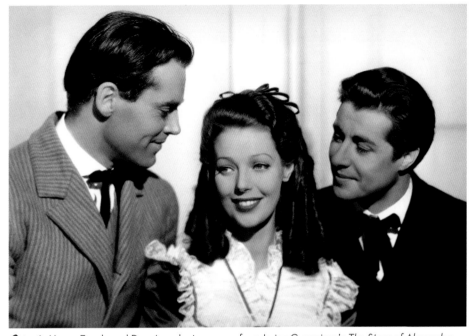

Opposite: Henry Fonda and Don Ameche in a scene from Irving Cummings's *The Story of Alexander Graham Bell Above:* Henry Fonda, Loretta Young, and Don Ameche

THE STORY

While trying to help his hearing-impaired sweetheart, an inventor makes a momentous discovery, but he is soon challenged for the rights to it.

PRODUCTION HIGHLIGHTS

Even before Darryl F. Zanuck merged Twentieth Century Pictures with the Fox Film Corporation in 1935, he had favored costume films, making hits of *Les Misera-bles* and *Call of the Wild*. The period films he made at Twentieth Century-Fox did well because his contract players could suppress their modernity for the duration of a feature. Loretta Young and Alice Faye were believable in period roles, unlike M-G-M's Joan Crawford and Jean Harlow. With *Ramona, In Old Chicago*, and *Suez*, Twentieth Century-Fox became known as "19th Century-Fox." Since 1939 was a year to look backward, Zanuck put ten costume pictures on his release schedule.

The Story of Alexander Graham Bell was developed as an original studio project, primarily by Lamar Trotti, a prolific writer who had served a Hollywood apprenticeship as a censor at the Studio Relations Committee, the predecessor of the PCA. As the basis for a feature film, the Bell story was difficult, since the discovery could not constitute the climax, and the script had to earn the approval of Bell's daughter, Mrs. Gilbert

Grosvenor. There had been few films that included characters with hearing impairments (other than those that used them as tasteless running gags), so Trotti and his colleagues had to find a sensitive yet accurate way of portraying Bell's wife, the former Myrtle Hubbard. Their solution was dramatically effective but scientifically dubious. Even though this was the first Hollywood film to show a "deaf" character speaking in a hearing-impaired voice, it veered into irresponsibility, because she appeared to be able to read lips and speak without any difficulty. "Mrs. Bell was a deaf mute," said Loretta Young, "but I was only allowed to play her as a deaf person. The real story wasn't told. It was just another part in hoop skirts."

In step with the out-of-town trend, *The Story of Alexander Graham Bell* had a star-studded premiere at San Francisco's Golden Gate International Exposition. The film was a hit, instantly linking the popular image of the telephone with Don Ameche, who portrayed its inventor. It soon became "hep" to refer to a phone as the "Ameche."

Critical Reaction

"Audiences in Grauman's Chinese and Loew's State theaters yesterday were exceptionally responsive to this tale of an inventor's prowess, one that represents a conquest so intimately associated with modern life. If there is error in the picture, it is on the side of Don Ameche's effervescence and of too much sentimentalism between himself and Loretta Young. There are scenes that come close to going overboard. There also appear to be errors in the perfect visualization of a woman afflicted by deafness."

—EDWIN SCHALLERT, *LOS ANGELES TIMES*

DARK VICTORY

RELEASED APRIL 22, 1939

"As long as I live, I'll never take orders from anyone. I'm young and strong and nothing can touch me."

THE STORY

When a spoiled young socialite is stricken with a brain tumor, she expects to control her rehabilitation but the disease returns just as she falls in love with her physician.

Opposite: Bette Davis and Mary Currier in a scene from Edmund Goulding's *Dark Victory*
Right: A portrait of Bette Davis made by George Hurrell for *Dark Victory*

PRODUCTION HIGHLIGHTS

If 1939 was Hollywood's greatest year, it was in part because it was also Bette Davis's greatest year. She began it by winning an Academy Award for William Wyler's *Jezebel*. She had overtaken Kay Francis to become the top female star at Warner Bros. and would soon be its top star. Her 1939 projects reflected this. The first was *Dark Victory*, which had been a Tallulah Bankhead play. Davis knew that David O. Selznick owned it. "Bette has pestered me for six weeks," Jack Warner told production head Hal Wallis. "Just get her off my back." Warners paid Selznick $27,500 for the play. Screenwriter Casey Robinson and director Edmund Goulding improved it by giving the doomed Judith Traherne a close friend and confidante. "This was so that Judith would not have to ever complain about her tragedy," said Davis. Geraldine Fitzgerald filmed these scenes before going to work on *Wuthering Heights*, but *Dark Victory* was held up for editing and her second American project became her debut.

In late September 1938, as *Dark Victory* was about to start filming, Bette Davis's personal life became difficult.

On the rebound from a failed affair with *Jezebel* director William Wyler, Davis got involved with Howard Hughes, only to be threatened with blackmail by her husband, bandleader Harmon Nelson. Davis left Nelson and moved into the dressing room recently vacated by Kay Francis. After a week of filming, Davis came to Wallis. "Hal, I've wanted to play this part for years," she said. "I don't think I'm up to it at this time. I think you should replace me. I'm sick."

"Bette," Wallis replied, "I've seen the first week's rushes. Stay sick." But Wallis privately made sure that she got better. "It's up to you guys to keep the lady on an even keel," he told Goulding and her leading man, George Brent.

Davis soldiered on, as was her wont. Goulding helped her in every way possible, acting out scenes for her, rewriting, even composing a song for the musical score. "He was one of Hollywood's great-est directors," said Davis. "He was what we called a 'woman's director' and a 'star-maker.'" As Hedda Hopper observed on the stable set, Davis did some directing of her own. "Bette suggested that Humphrey Bogart take hold of her shoulder instead of her forearm," wrote Hopper. "It added strength to the situation." When Wallis saw the rushes of the scene, he sent a memo to Goulding: "That stable scene is very beautifully played. Davis is splendid in it and so is Bogart."

Dark Victory went through a pre-view-and-re-cutting process, so it was not released until April. The studio was nervous. "We all thought its subject matter would do it in," recalled Geraldine Fitzgerald. Its Los Angeles premiere was emotional, to say the least. "Time and again," reported Edwin Schallert, "Miss Davis had the audience breathless, even interrupting the picture with applause. This is a triumphant performance."

Critical Reaction

"When scenes intrude in your private life for days after you've seen a picture and you can't push them out of your mind, then it's got something. That's what *Dark Victory* has done to me since I attended the preview. Whatever happens to you the week it opens, don't miss it."
—HEDDA HOPPER

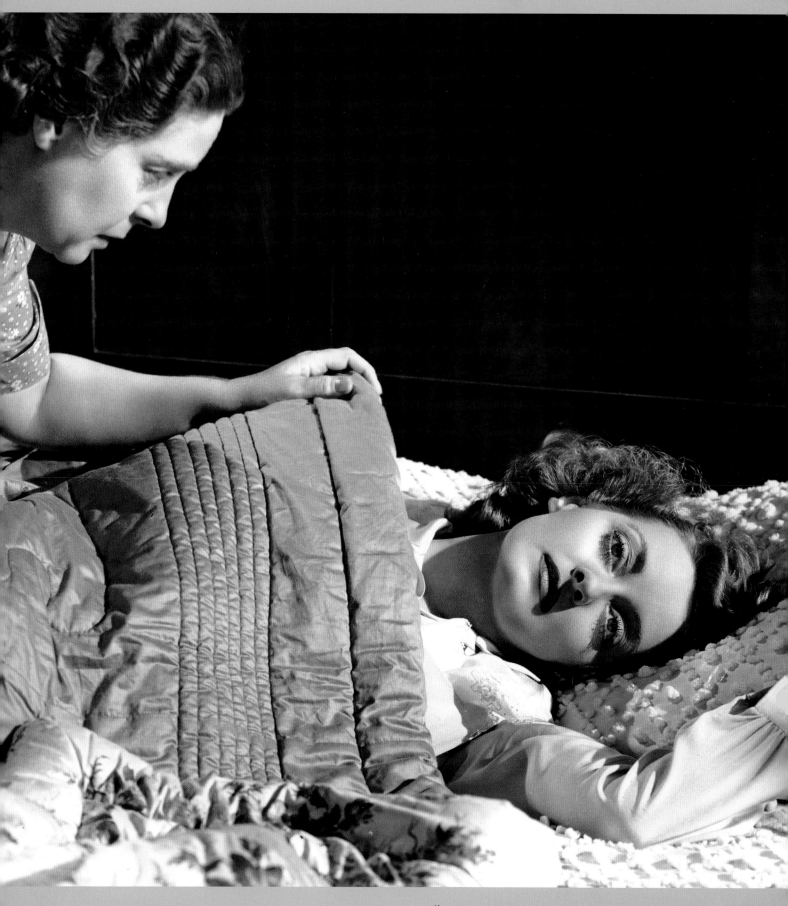

Above: Virginia Brissac and Bette Davis in a scene from *Dark Victory*

UNION PACIFIC

RELEASED MAY 5, 1939

"The highest and longest railroad has just come out of McPherson's boiler, so don't you be insultin' it!"

THE STORY

A female Union Pacific postmaster helps her engineer father build the transcontinental railroad while being romanced by a rascal who is trying to stop it and a troubleshooter who is trying to help it.

Left: A scene from *Union Pacific*

PRODUCTION HIGHLIGHTS

Anniversaries were motivating 1939 projects. If anyone could take pride in an anniversary, it was Cecil B. DeMille. In 1914 he and Jesse Lasky had established Hollywood as the film capital by making *The Squaw Man* there. That film was a western. It was only fitting that DeMille's 1939 entry be a western. There was another anniversary coming up. On May 10, 1869, the Transcontinental Railroad had been completed. Paramount owned a novel about it called *Trouble Shooter.* It was written by Ernest Haycox, the same author whose short story, "Stage to Lordsburg," had served as the basis for *Stagecoach.* DeMille assigned Jesse Lasky Jr. and a gang of writers to *Trouble Shooter.* Then DeMille made a deal with the Union Pacific Railroad to use its name and began making the biggest Western Hollywood had ever seen.

Jesse Lasky Jr. had five years of experience as a screenwriter when he began working for DeMille, but in order to create scenes that would please the

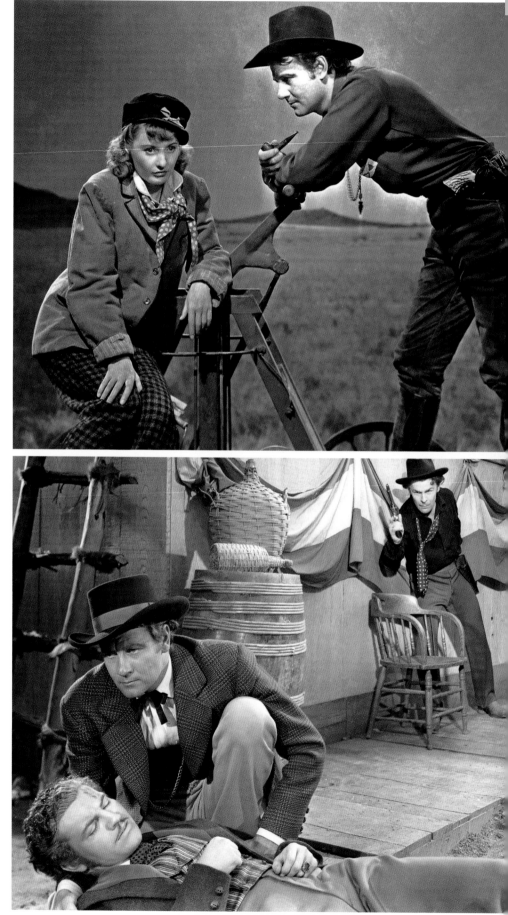

notoriously demanding, almost autocratic DeMille, he had to unlearn habits. Like many writers, Lasky tended to define characters through dialogue rather than through imagery. DeMille had cast Brian Donlevy as Campeau, the villainous gambler hired by the Central Pacific to keep the Union Pacific from reaching the terminus first. DeMille wanted some piece of acting "business" to fully define Donlevy as a villain. Lasky persisted in writing about the inner character. "Business is what the actors do that I can photograph!" DeMille yelled at Lasky during a story conference. "I can't photograph what they think or feel! What does Donlevy do with his hands?" DeMille kept after Lasky, finally calling him in the wee hours of the morning. In desperation, the groggy writer came up with the quirk of dipping a cigar end in a glass of whisky. "Good, Jesse," said DeMille. "Put it in the script at once." Then he hung up, leaving Lasky to get out of bed and rewrite the scenes. It was this attention to detail that made every scene in *Union Pacific*, no matter how sprawling, detailed, believable, and enjoyable.

The heroine of the film was an engineer's daughter and assistant postmaster named Mollie Monahan. Barbara Stanwyck had been a star since her early years at Columbia with Frank Capra. Playing an Irish lass in a huge DeMille film was a challenge, but she met it. "I have never worked with an actress," wrote DeMille, "who was more cooperative, less temperamental, and a better workman, to use my term of highest compliment, than Barbara Stanwyck."

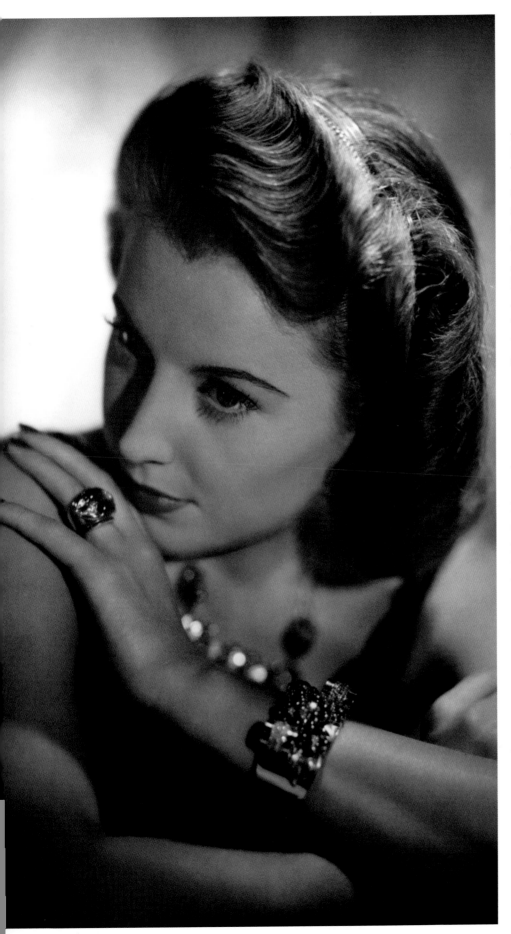

Union Pacific was the fourth 1939 film to enjoy a premiere outside of Los Angeles. (The others were *Let Freedom Ring* in Tucson, Arizona; *Dodge City* in its namesake; and *The Story of Alexander Graham Bell* in San Francisco.) A special U.P. train carried DeMille, Stanwyck, and a host of celebrities to Omaha, Nebraska, for the April 27 premiere, which was part of a huge festival called "Golden Spike Days." As anticipated, the publicity gave the film's release a boost, and it became the top moneymaker of early 1939, ultimately grossing $3.2 million.

Critical Reaction

"Even in a season of outdoor pictures, *Union Pacific* stands out, lustily and luminously, *by* virtue of its multiplicity of sure-fire ingredients, the work of the principals, and what DeMille is able to evoke from them. *Union Pacific* can well take its place alongside *Stagecoach* as an example of the newer sort of pioneering epic, and will probably have even greater box-office appeal."

—EDWIN SCHALLERT, *LOS ANGELES TIMES*

Opposite from top: Barbara Stanwyck and Joel McCrea in Cecil B. DeMille's *Union Pacific* ∗ Robert Preston, Joel McCrea, and Brian Donlevy *Left:* A portrait of Barbara Stanwyck by Eugene Robert Richee

CONFESSIONS OF A NAZI SPY

RELEASED MAY 6, 1939

"Germans in the United States must be brought back to the racial unity and common faith of all Germans! As racial comrades! As Germans!"

THE STORY

An FBI agent investigating Nazi spies who are pilfering United States military secrets faces danger when the ring members find him out.

PRODUCTION HIGHLIGHTS

Since Hollywood derived nearly a third of its income from the so-called foreign market, the political events of 1938 cast a shadow on income projections. In March Adolf Hitler's totalitarian regime annexed Austria. In October he annexed the Sudetenland. In November he commenced the annihilation of Jews in Germany. Warner Bros. had closed its Berlin offices in 1934. In April 1938 it closed its Austrian exchange. "Business is based on keeping contracts," said Harry Warner. "Hitler does not keep his contracts, either with men or with nations."

What precipitated the first Hollywood film to use the word *Nazi* was a series of events that occurred not in Europe but in America, where the Federal Bureau of Investigation uncovered a spy ring. In June 1938, while a trial was being readied, Warner Bros. bought the rights to the story from Leon G. Turrou, the FBI agent most closely connected with the case. Harry Warner had been agitating against Nazism for five years, but he fell ill, so Jack Warner stepped in to help producer Hal Wallis and screenwriter Milton Krims with pre-production. Casting *Confessions of a Nazi Spy* was difficult. German Americans feared reprisals against relatives in Germany. Edward G. Robinson was not afraid to participate. "I want to appear in the international spy ring story you are going to do," Robinson wrote Wallis. "I want to do that for my people."

Dr. George Gyssling, the German consul, brought pressure on Joseph Breen and the PCA to make Warners cancel the production. The three studios still doing business with Germany (M-G-M, Paramount, and Twentieth) also urged Warners not to proceed. America was neutral; there was no reason to rile Europe. *Confessions of a Nazi Spy* was held up long enough to allow for transcripts from the December trial to be incorporated into the script. The film went before the cameras on February 1, 1939.

"Warners' Nazi spy story is pure dynamite," wrote Hedda Hopper in her March 7 column. "The script is given out only to actors on the set. None of it is allowed to be taken home. Two of our biggest radio announcers turned down parts, so the *March of Time* commentator is arriving to be in it. It's so inflammable that it may burn up the screen." Litvak filmed his scenes on closed sets, and extra security guards were stationed outside. When a microphone boom collapsed, narrowly missing Litvak, espionage was suspected but could not be proved. *Confessions of a Nazi Spy* was completed without incident. Getting it shown was another matter.

As the PCA had warned the studio, the censor boards in numerous countries chose not to cut scenes from the film but simply to ban it. Argentina, Brazil, Chile, Denmark, Hungary, Ireland, and Switzerland refused to show the controversial film. There were reports of theaters being vandalized. A Warner theater in Milwaukee was burned down. The film did only average business, pos-

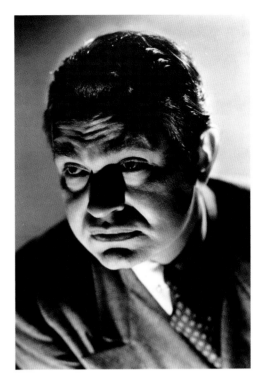

Opposite: Paul Lukas and Edward G. Robinson
Above: A portrait of Edward G. Robinson made by George Hurrell for *Confessions of a Nazi Spy*

sibly because word of mouth from some patrons described it as a feature-length documentary, which it resembled to a certain extent. All in all, *Confessions of a Nazi Spy* was a unique film, worthy of inclusion in 1939's cavalcade of quality.

Critical Reaction

"Even though the audience was inclined, at times, toward the expression of personal emotion through hisses, these quickly subsided in the face of the cold, positive presenting of the case against Nazi espionage. The appreciation of the result was testified to by long applause at the conclusion."
—EDWIN SCHALLERT, *LOS ANGELES TIMES*

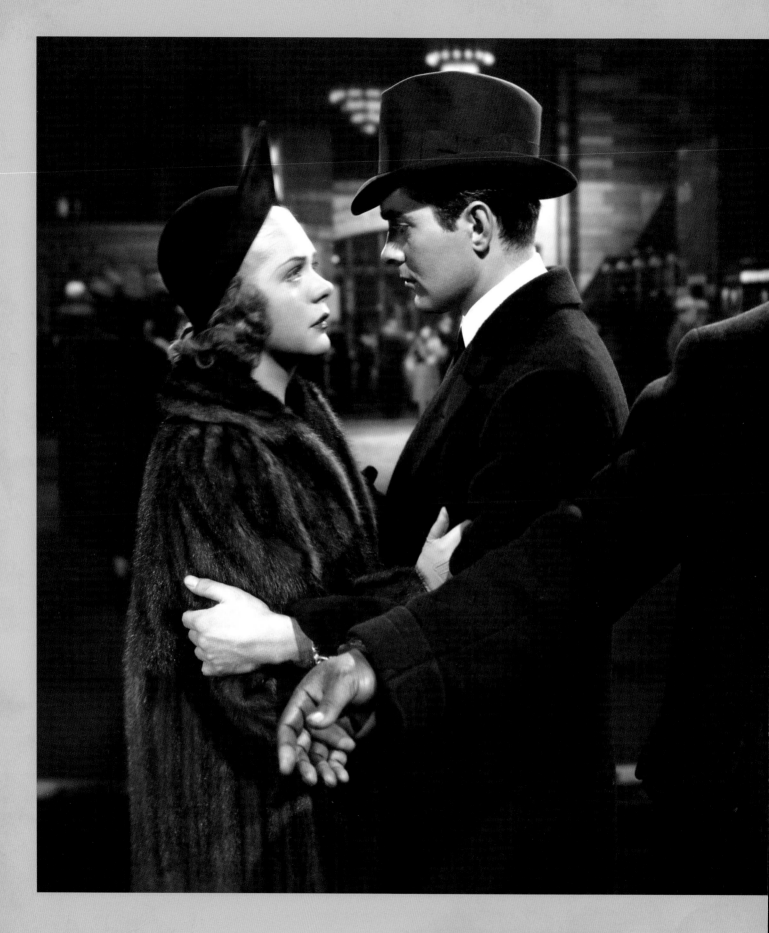

ROSE OF WASHINGTON SQUARE

RELEASED MAY 12, 1939

"Wait a minute! Wait a minute! You ain't heard nothin' yet!"

THE STORY

A torch singer aims for stardom in the *Ziegfeld Follies* but her gambler boyfriend gets in her way.

Left: Alice Faye, Tyrone Power, and Blue Washington in Gregory Ratoff's *Rose of Washington Square*

PRODUCTION HIGHLIGHTS

Darryl Zanuck was intrigued by the legendary romance of Ziegfeld star Fanny Brice and gambler Nicky Arnstein. The torch song "My Man" was fixed in the public's mind as the lament of the star whose husband had gone to prison for fraud. Because the story had played itself out in the press fifteen years earlier, Zanuck and his colleagues felt safe drawing on its basic elements. *Alexander's Ragtime Band* was still bringing in money, so Zanuck put that film's stars, Alice Faye and Tyrone Power, in the Brice story, with Al Jolson thrown in for good measure. Not everyone was so sure about the material. "We knew we were in trouble before the film went into production," recalled composer Walter Scharf, who was working at Fox as an orchestrator. "Miss Brice was going to sue."

Alice Faye was, with Shirley Temple and Sonja Henie, a major moneymaker for Fox. She was a convincing actress and an accomplished singer, yet she never truly enjoyed film work. She did not enjoy making *Rose of Washington Square*, and she was even less happy when reviews made invidious comparisons to Brice's renditions of the songs that Faye performed in the film. Every review pointed out the disingenuous attitude that this was supposed to be an original story. Then, on May 23, Arnstein filed suit, seeking damages of $400,000 for unauthorized use of his life story, for libel, and for violation of his privacy. The suit named Fox, Faye, and Power; director Gregory Ratoff; writers Nunnally Johnson, John Larkin, and Jerry Horwin; and executives Darryl Zanuck and Joseph Schenck.

On July 14, Brice filed a suit for defamation of character, unauthorized use of her life story, and invasion of privacy. This suit named Twentieth Century-Fox, Zanuck, eight theaters, Tyrone Power, Al Jolson, and Alice Faye. The action asked for damages of $750,000. Lawyers at Twentieth filed an answer denying that any part of Brice's life had been used in the film, but that if it had, she had "by reason of her activities forfeited and abandoned any alleged right of privacy." Within a year, both cases were settled out of court. Arnstein was said to have settled for $20,000. Brice agreed to $30,000. Motion picture budgets include a contingency allowance, but *Rose of Washington Square* made so much money—in part from the lawsuit publicity—that the $50,000 spent to settle the lawsuits would have looked like petty cash.

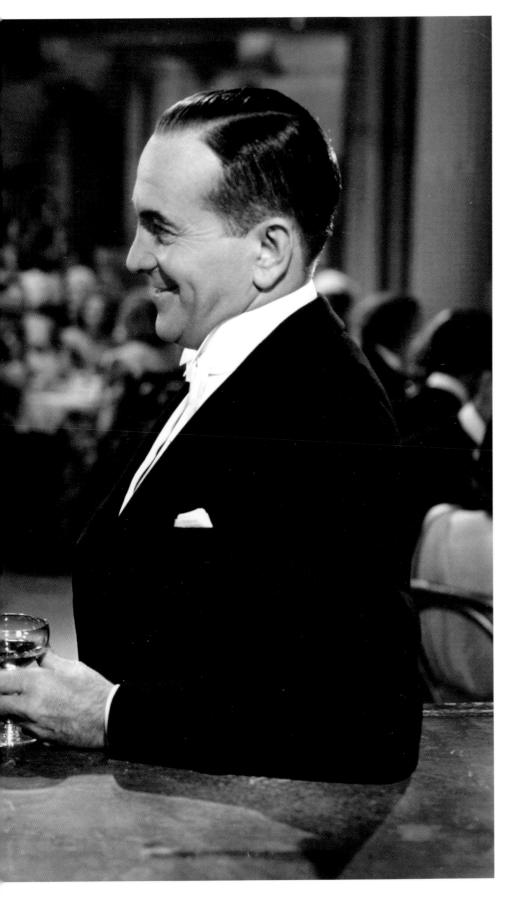

Critical Reaction

"The 'Rose of Washington Square' is neither Al Jolson nor Tyrone Power (as we had feared), but Alice Faye, who flowers lushly in the cabarets and flounces of the post-war years. Miss Faye doesn't resemble Fannie Brice; she doesn't sing 'My Man' as well, either. If she did, of course, it would have been just too coincidental."

—FRANK S. NUGENT,
THE NEW YORK TIMES

Left: Alice Faye and Al Jolson

ONLY ANGELS HAVE WINGS

RELEASED MAY 15, 1939

"Someday I'll get a straight answer from you, and I won't know what to do with it."

THE STORY

The boss of a South American air transport company is trying to stay in business without killing his pilots when his ex-fiancée shows up with her new husband, a disgraced flier.

PRODUCTION HIGHLIGHTS

In 1939 Howard Hawks lost *Gunga Din*, but he got a more personal project, a story that had been gestating for five years. While in Mexico filming *Viva Villa!* for David O. Selznick in 1933, Hawks met a group of fliers whose lives fired his imagination. He inserted these characters into a story by a magazine writer named Anne Wigton and then had the eminent screenwriter Jules Furthman turn it into a suspenseful script for Columbia Pictures, where Hawks's recent failure with RKO's *Bringing Up Baby* would be overlooked. Harry Cohn needed a starring vehicle for Cary Grant, who after five years of uninspired leading-man roles, had become a star with screwball comedies like *Topper*, *The Awful Truth*, and *Holiday*. Grant had enjoyed working with Hawks on *Bringing Up Baby* and trusted him to further define his newfound persona. *Plane No. 4* went into production in December 1938 with a much larger budget than the average Columbia feature.

The *Los Angeles Times* film critic Philip Scheuer visited the Columbia studios ranch to see the sprawling set that

Right: Victor Kilian, Cary Grant, Jean Arthur, Thomas Mitchell, Jean Arthur, and Allyn Joslyn

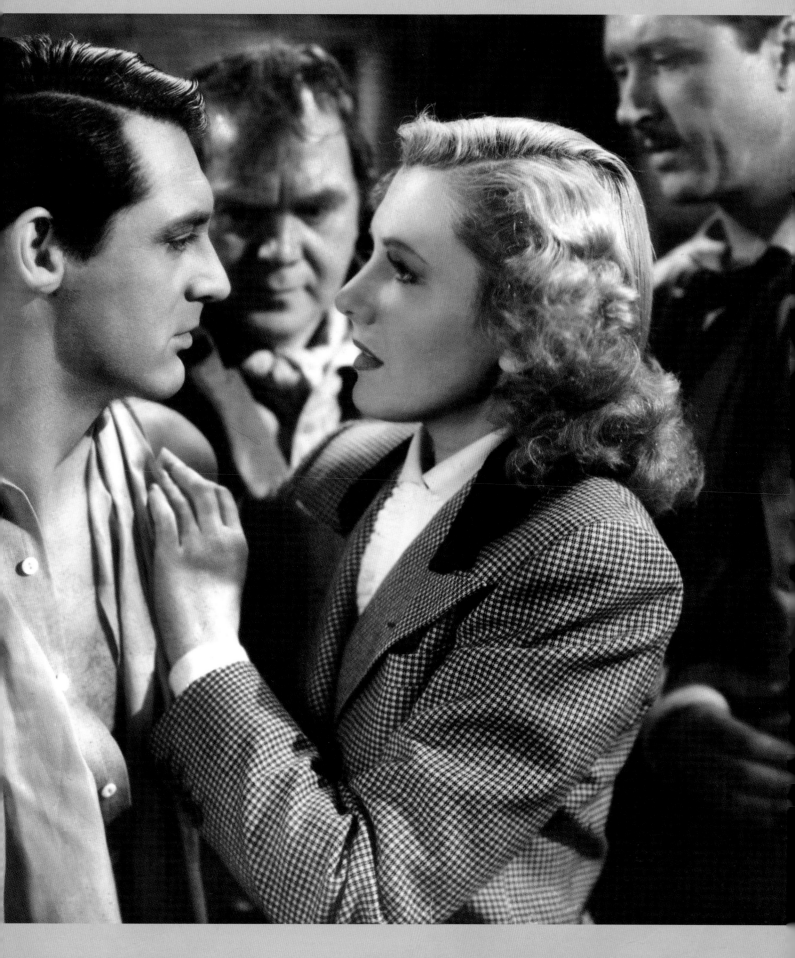

art director Lionel Banks had built to represent the waterfront of a village in Ecuador. "Through a man-made fog," wrote Scheuer, "you can see the lights of small craft reflected in black water, and the freighter *San Luis* loading cargo at the dock. The reverse view, from the second deck, shows a bustling village thronged with natives and tourists, burros, and water buffalo, the Zuider Zee American Bar, a dirty-white stucco National Fruit building, flare-lighted shops beneath sheds and, beyond, the beginnings of a bamboo village. Strangest of all are the gulls, circling against a painted cyclorama of mountains and ravines, lending perspective to distance." The seagulls were contained by a tarpaulin cover that enabled the company to shoot day for night, except that wind and rain played havoc with the flexible roof. It flapped and came loose.

Hawks had trouble getting a performance from Rita Hayworth. "I hadn't been in a big 'A' picture before," recalled Hayworth. "I was really frightened." After trying to get her to play a drunken scene the way he wanted it, Hawks had Cary Grant—without warning—pour two pitchers of water over her head. This eliminated a page of dialogue and let her play the rest of the scene with her wet hair in front of her face. Hayworth recalled being "very unhappy" about Hawks's treatment, and yet the film—wisely retitled *Only Angels Have Wings*—advanced her career. Grant did well, too. *Only Angels Have Wings* cemented his stardom.

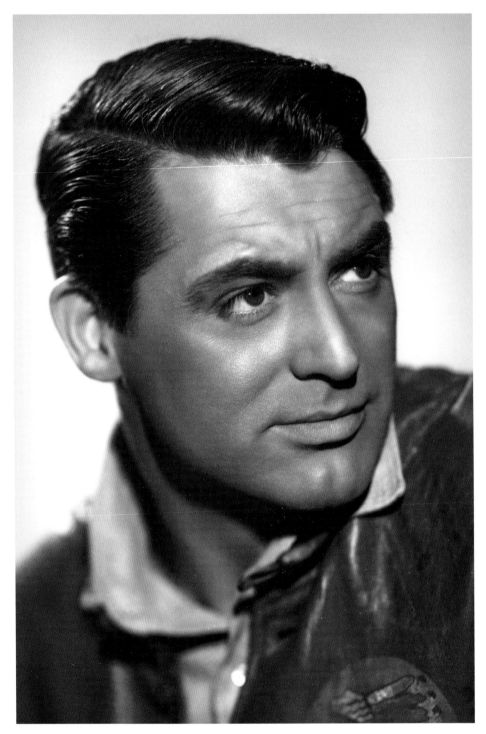

Above, right: A portrait of Cary Grant by Irving Lippman for *Only Angels Have Wings*
Opposite: Cary Grant, Allyn Joslyn, Jean Arthur, Sig Ruman, and Thomas Mitchell

Critical Reaction

"Howard Hawks, whose aviation melodramas must drive airline stock down two to three points per showing, has produced another fatality-littered thriller in *Only Angels Have Wings*. Even the title is ominous. The brew stirs slowly, but moves splendidly whenever the pilot's wheels leave the ground. Few things, after all, are as exciting as a screaming power dive. But when you add it all up, it's a fairly good melodrama, nothing more." **—FRANK S. NUGENT,** *THE NEW YORK TIMES*

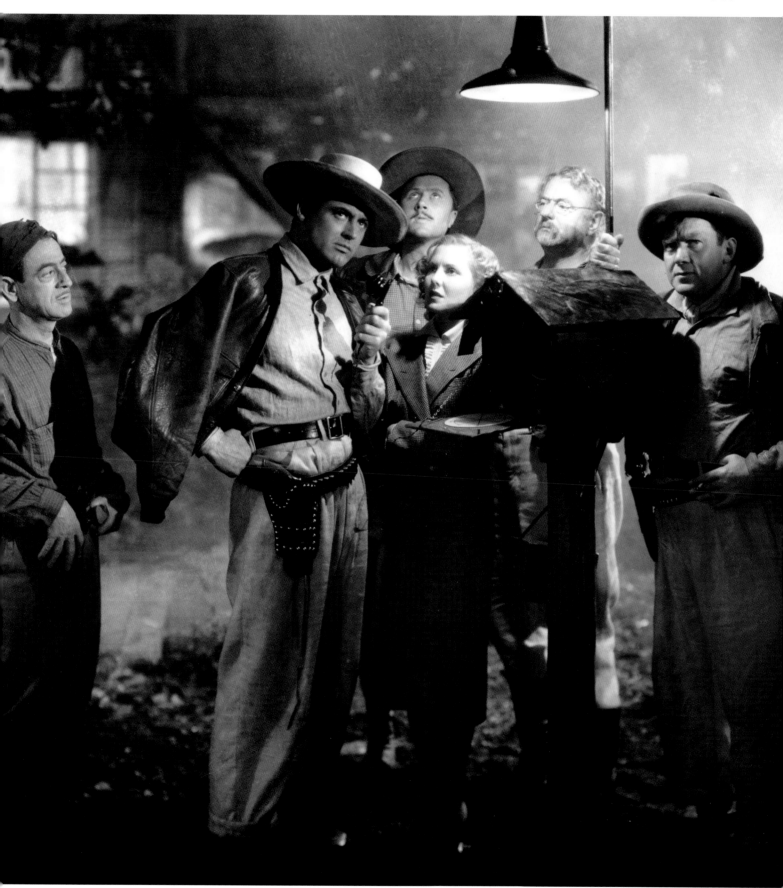

YOUNG MR. LINCOLN

RELEASED JUNE 9, 1939

"By jing, that's all there is to it. Right and wrong."

THE STORY

A rawboned young man from New Salem is inspired by law books to become a lawyer, but his newfound knowledge is tested by a lynch mob.

Left: Henry Fonda in John Ford's *Young Mr. Lincoln*

PRODUCTION HIGHLIGHTS

Abraham Lincoln was considered a worthy subject for the screen, even though he had done nothing for D. W. Griffith. *The Birth of a Nation* had been controversial, and his first sound film, *Abraham Lincoln* (1930), had been a failure. In 1938 Twentieth Century-Fox screenwriter Lamar Trotti had just finished *In Old Chicago* and was looking through story department files when he found drafts of *The Young Lincoln*, a screenplay that Winfield Sheehan had assigned Howard Estabrook to write before the Fox Film Corporation merged with Darryl F. Zanuck's company in 1935. Trotti showed the *Lincoln* drafts to Zanuck, who assigned him to create a project based on Lincoln's early years.

Trotti had been a Hollywood censor and before that a Georgia journalist. A trial he covered years earlier bore a resemblance to the Duff Armstrong case. Lincoln won the case by using the almanac to determine the moon's position on the night of a crime. "Lamar Trotti is practically an authority on Lincoln," Zanuck told John Ford, who also admired Lincoln and had made him a character in several of his films. "Everybody knows Lincoln was a great man," said Ford. "The idea of this picture was that even as a young man you could sense that there was going

to be something great about him." The actor Ford wanted to play Lincoln was likewise sympathetic.

"I'd been a Lincoln fan, if that's the way to say it, most of my life," said Henry Fonda. "Long before I knew I was going to become an actor, I had read Carl Sandburg's three books on Lincoln." It was Zanuck who first visualized Fonda as Lincoln. Fonda did not share his vision. "I didn't think I could play Lincoln," said Fonda. "Lincoln to me was a god. It was just like asking me to play Jesus, or something, you know! Well, they talked me into doing a test." The test had Fonda in full makeup doing a scene with an actress. When he looked at the edited footage, he was astonished. "It looks like Lincoln!" The illusion was destroyed when he heard himself speak. "I'm sorry, fellows," he said. "It won't work." Zanuck prevailed upon Ford, who called Fonda to his office and blasted him with a litany of expletives. "He could only talk to me using all the bad words," recalled Fonda. "What he was doing was shaming me." Then Ford brought Trotti with him to Fonda's home and they read him the screenplay. "Trotti had written a beautiful script," said Fonda. "I cried and everything." But he was still unsure of himself. Finally he remembered what Spencer Tracy said that Alfred Lunt had told him, the secret

of his vaunted acting technique. "Learn the lines," said Tracy. "And try not to fall down or bump into a chair."

As Ford shot *Young Mr. Lincoln*, first on location at the Sacramento River, and then on the Twentieth Century-Fox backlot, Zanuck reviewed the footage. Known as a skilled story editor, he was also a judge of images. "I feel that we should avoid shooting down on Lincoln," Zanuck told Ford. "Shoot up on him. Not only does it give him height, which is essential, but when you look up at him, he looks exactly like Lincoln and not Fonda. He looks great in a low-camera setup where you see his whole figure sprawled out or standing. I like best the scenes where his eyes seem dark and deep-set and where you can see the cleft in his chin." Following the out-of-town fashion, *Young Mr. Lincoln* was premiered in Springfield, Illinois, on May 30, 1939.

Above: Henry Fonda in John Ford's *Young Mr. Lincoln*

Critical Reaction

"Without a trace of self-consciousness or an interlinear hint that its subject is a man of destiny, *Young Mr. Lincoln* follows Abe through his years in Illinois, chuckling over his gangliness and folksy humor, sympathizing with him in his melancholy. Henry Fonda's characterization is one of those once-in-a-blue-moon things: a crossroads meeting of nature, art, and a smart casting director. His performance kindles the film, makes it a moving unity, at once gentle and quizzically comic."
 —FRANK S. NUGENT, *THE NEW YORK TIMES*

JUAREZ

RELEASED JUNE 10, 1939

"What else might a Hapsburg have expected from a bourgeois Bonaparte?"

Above: Paul Muni *Opposite:* Poster art of Paul Muni and Bette Davis for William Dieterle's *Juarez*

THE STORY

Napoleon III sends the Austrians Maximilian and Carlota to be Emperor and Empress of Mexico but withdraws his support when they are threatened by the revolutionary Benito Juarez.

PRODUCTION HIGHLIGHTS

In 1938 Hollywood was in the business of manufacturing entertainment. The ever-increasing costs of producing feature films required that they please patrons, not confuse them with ambiguous content. Under orders from the PCA, films that featured the controversial Spanish Civil War were made to use the war as a setting, not as a topic; thus, Paramount's *Last Train from Madrid* (1937) and United Artists' *Blockade* (1938) were so "neutral-ized" that their stories could have been set in the American Civil War.

As fascism grew more truculent in Europe, isolationism grew more fervent in the United States. Americans tried to ignore fascism. Hollywood could not. Refugees from Nazi terrorism were working in Hollywood, many of them at Warner Bros.; émigrés such as actor Peter Lorre and director Anatole Litvak. The studio had a stake in democracy. While the industry stricture against propaganda films made it difficult to produce projects such as *Confessions of a Nazi Spy*, the same message could be sent in a period film. German émigré Wolfgang Reinhardt was cowriting the screenplay for *Juarez*. He told producer Hal Wallis and associate producer Henry Blanke that the film had a responsibility. "The story must be so clear," said Reinhardt, "that even a child can recognize that Napoleon III, with his intervention in Mexico, can be no one but Mussolini and Hitler with their adventure in Spain." The resulting film was perhaps the most unusual of 1939, both in structure and tone.

Juarez cost $1.75 million to make. A film of that scale needed at least two stars. Paul Muni was playing Juarez, Brian Aherne was Maximilian, and Bette Davis was Carlota, yet the potential for powerful scenes was not being realized. Juarez had never met the Hapsburgs. Even as their destinies interwove, they lived in different worlds. As Reinhardt worked with John Huston on the script, it became obvious that they were writing two parallel stories; they were almost two films. At one point the studio contemplated the possibility of releasing the film in two parts. The Hapsburg scenes began to outweigh the Juarez scenes. Wanting Juarez to hold the spotlight, Muni agitated for (and got) more scenes.

Some of his critiques were valid. "Juarez would become a greater figure," Muni wrote Wallis, "if the audience would have a few visual glimpses. Actors can only do so much with dialogue. What a vivid flash can do, no actor can do. The awesomeness and grandeur of the country; its gigantic trees that are thousands of years old; the mysterious Aztecs—something of that must be seen." The film did feature spectacular vistas and huge sets, but even though Wallis, Muni, Blanke, and director William Dieterle had done research in Mexico, the film was shot entirely in California. The huge sets were created by studio artisans at the Warner Bros. ranch in Calabasas.

The first preview of *Juarez* pointed up its structural problems. "There were laughs in all the wrong places," recalled Wallis, "and many people left before the ending." Working with editor Rudi Fehr, Wallis cut twenty minutes of footage and rearranged more. "You cannot sit in

85

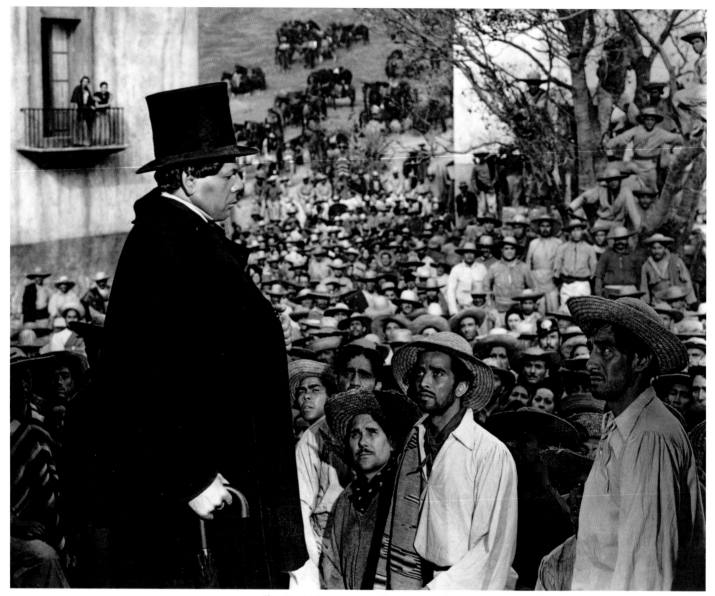

Above: Paul Muni in a scene from *Juarez* *Opposite:* A portrait of Bette Davis made by George Hurrell

a projection room, look at a picture, and think you have it right on the nose," said Wallis. "In a picture as complex as this, the audience will have to tell us if we are right." *Juarez* became the eighth-highest-grossing film of 1939, but even though the production was a model of efficiency, its settings, salaries, and retakes had been expensive, so it barely turned a profit. Still, the film's message was heard.

Critical Reaction

"Because history repeats itself, this screen record of the past has become strangely contemporary, revitalized, and significant. In the contest between dictator and democrat, the Warners have owned their uncompromising allegiance to the latter. They have not sidestepped the responsibilities imposed by the theme's political parallelism. With pardonable opportunism, they have written between the lines of Benito Juarez's speeches a liberal's scorn for fascism and Nazism."

—FRANK S. NUGENT, *THE NEW YORK TIMES*

"While performances shade somewhat into the background of this panorama, there are brilliant moments for the individual player, none perhaps more powerful than that allotted to Miss Davis when she appeals to Napoleon for aid. It is a sensational exhibition of frenzy." **—EDWIN SCHALLERT,** *LOS ANGELES TIMES*

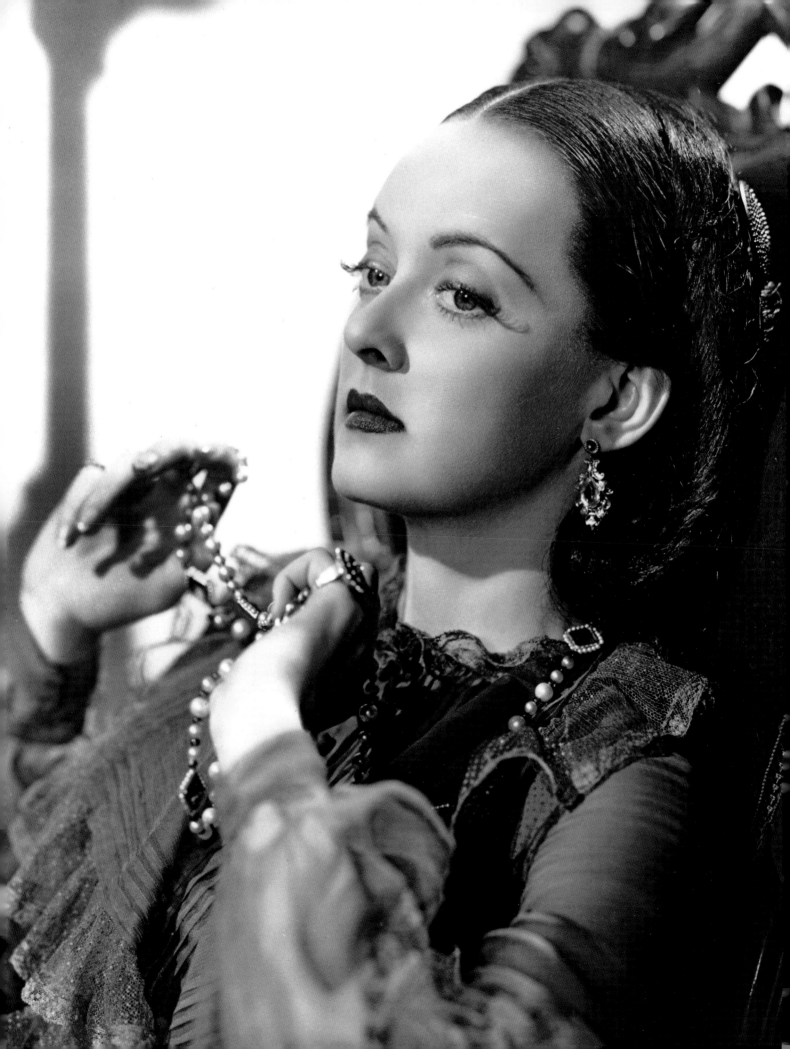

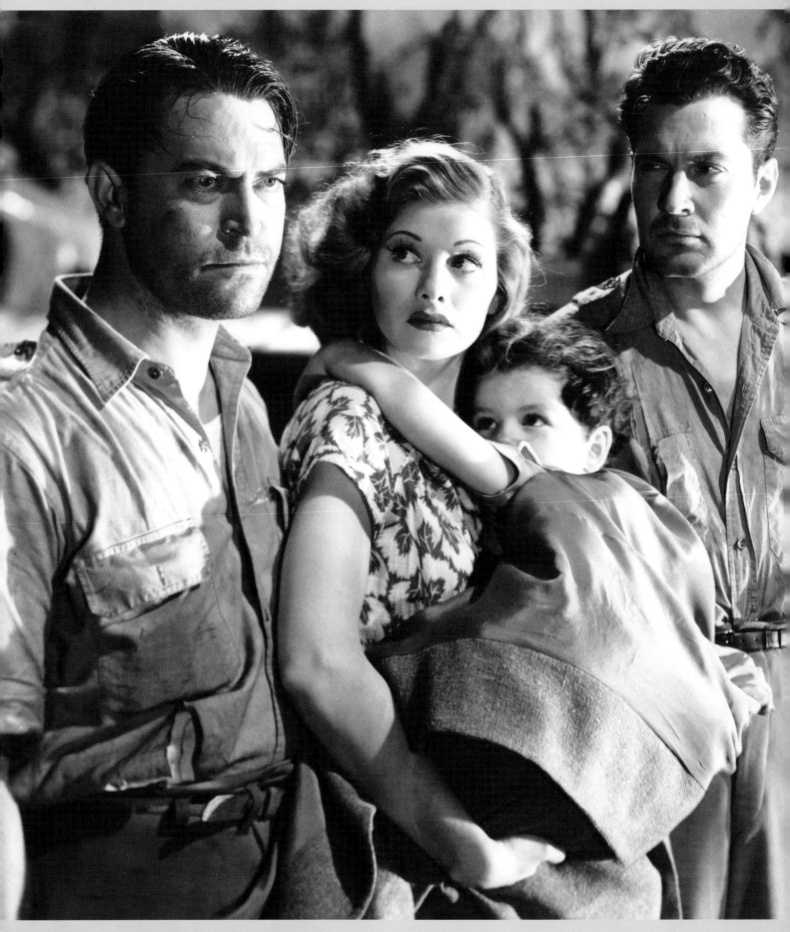

FIVE CAME BACK

RELEASED JUNE 23, 1939

"Since I am to have my neck cut by one kind of savage or stretched by another, I have nothing to gain either way."

THE STORY

When a passenger plane crashes in a jungle populated by headhunters, its crew is able to repair it, but the craft will not be able to carry all its passengers to safety.

Left: Chester Morris, Lucille Ball, Casey Johnson, Kent Taylor, and Wendy Barrie in a scene from *Five Came Back*

PRODUCTION HIGHLIGHTS

In the 1930s, B pictures were consistently profitable. They cost less to make but no less to see. They were also a training ground for studio employees. The ingredients of a low-budget project were usually an original screenplay (to avoid paying for a literary property), standing sets, a fledgling director, contract players, and a fading star like Richard Dix, Warner Baxter, or Chester Morris.

Five Came Back was based on an original story by Richard Carroll, who would have a solid career at Twentieth Century-Fox. It was adapted by Nathanael West, who would gain posthumous fame for his novel *The Day of the Locust*. West was not happy when producer Robert Sisk had his screenplay worked over by Jerome Cady and then by Dalton Trumbo. Curiously, the careers of all three screenwriters would end suddenly. West was killed in an auto accident in 1940. Cady was killed by sleeping pills in 1948. Trumbo was jailed and blacklisted in 1947, a victim of the House Un-American Activities Committee. Only after thirteen years was he able to work openly in Hollywood. *Five Came Back* was only a "programmer," but its incisive

dialogue and suspenseful plot was the work of first-rate talents.

Budgeted at only $225,000, the film was directed by John Farrow, who made the most of his resources, even carrying more trees onto the jungle set. He was tough on his actors, especially Lucille Ball, who had been doing comedy B pictures for two years. *Five Came Back* got a very good review in the *New York Times*. This and word-of-mouth advertising made the film an unexpected hit, with a profit of $262,000. *Five Came Back* helped Ball graduate to better roles and gave Farrow a crack at A pictures.

Critical Reaction

"*Five Came Back* is a rousing salute to melodrama, suspenseful as a slow-burning fuse, exciting as a pinwheel, spectacularly explosive as an aerial bomb. And naturally it runs up a staggering list of fatalities. Although Dalton Trumbo and his fellow-scriptists probably would be the last to insist their plot is virgin territory, they have landscaped it very well."

—FRANK S. NUGENT, *THE NEW YORK TIMES*

Below: Kent Taylor, Wendy Barrie, Casey Johnson, Lucille Ball, and Chester Morris *Opposite, clockwise from top:* Chester Morris, Lucille Ball, Allen Jenkins, John Carradine, Joseph Calleia, Patric Knowles, Elisabeth Risdon, C. Aubrey Smith, Wendy Barrie, and Kent Taylor • Lucille Ball and Chester Morris • Headhunters threaten the lives of the stars of *Five Came Back.*

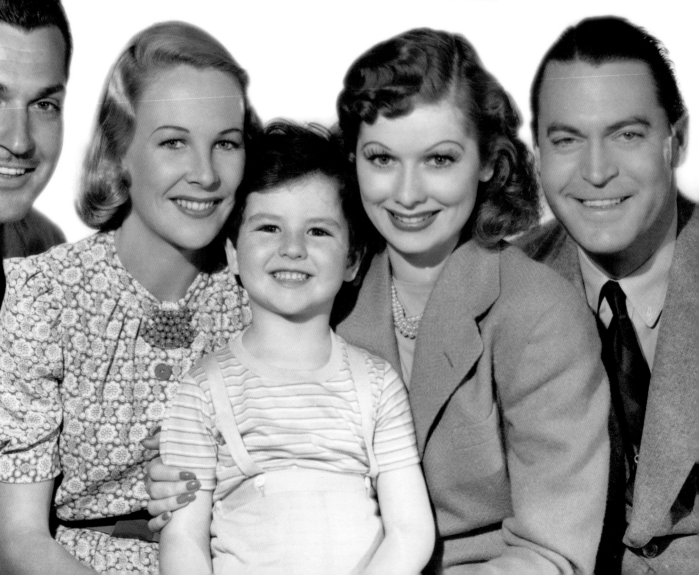

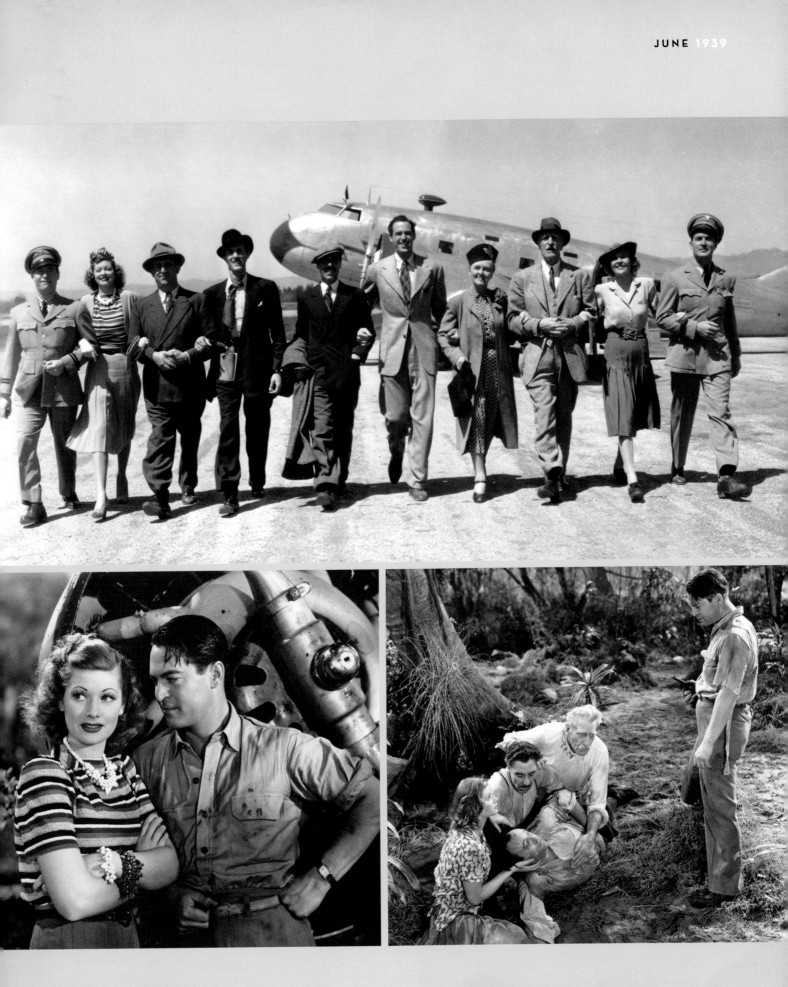

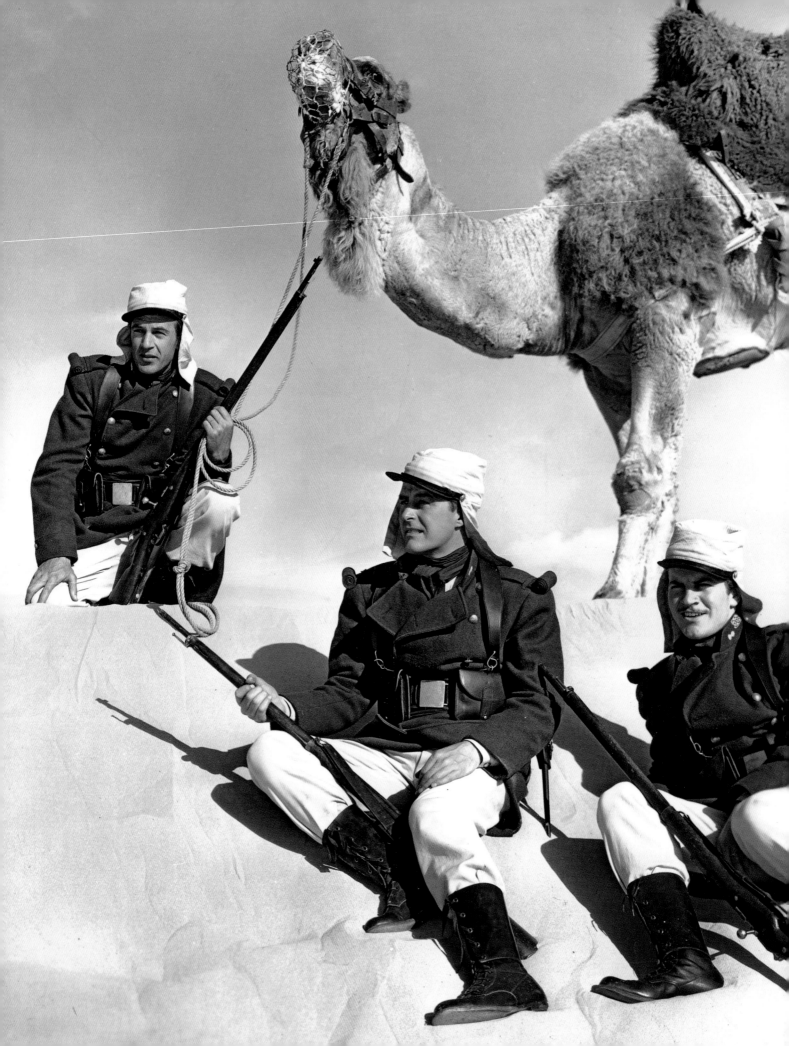

BEAU GESTE

RELEASED JULY 24, 1939

"The love of a man for a woman waxes and wanes like the moon, but the love of brother for brother is steadfast as the stars and endures like the word of the prophet."

THE STORY

When three English brothers join the French Foreign Legion to save face after a family scandal, a sadistic sergeant begins to exploit them.

Opposite: A portrait of Gary Cooper, Ray Milland, and Robert Preston made for William Wellman's *Beau Geste*

PRODUCTION HIGHLIGHTS

Very few of the big films of 1939 were remakes. The wealth of writing talent in Hollywood made recycling films of an earlier era unnecessary. A notable exception was *Beau Geste*. The colossally popular 1926 film had made stars of Neil Hamilton, Ralph Forbes, and Ronald Colman. Thirteen years later, only Colman was still a star. Silent films were regarded as prehistory and Paramount owned the rights to the P. C. Wren novel, so a remake might turn contract players like Robert Preston and Ray Milland into stars. And the studio needed a vehicle for Gary Cooper, who had one film left in his contract. Paramount boss William LeBaron gave the project to William Wellman, who was known for *Wings*, *Public Enemy*, and *A Star Is Born*.

Wellman made realistic films, so he elected to film this story of the French Foreign Legion in a real desert, not on the Guadalupe Dunes, which were near the ocean. He took his cast and crew to the sand dunes of Buttercup Valley, a California region near Yuma, Arizona. "That was a rugged picture," said Wellman. "You had to be tough. We were out in the middle of the desert." There were one hundred tents in the camp. No women were allowed. The actors felt cut off from civilization, as if they were legionnaires. "It looked like the Sahara," recalled Preston. "It was completely sand." Working from his tent city, Wellman marshaled eight hundred extras into a battle scene that took one week and $250,000 to shoot.

"We used to go into the Mexican border towns at night for a little relaxation," said Preston. One night he was dining in a roadhouse with Wellman, Cooper, and Milland, when a menacing character came to their table. "Hey! Aren't you Bill Wellman?" said the man. "I was your mechanic in France." The man proceeded to show weathered snapshots of three Lafayette Escadrille warplanes that Wellman had cracked up in World War I. After this, the actors had new respect

Left: Harold Huber, George Chandler, Robert Preston, Gary Cooper, and Brian Donlevy in a scene from *Beau Geste*

for "Wild Bill" Wellman. "For a crazy man," said Preston, "Bill had a marvelous sympathy and understanding of the actor. It was the only way you could work with Gary Cooper." Because Cooper was so mellow, even to the point of sleeping on sets between takes, and because his acting looked effortless, critics took him for granted. "Cooper never made a move that wasn't thoroughly thought out and planned," said Preston. "He was probably the finest motion-picture actor I ever worked with."

Critical Reaction

"William A. Wellman has maintained the air of mystery and surprise which gave great appeal to the prior version. It will be difficult to shut out one's memory of that famous triumvirate, Ronald Colman, Neil Hamilton, Ralph Forbes; and Noah Beery's unrivaled presentation of the tyrannical sergeant."

—EDWIN SCHALLERT, *LOS ANGELES TIMES*

"The audience reaction last night in the Paramount Theatre was something to see. The capacity house seemed to enjoy the production immensely, although strangely enough, tragic moments brought laughs. This seems to be the rule these days. It happened during the screening of *Four Feathers* and at screenings of other recent features. As the saying goes, tragedy and comedy are thinly separated."

—JOHN L. SCOTT, *LOS ANGELES TIMES*

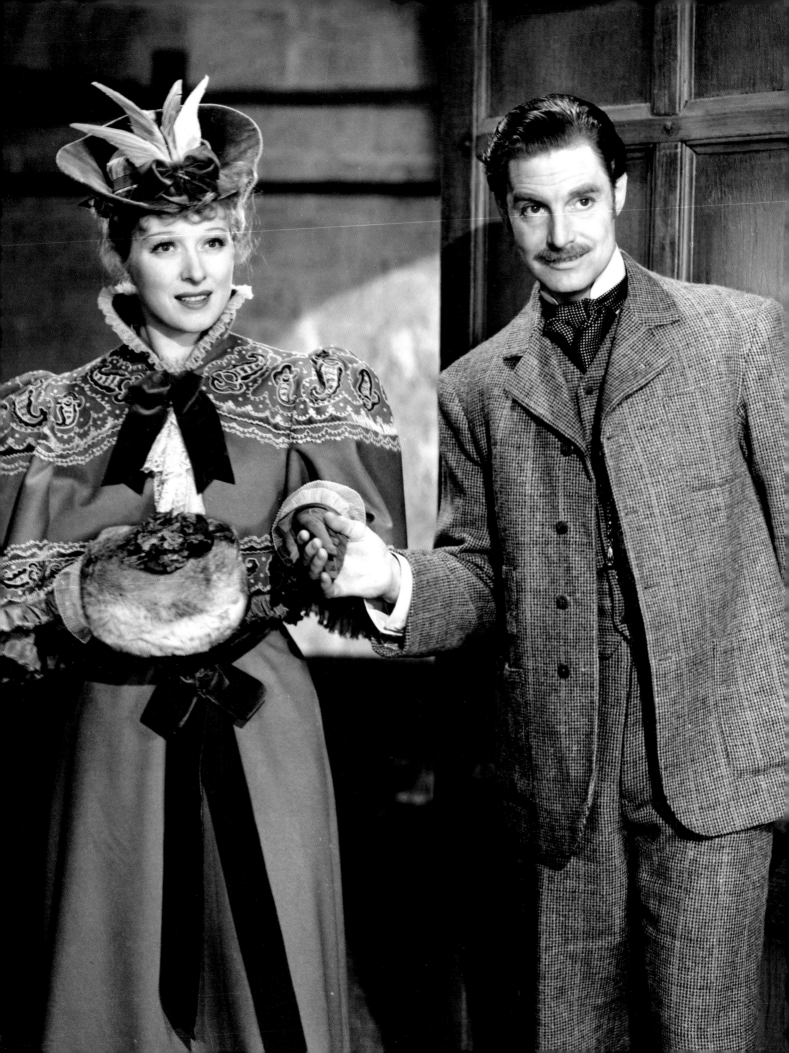

GOODBYE, MR. CHIPS

RELEASED JULY 28, 1939

"I don't see how you could ever get old in a world that's always young."

THE STORY

A schoolteacher inspires generations of boys even as he mourns his dead wife and fights administrative opposition.

PRODUCTION HIGHLIGHTS

In the late 1930s, M-G-M was conducting an intercontinental experiment. The studio had installed a subsidiary company called M-G-M-British at the Denham Studios in South East England. The idea was to capitalize on the popularity of British stars. M-G-M-British would make films with both British and American talent. Its two 1938 releases, *A Yank at Oxford* and *The Citadel*, had British producers, American directors, and mixed casts. The films were surprisingly profitable. As 1938 waned, this was important. Income from Europe was diminishing in direct proportion to fascist expansion. If Italy would not pay to see American films, England would, at least for a while. When M-G-M director Sam Wood traveled to Denham in early 1939, he sensed anxiety. "In England," he said, "people are keenly conscious of the war scare." Wood was there to direct a project that had been floating around M-G-M for years.

Goodbye, Mr. Chips was a novel by a British author, James Hilton, but it had been published by the American book company Little, Brown, in 1934. The powerful critic Alexander Woollcott raved about it until it became a success. Readers saw their own childhood in the story of schoolteacher Charles Edward

Chipping. Before long, the M-G-M producer Irving Thalberg bought the book and brought Hilton to Hollywood. Thalberg died in 1936, so the project sat on the shelf until 1938, when M-G-M-British needed a project.

Hilton had strong feelings on who should play Chipping. "I would rather have an American who can feel what it ought to be," said Hilton, "than an Englishman who is selected because he has the English accent. So many people think of Chips as a little wispy man. I think Wallace Beery has the warmth for it." Producer Victor Saville cast Robert Donat, whose work in *The Citadel* was much admired. Saville cast Elizabeth Allan as Chipping's wife, Katherine. Allan had been set for *The Citadel* but had been unceremoniously bumped from it in favor of Rosalind Russell. As Allan prepared for *Mr. Chips*, Wood saw a screen test of an actress whom Louis B. Mayer had brought back from England a year earlier. Greer Garson had been waiting that entire year for a decent role and was ready to go home. Wood offered her the part of Katherine. She accepted, and once again Allan was bumped. No one expected Allan to sue the studio. She did, and she won. M-G-M appealed and won. Then Mayer blacklisted Allan. She

Opposite: Greer Garson and Robert Donat in a scene from Sam Wood's *Goodbye, Mr. Chips*

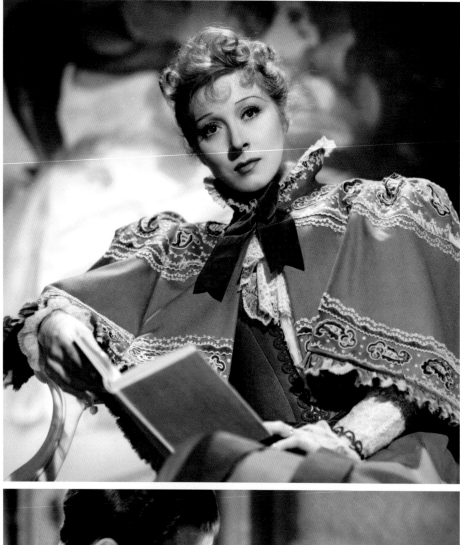

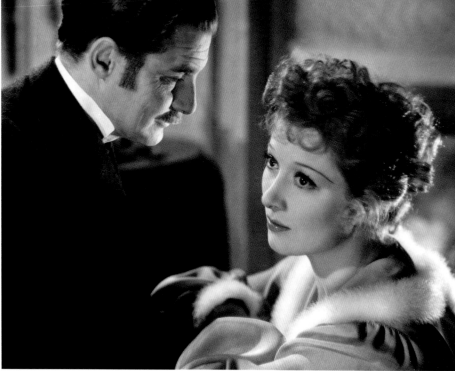

Top and opposite: Portraits of Greer Garson by Claude Davis Boulton for *Goodbye, Mr. Chips* *Above:* Greer Garson and Robert Donat

returned to England, where she enjoyed a distinguished career.

Garson made the most of her first American role, perhaps because she was acting it on British soil. Donat concentrated so fully on his characterization that he virtually became Chipping. "Mr. Donat made a deep impression on me by always remaining in character as old Mr. Chips, even when he was off-camera. Many people thought this was rather affected of him, but it was dedication to the role." Dedication was a theme of the film's genesis. The opening credits of the film bore the legend: "We wish to acknowledge here our gratitude to the late Irving Thalberg, whose inspiration illuminates the picture of *Goodbye, Mr. Chips.*"

Critical Reaction

"In a year in which the great nations of the world are choosing partners for a dance of death, this cavalcade of English youth becomes an almost unbearable reminder of something which in a mad and greedy world may be allowed to perish from the earth. I am here to testify that in my own experience, the most moving of all motion pictures is *Goodbye, Mr. Chips.*"

—ALEXANDER WOOLLCOTT ON
THE TOWN CRIER, CBS RADIO

"The book one muses over respectfully in the quiet of a study is apt to be coarsened, cheapened in its mutation to the imagery of the screen. The film of *Goodbye, Mr. Chips* is not entirely an exception. Some parts of it are brought home with eye-blackening vigor. But on the whole it is admirable and right and comes honestly by its emotionalism."

—FRANK S. NUGENT, THE NEW YORK TIMES

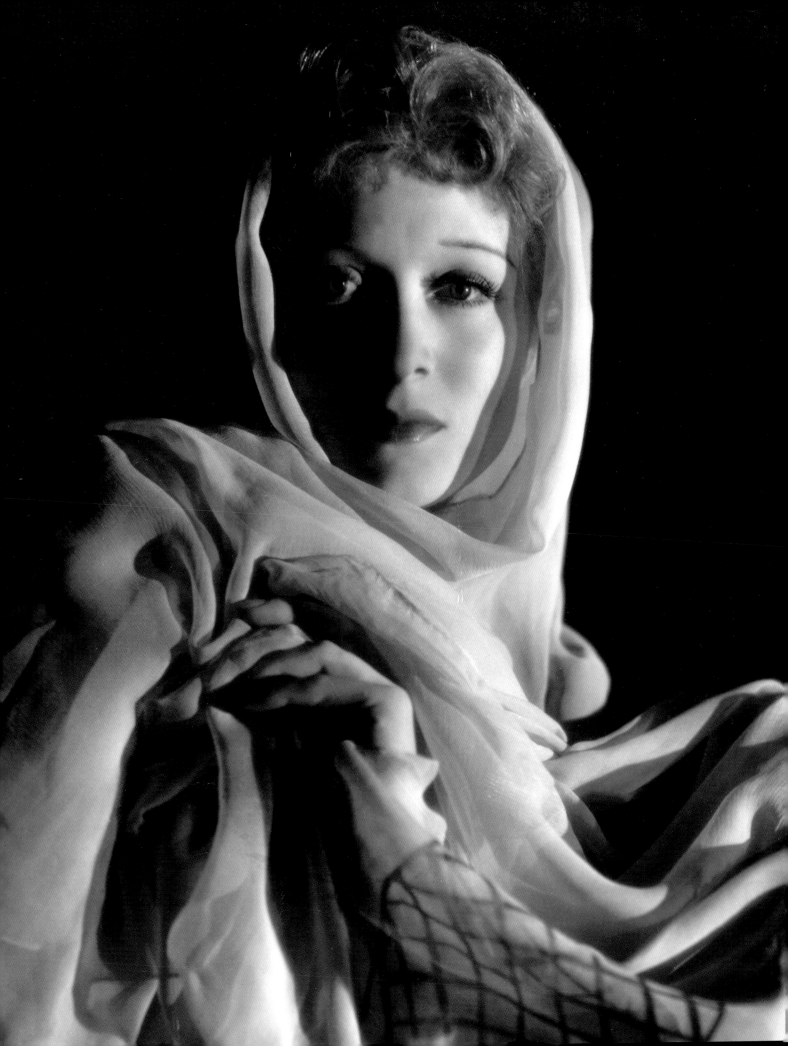

BACHELOR MOTHER

RELEASED AUGUST 4, 1939

"Of course he talks. Why, he can recite the first line of Gunga Din."

THE STORY

When a department store clerk finds an abandoned infant on a doorstep, no one will believe that it is not her child, not even her boss's son, who is determined to help her.

PRODUCTION HIGHLIGHTS

Every film released in 1939 had to run the Production Code gauntlet. Producers had found that mild comedies warranted less PCA scrutiny than mysteries or romances. *Bachelor Mother* derived from a harmless story by Felix Jackson. It had been filmed in Hungary as *Kleine Mutter* and was now being adapted for RKO by screenwriter Norman Krasna. It immediately ran afoul of PCA boss Joseph Breen, who objected to the story of an apparently unwed mother. He was opposed to any "comedy play that depended upon a suggestive situation." To make the story filmable, Breen mandated a style of performance: "We recommend that this material be read perfectly straight." The logic of this illogical notion was that the knowing segment of the audience would get the joke while the innocents that the Code was written to protect would think that the stork got the wrong address. The film's executive producer was Pandro S. Berman, who was in large part responsible for keeping RKO afloat through the depression. He agreed to Breen's terms and then cast Ginger Rogers as the salesgirl and David Niven as her boss's son. "They're going to expect you to dance," Sam Goldwyn said to Niven. "Show them you can act."

When the film was two days from starting, Berman hit another roadblock. He received a letter from Ginger Rogers about the script. "Instead of working laughs out of natural situations," Rogers wrote, "you build a situation around a laugh. Why, I don't know. There is no love between these two people. A story that has a boy and girl as its leading characters is expected to be a love story. If we were to meet these two people in our drawing room, we would say that they are bores." Rogers eventually got to the crux of the problem—how she was being presented. "So why do we make a picture about them? Just because it would be cute to say 'Ginger Rogers picked up a baby and tried to convince her intimate friends that it wasn't hers'? Even the girl's landlady isn't surprised that she has a baby! God! What are we coming to?"

Berman assured Rogers that the script had been carefully prepared and that it was better than 90 percent of Hollywood scripts going into production. He then reminded her of their past successes and how he had avoided putting her in any project in which he did not have the utmost faith. "Your career to date has been handled more judiciously than any other woman's," wrote Berman. "I do not know an actress today—and I

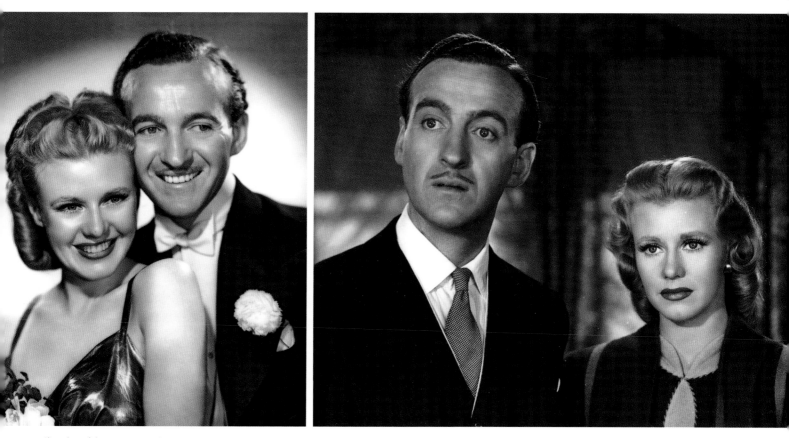

Above from left: A portrait of Ginger Rogers and David Niven made by Ernest Bachrach for *Bachelor Mother* ✳ David Niven and Ginger Rogers in a scene from Garson Kanin's *Bachelor Mother*

include Garbo, Shearer, Crawford, and even Bette Davis, who rates at the top of her profession—who has had such a succession of box-office successes and characters beloved by audiences." Rogers disregarded Berman's arguments and refused to begin the film. Berman put her on suspension. She backed down and made *Bachelor Mother*.

"I loved working with David Niven and the precious baby," wrote Rogers, "and Garson Kanin was a lively director. Gar was imaginative and spontaneous and his sense of comedy smoothed out any prob-lems." The film's preview was an indication of what was to come; the audience went wild. Within weeks of its release, it had made David Niven a star. "It was widely acclaimed as the best comedy of the year," wrote Niven. Berman was vindi-cated, and *Bachelor Mother* gave Rogers a new career as a comedienne. No one gave Breen credit, but it was generally noted that the film was funny because Rogers and Niven played their scenes straight. "In a year of champions," wrote Rogers, "*Bachelor Mother* was one of RKO's box-office winners."

Critical Reaction

"A jest as broad as this usually is coars-ened in the playing, with every one wear-ing cap and bells and drowning audience laughter with their own. Mr. Kanin has wisely kept his cast in check and, having a wise cast, has seen that the audience enjoys the joke alone."

—FRANK S. NUGENT, *THE NEW YORK TIMES*

"The preview audience paid the pro-duction the tribute of plenty of laughter last night."

—EDWIN SCHALLERT, *LOS ANGELES TIMES*

IN NAME ONLY

RELEASED AUGUST 18, 1939

"What's wrong with romance? What's wrong with illusions, as long as you can keep them?"

THE STORY

A man tries to escape a loveless marriage when he meets a sincere young widow, but his devious wife blocks his efforts to get a divorce.

PRODUCTION HIGHLIGHTS

Cary Grant's nonexclusive contract with RKO Radio Pictures brought him a third release in 1939. *In Name Only* was a heavy emotional drama, one of the last he would do. His star persona was becoming fixed, and, as he believed that he was a product that had to be sold in a consistent fashion, he would henceforth limit himself to roles that fit that persona. An unhappy husband was not his kind of role, but it did give him the opportunity to play opposite Carole Lombard, who was also taking a break from comedy, and Kay Francis, who was starting fresh after seven years as a Warner Bros. star.

Francis had been badly used by Warners. When Bette Davis became more popular than Francis, Warners tried to make Francis break her contract, but she held on to the very last, enduring two years of mediocre films. *In Name Only* gave her an opportunity, if not to star, to show her versatility. At Warners she had been reduced to being a clothes horse. "I want to be an actress," she said, "not just a woman who dresses up and speaks noble lines." The title *In Name Only* refers to her character's marriage. She has married solely for wealth and position, and she is determined that her frustrated husband not get away from her. It was an unsympathetic role for a star to essay. "When I played the heavy in *In Name Only*," said Francis, "my friends told me I was crazy. I said I had to do something other than the mush I'd been playing." Francis was wise to take the part. She dominated her scenes with Grant and Lombard.

Lombard was distracted during the making of the film. She had just married Clark Gable and was decorating a new home. She had been photographed by Ted Tetzlaff in ten films, but in this film

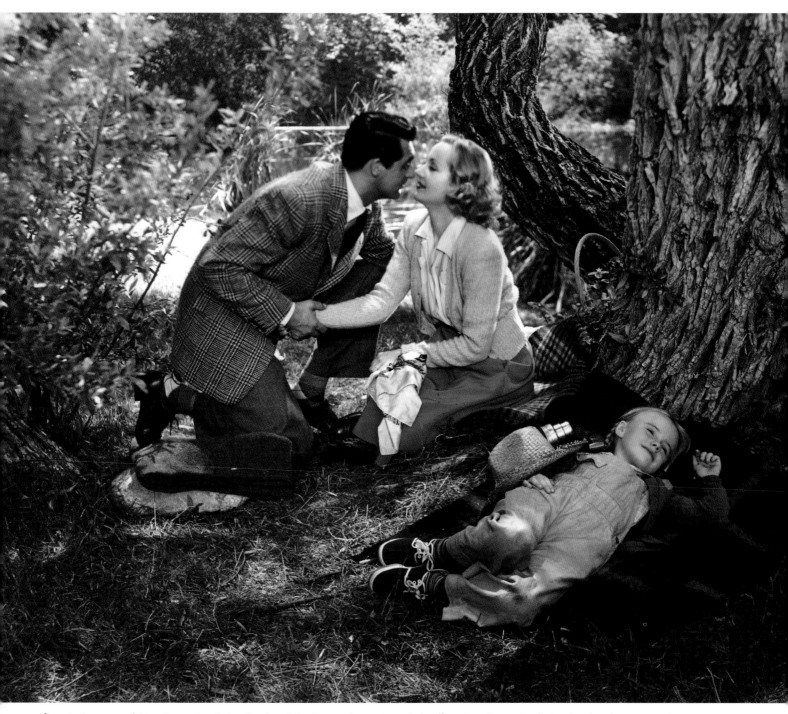

Opposite: A portrait of Cary Grant, Carole Lombard, and Kay Francis for *In Name Only* *Above:* Cary Grant, Carole Lombard, and Peggy Ann Garner

Critical Reaction

J. Roy Hunt was the cinematographer. Even though he was not known as a glamour expert, he devised lighting for Lombard's close-ups that was uniquely luminous, making *In Name Only* a showcase for her beauty.

"When the wife gets the hisses from a preview audience and the other woman wins applause, you can wager that the scenarist, director, and cast have done right by a picture. I wouldn't want to treat this lightly. *In Name Only* is the kind of picture that goes miles and miles in finding popular favor. It is a remote descendant of *Back Street* and *Only Yesterday,* meeting with the current demands of censorship."
—EDWIN SCHALLERT, *LOS ANGELES TIMES*

103

STANLEY AND LIVINGSTONE

RELEASED AUGUST 18, 1939

"The man you were sent to rescue doesn't want to be rescued."

THE STORY

An American journalist makes a perilous expedition to find and rescue a lost missionary, the first European who has entered the interior of Africa.

PRODUCTION HIGHLIGHTS

In keeping with Darryl Zanuck's quest for diverting stories from the headlines of an earlier era, Twentieth Century-Fox put all its might behind a project based on the legendary 1871 meeting of Henry Morton Stanley, an ace reporter at the *American Herald*, and David Livingstone, a British physician, missionary, and explorer. The unusual nature of the project put a strain even on Zanuck's impressive resources. Most of the film was to take place in Africa. Twentieth possessed the largest, best-equipped studio backlot in Hollywood, and M-G-M had been shooting *Tarzan* films at Lake Sherwood, but Zanuck dispatched a camera crew and acting doubles to Africa in late 1937. The famed jungle-filmmaker Osa Johnson accompanied Otto Brower's crew to act as a consultant. As Johnson knew, and as M-G-M had learned while filming *Trader Horn* in 1929, trekking through Africa was both strenuous and dangerous. There were close calls with animals and natives, but the crew returned intact.

The next question was who could portray the intrepid Stanley. Zanuck did not have an actor in his stable of players who looked the part, so he turned to

Right: Walter Brennan and Spencer Tracy in Henry King's *Stanley and Livingstone*

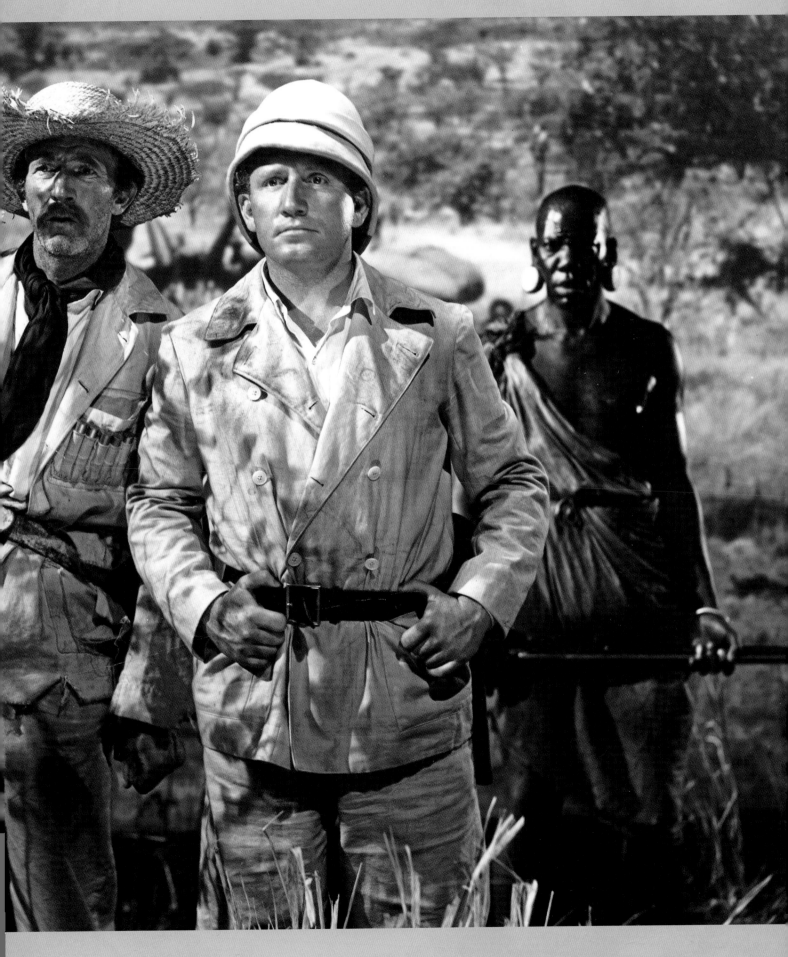

Louis B. Mayer. A deal was struck. Mayer would lend Spencer Tracy to Zanuck in exchange for Tyrone Power, who would appear in *Marie Antoinette*. Zanuck would later regret the deal, saying that Power had been given too little screen time in the Norma Shearer film. Zanuck could not complain too much, because Mayer also lent Myrna Loy for *The Rains Came*. And Tracy, who had just won his second Academy Award, would enhance the box-office appeal of *Stanley and Livingstone*.

Tracy took his craft seriously, but not himself. "Look," he said, "the only thing an actor has to offer a director, and, finally, an audience, is his performance." To create that performance, Tracy usually locked himself in a room and built it from the ground up. Once in a while he got stuck. In this film, there was a line he did not want to say, not because he could not find the interpretation but because he thought it would be ridiculed. Since H. M. Stanley supposedly uttered the words, "Dr. Livingstone, I presume?" the phrase had passed beyond legend and into the realm of caricature. Director Henry King had to assure Tracy that it could be spoken without ruining a crucial scene. "I can't say it," said Tracy. "I can't

say it." King coached Tracy, telling him to think about Stanley, about his patience, endurance, his suffering, and how exhausted he would be when he says the line. "I could kill you," said Tracy to King. "You've played the scene for me. I just didn't have sense enough to think about it." Oddly enough, when it came time to film the line, Tracy kept breaking up. No one laughed when the scene played in theaters, though, because it came at the end of a skillfully edited buildup. *Stanley and Livingstone* was a hit for Twentieth Century-Fox in a very big year.

Critical Reaction

"The film's ring of truth is sounded by the exceptional performance of Sir Cedric Hardwicke as a credible Livingstone and Spencer Tracy as Stanley, who reads that classic emotional understatement made at Ujiji—'Dr. Livingstone, I presume.'—as a dramatic summation rather than a time-worn gag-line." **—NEWSWEEK**

Left: Spencer Tracy and Sir Cedric Hardwicke

THE WIZARD OF OZ

RELEASED AUGUST 25, 1939

"And remember, my sentimental friend, that a heart is not judged by how much you love, but by how much you are loved by others."

THE STORY

A tornado transports a girl from a Midwest farm to a magical world, but she misses her family, so she asks three new friends to help her get home.

Opposite: Jack Haley, Bert Lahr, Judy Garland, Frank Morgan, and Ray Bolger in Victor Fleming's *The Wizard of Oz*

PRODUCTION HIGHLIGHTS

How many fantasy films had been made since the advent of sound? *Alice in Wonderland*, *A Midsummer Night's Dream*, and *The Green Pastures* were among the few that used heavy costumes and special effects to create another world. None had been lucrative. Likewise, the few attempts to film L. Frank Baum's books had failed. The fabulous unreality of his stories made them phenomenally popular, with sales approaching $80 million, but film was too literal a medium for the land of Oz. Samuel Goldwyn thought otherwise. In 1934 he paid the Baum estate $40,000 for the Oz stories, hoping to condense them into an Eddie Cantor vehicle. By 1937 Cantor was no longer a Goldwyn contractee, and Walt Disney was wowing Hollywood with his own brand of fantasy in *Snow White and the Seven Dwarfs*. In November 1937, the Warner Bros. director Mervyn LeRoy was becoming an M-G-M producer; Louis B. Mayer thought he might be the next Irving Thalberg. Already at M-G-M was Arthur Freed, the lyricist of "Singin' in the Rain" and many other standards. While waiting to become a producer, he was nurturing a preternaturally talented teenager. "Judy Garland interpreted a song

better than anyone," said Freed. "You just couldn't mistake that talent. There was so much of it."

When *Snow White*'s grosses reached $16 million, word got out that Goldwyn owned the best Baum property. This was news to Goldwyn. "What is it?" he asked Freed.

"A fantasy."

That was all Goldwyn needed to hear. He put the property on the block. LeRoy and Freed urged Mayer to purchase it. Nicholas Schenck, head of Loew's Inc. (the parent company of M-G-M), told him not to. "Nick didn't like it," said Freed. "He said fantasy was dead." LeRoy and Freed persisted. Five other companies submitted bids. Goldwyn wanted $75,000. In February 1938, Mayer paid it.

The heroine of Baum's stories was a Midwest girl named Dorothy. Both Freed and LeRoy envisioned Garland in the role. "It took me a while," said LeRoy, "but I finally convinced L. B. to go along with me. I contacted Judy and signed her for the part." LeRoy assumed that he would produce *and* direct the Technicolor Oz film. He was brought up short when Mayer told him: "It's too big for you to do both. You can produce it.

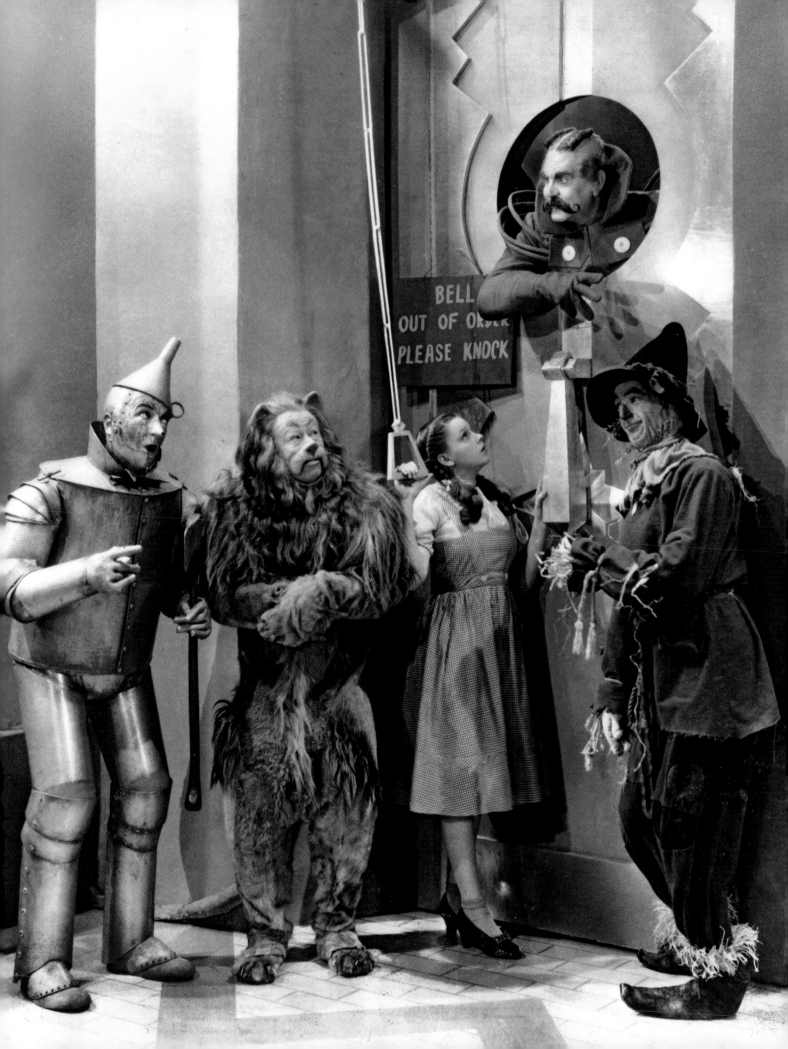

Above: Margaret Hamilton, Judy Garland, and Ray Bolger

That's all." Mayer made Freed LeRoy's associate producer, and, in March 1938, they assigned Irving Brecher, the first of many writers, to create *The Wizard of Oz*. Ultimately, a British playwright named Noel Langley structured the film, went away while Florence Ryerson and Edgar Allan Woolf scripted it, and then came back to give it a whimsical polish. The final draft bore the fingerprints of many distinguished writers; F. Scott Fitzgerald, Herman Mankiewicz, and Ogden Nash were among them. Still, it had to be approved by Freed, and finally by LeRoy, both of whom had grown up with the *Oz* books.

Seven months of preparation followed. *The Wizard of Oz* grew to be the largest,

the most elaborate, the most eccentrically detailed production in M-G-M's fourteen-year-history. By November 1938, when Victor Fleming came on as director, the film had gone through ten writers, three directors, two witches, two tin men, and countless costume changes. One component stayed constant: the composing team of E. Y. Harburg and Harold Arlen. Freed told them to try something new for this film. It should not stop for each musical number. The songs should be woven seamlessly into the action. "It was a chance to express ourselves in terms we'd never been offered before," recalled Harburg. "Not just songs but the acting out of entire scenes, with dialogue in verse, set to Harold's music. That was our idea."

LeRoy and Freed collaborated happily on the supervision of the immense project, agreeing that the film should "look like nothing in existence." This concept was carried out by every studio department, but especially by wardrobe and makeup. Gilbert Adrian was faced with the necessity of designing more than 3,200 costumes. Fortunately he was an *Oz* fan. As a child he had drawn his own versions of the *Oz* characters, so he used these as a starting point, eventually describing the project as the "greatest fun I have ever had in film work." Jack Dawn's makeup department had to find new ways to create faces for characters like the Scarecrow, the Tin Man, and the Cowardly Lion. "It was a monumental task," said Dawn's then assistant William Tuttle. "The entire field of makeup was encompassed in that one picture."

When Hedda Hopper visited the set in October 1938, she saw what the costume and makeup departments had accomplished. "I never expected to live long enough to see a zipper on a lion," wrote Hopper. "Imagine my surprise when I viewed Bert Lahr zipped inside one. He carries a real lion skin on his back and it weighs seventy-five pounds." The lion's face fit over Lahr's upper lip and nose and tied to his ears, and included a set of whiskers that wiggled for close-ups. Lahr could not eat solid food while wearing it. Ray Bolger's scarecrow costume was only slightly less punishing. "They gave Ray an India rubber face, glued on over his own," said Hopper. "He spent last weekend in seclusion, rubbing lemon verbena cream into his pores. He hadn't quite gotten the knack of pulling off his new face, and a considerable amount of his own came with it." As unpleasant as this was, other actors suffered more. Buddy Ebsen,

Left: Jack Haley, Judy Garland, and Ray Bolger

playing the Tin Man, suffered an allergic reaction to the aluminum powder in his makeup and ended up in a hospital, so ill that he had to be replaced by Jack Haley. Margaret Hamilton, who played the Wicked Witch of the West, was badly burned when a flame-and-smoke effect fired too early; she recovered in time to return to the film.

Fleming was not an obvious choice to direct a fantasy; his best-known films were *Red Dust* and *Test Pilot*, virile Clark Gable vehicles. Yet LeRoy had a sense that Fleming "would be great for that fantasy that we needed." Fleming had worked well with child actors in *Treasure Island* and *Captains Courageous*. "That man was a poet," recalled Freed. "I used to have bread and coffee with him every morning before we shot *The Wizard of Oz*, feeling out his mind." Fleming said that he was taking the assignment so that his young children could enjoy the story of a "search for beauty and decency." Garland responded to Fleming's direction; she remembered him as a "darling man." Hamilton remembered him as a director who "knew exactly what he wanted." His assistant director, Wallace Worsley, recalled that "LeRoy let Fleming do it his own way." There were snags and disagreements, to be sure. On a project of this magnitude, with deadlines looming and arc lights heating up performers in bulky costumes, there were bound to be tense moments. One day Worsley gently chided Billie Burke, who was playing Glinda the Good Witch, for arriving late. She drew back in shock. "You're . . . you're *browbeating* me!" she said, bursting into tears.

Two weeks before *The Wizard of Oz* was to end, David O. Selznick asked Fleming to direct *Gone With the Wind*. When Fleming left, King Vidor stepped

in to finish *Oz*, which meant a few scenes in Kansas. One sequence had Garland singing "Over the Rainbow." Vidor consciously used the camera dolly to enhance the number. "I was able to keep the movement flowing freely, very much in the style of a silent movie," said Vidor. Unlike the rest of the film, these scenes were shot with black-and-white film. After being processed at the M-G-M lab, the few black-and-white reels were subjected to the sepia toning process and joined to the reels that had been processed at the Technicolor plant.

There were a few retakes shot in June, and then the sneak previews began. Several scenes were cut: the Scarecrow's solo dance, the "Jitterbug" number, and "Over the Rainbow." This last scene was too much for Freed and LeRoy. They argued with Mayer's yes-men, who said it was incongruous to have a too-slow ballad sung in a barnyard. "The song stays," Freed told Mayer. "Or I go." The song stayed.

Hedda Hopper was given a special preview of the finished *Wizard of Oz*. "*The Wizard of Oz* has given us humans as interesting as Disney's cartoons," wrote Hopper. "These are real people, moving in a world of fantasy without taint of ridicule. And, oh, what a relief to be carried away into another world and not have to look at propaganda, prisons, triangles, or spies. It lifts you right out of this drab workaday world and makes you long for your lost childhood." The film opened in New York on August 27. "Nearly 10,000 people waited in line to see *The Wizard of Oz* yesterday at the Capitol," wrote the *Los Angeles Times* correspondent. "All that local scribes can do is analyze what is already a historic box-office phenomenon."

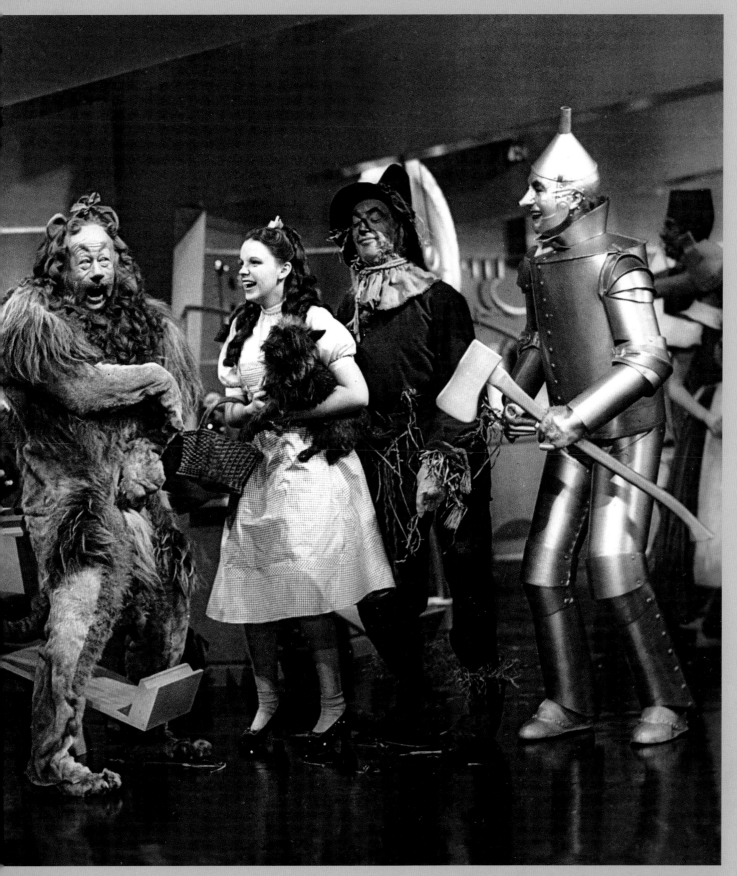

Above: Bert Lahr, Judy Garland, Ray Bolger, and Jack Haley

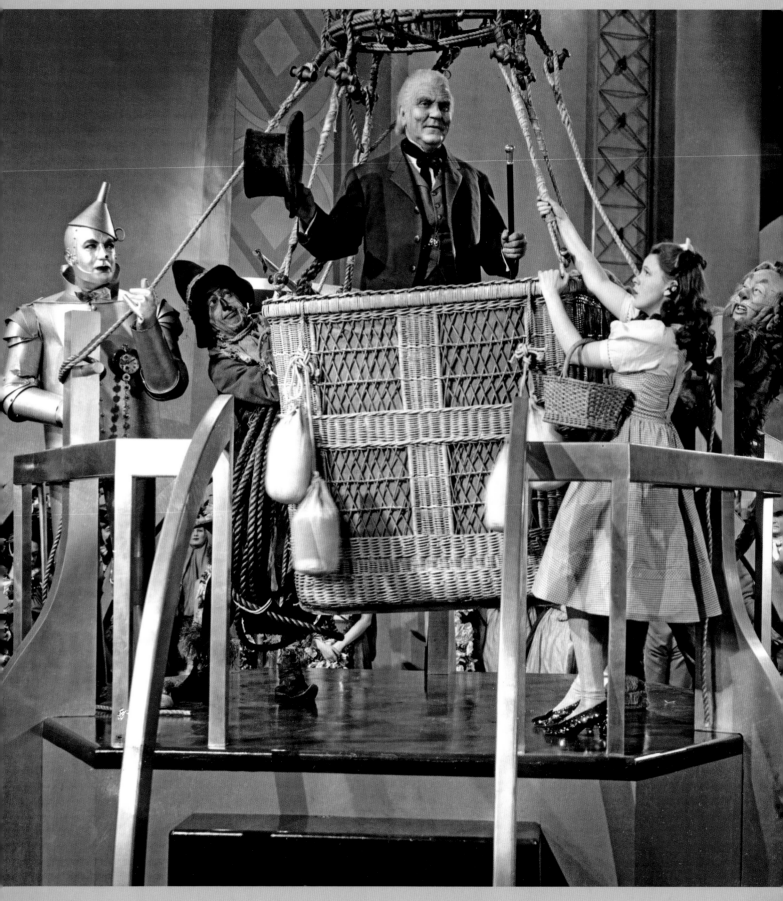

Above: Jack Haley, Ray Bolger, Frank Morgan, Judy Garland, and Bert Lahr

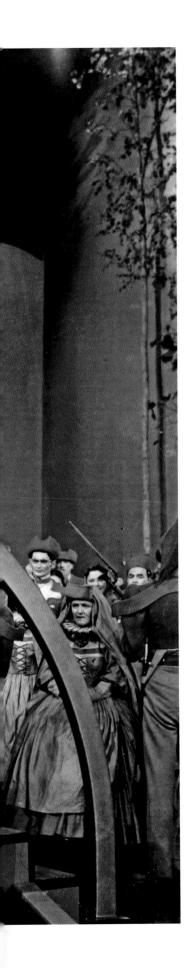

Critical Reaction

"By courtesy of the wizards of Hollywood, *The Wizard of Oz* reached the Capitol's screen yesterday as a delightful piece of wonder-working which had the youngsters' eyes shining and brought a quietly amused gleam to the wiser ones of the oldsters. Not since Disney's *Snow White* has anything quite so fantastic succeeded half so well. A fairybook tale has been told in the fairybook style, with witches, goblins, pixies, and other wondrous things drawn in the brightest colors and set cavorting to a merry little score." **—FRANK S. NUGENT, *THE NEW YORK TIMES***

"A new experience and a new thrill dawned in Hollywood last night for the motion picture devotee. Simultaneously it was established that *The Wizard of Oz*, which magically evoked such dual responses, will unquestionably appeal to a world-wide audience. The viewing of this picture with movietown first-nighters does naught but intensify admiration and enthusiasm for its attractions."

—EDWIN SCHALLERT, *LOS ANGELES TIMES*

One Family's Reaction in 1939

Arthur Millier was an art educator and *Los Angeles Times* art critic. He and his family were interviewed after viewing *The Wizard of Oz* during its first run.

Arthur Millier Sr. said: "Technicolor is fine, but the shots that really thrilled me were the sepia ones on the Kansas farm."

Mojave Millier, age thirteen, said: "I liked the Munchkins best. The movie was all so oddly real that I felt I was living the story with Dorothy. It gives you such a nice feeling to hate somebody that I just know you'll enjoy hating the Wicked Witch."

David Millier, age nine, said: "I liked the part when the cyclone came and Dorothy was in the house in midair and around her she saw people in boats and riding on bicycles. I wondered how they did that. The Cowardly Lion was sure good. When he went up to say his name to the Wizard, he fell down and bawled his head off. I laughed so loud that my mother pinched me to make me pipe down."

Mrs. Arthur Millier said: "Judy Garland retains that something that little girls lose when permanents, social standards, and voice culture get a toe-hold on their consciousness. I was living it all over again when I was startled to hear children whispering: 'How d'ya suppose they got that effect?' and 'She sure is no Hedy Lamarr!' And, when the soldiers chased Dorothy and her party, a youth said, 'Boy, would a machine gun fix *that* bunch!'"

THE ADVENTURES OF SHERLOCK HOLMES

RELEASED SEPTEMBER 1, 1939

"The nose of the police dog, although long and efficient, points in only one direction at a time."

THE STORY

A master detective must stop a master criminal before he wipes out an entire family and steals the most precious artifacts in England.

Opposite: Basil Rathbone and Ida Lupino in a scene from Alfred L. Werker's *The Adventures of Sherlock Holmes*

PRODUCTION HIGHLIGHTS

In early 1939 Darryl F. Zanuck had taken a chance and cast the well-known supporting player, Basil Rathbone, as Sherlock Holmes in Sidney Lanfield's *The Hound of the Baskervilles*. "A dextrous performance may be credited to Basil Rathbone," said an uncredited review in the Los Angeles Times, "but whether he can be full-fledgedly regarded as Holmes is doubtful. He has more volatile qualities than are usually associated with the meditative detective." The review ran on March 23. By April 3, screenwriter Edwin Blum had drafted the continuity for a second Sherlock Holmes feature. Darryl F. Zanuck had liked Rathbone in the part and believed he could carry a feature. Zanuck felt, however, that Blum was missing the essence of the Holmes personality.

"Holmes was written and played just right in *The Hound*," Zanuck advised Blum. "He was the superman of literary history. In your piece, Holmes is surprised too much. He is not so much the cunning and deliberate master as a quick opportunist. When he confronts his brilliant antagonist, Dr. Moriarty, we want to see Holmes clever—sardonic—witty. 'Doctor, I admire your brain. In fact, I admire it so much that I would love nothing better than to present it, pickled in alcohol, to the London Medical Society.'"

The Adventures of Sherlock Holmes was as well written, well mounted, and well played as Zanuck intended. The undervalued Ida Lupino played a damsel in distress, but a smart, plucky damsel, and her career improved accordingly. Rathbone, after years as a supporting

player, received star billing. The film was the first to contain the catchphrase, "Elementary, my dear Watson."

Although *The Adventures of Sherlock Holmes* was given the release treatment of a B picture, it was nonetheless a hit. Before long, Rathbone was being kidded by fans. "I have experienced nothing but embarrassment in the familiar street-corner greeting of recognition, which is inevitably followed by horrendous imitations of my speech, loud laughter, and ridiculing quotes of famous lines such as 'Quick, Watson, the needle' or 'Elementary, my dear Watson.'" Rathbone had to live with it, as a subsequent series at Universal Pictures made him the definitive Holmes. "Had I made but one Holmes picture," he wrote in 1962, "I should probably not be as well known as I am today. But the continuous repetition of story after story after story left me virtually repeating myself," said Rathbone. "My first picture was, as it were, a negative from which I merely continued to produce endless positives of the same photograph."

For Holmes purists, 1939 was the gold standard. For the British members of the cast, it was a trying time. Two days after the release of *The Adventures of Sherlock Holmes*, on September 3, Great Britain and France declared war on Germany, which had just invaded Poland. America remained neutral, but Hollywood's British colony, of which Rathbone, Bruce, and Lupino were members, waited anxiously for news from their families.

Right: A portrait of Basil Rathbone, Ida Lupino, and Nigel Bruce for Alfred Werker's *The Adventures of Sherlock Holmes*

Critical Reaction

"While the London of gaslight and hansom cabs may be regarded with a jaundiced eye by jitterbugs and machine-gun devotees, the picture succeeds admirably in recreating its milieu. You may catch yourself nodding at Twentieth Century-Fox's leisurely tempo in the more extended dialogue passages, but your pulse will eventually quicken—as it always has—to the exploits of Holmes and the phlegmatic Dr. Watson."
—PHILIP K. SCHEUER, *LOS ANGELES TIMES*

MAJESTIC HOLLYWOOD

120

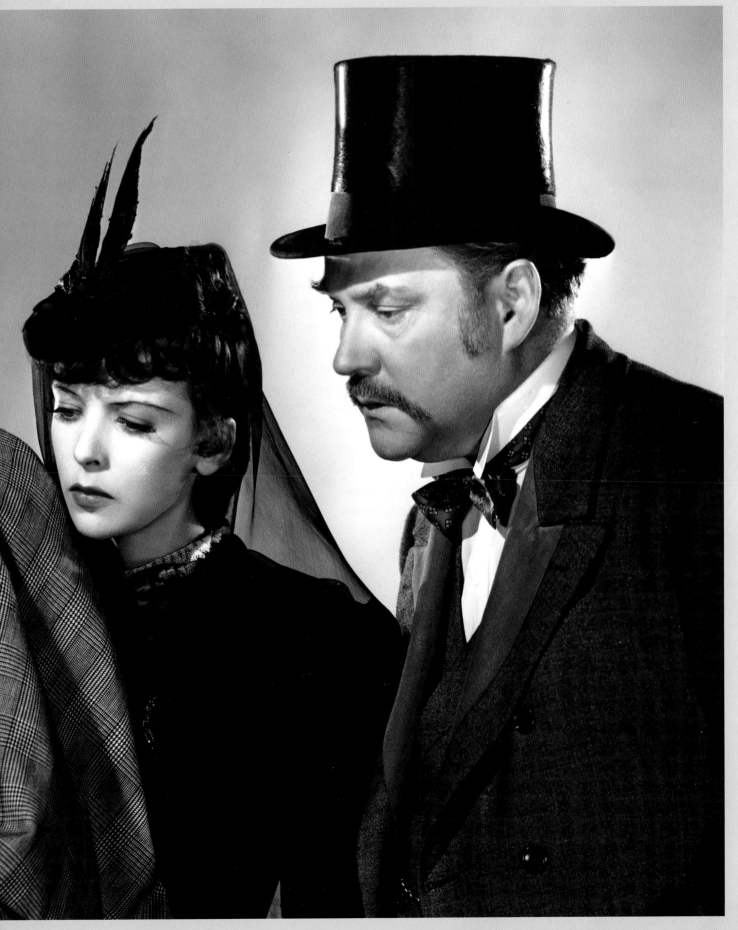

THE WOMEN

RELEASED SEPTEMBER 1, 1939

"I've had three years to grow claws, Mother! Jungle red!"

THE STORY

A trusting Park Avenue socialite loses her husband to a scheming shop girl but can only win him back if she becomes as cunning as her so-called friends.

PRODUCTION HIGHLIGHTS

In 1936 Clare Boothe Luce's *The Women* was a smash hit on Broadway. There had been plays about the idle rich but never one that focused on women and never one that was so unflattering. Using comedy, the play portrayed Park Avenue matrons as vain, capricious, and mean. Ilka Chase had given a sharp-edged, hilarious performance as Sylvia Fowler, the catty cousin of the "happily" married heroine, Mary Haines. It was assumed that Norma Shearer would play Mary. In the spring of 1939 she was M-G-M's most important star, coming off the success of *Idiot's Delight*, so she could not appear too eager to play in *The Women*. "You know," she told Hedda Hopper. "I hesi·tated a long time before playing this part. Then I decided that fighting to hold

a husband is every woman's problem." Who would play Sylvia? Rosalind Russell had been doing second leads at M-G-M for five years, and not too happily. She got herself dolled up at an Elizabeth Arden salon and charged into the office of producer Hunt Stromberg. "Hunt, tell me," said Russell. "Why haven't you tested me for the part of Sylvia?"

"We considered you," said Stromberg, "but you're too beautiful. What we want is somebody to look funny, to get a laugh every time she pokes her head around a door." Russell was firm. She persevered. Stromberg set up a screen test for her with director George Cukor. "I don't want you," Cukor told Russell. "I don't see you in this part." But when he directed the test, and Russell became

Left: Phyllis Povah, Paulette Goddard, Joan Crawford, Rosalind Russell, Norma Shearer, Mary Boland, and Florence Nash

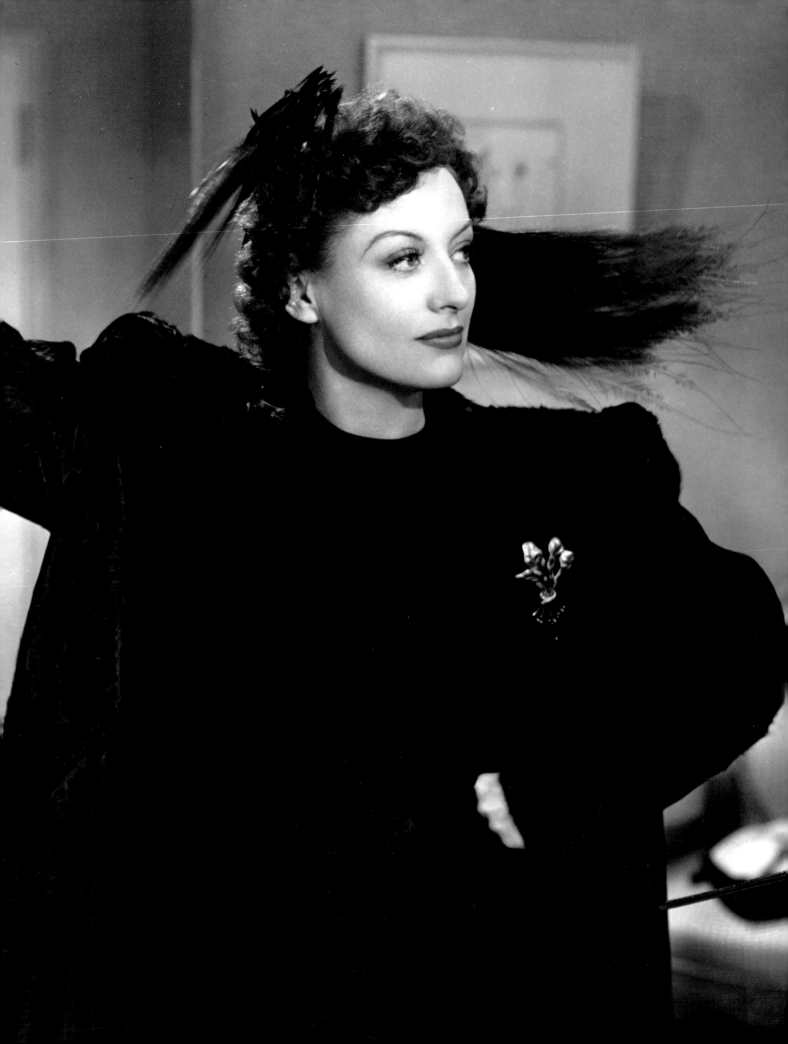

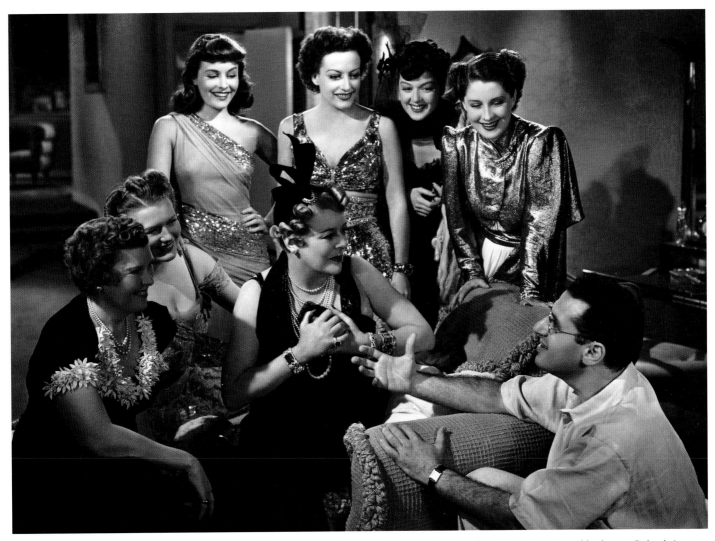

Opposite: Joan Crawford in a scene from *The Women* *Above:* George Cukor directs Florence Nash, Phyllis Povah, Paulette Goddard, Mary Boland, Joan Crawford, Rosalind Russell, and Norma Shearer on the set of *The Women*

more and more wacky, Cukor loosened up. The next day, Russell got a call from M-G-M. "I could hear them laughing in the screening room," recalled Russell. They were giving her the part.

Who would play Crystal Allen, the mercenary shopgirl who snares Mary's husband? "When I saw the stage pro·duc·tion," said Joan Crawford, "I knew immediately that the one role I wanted to play was that of Crystal, this in spite of the fact that, as a character, she had few, if any, redeeming features. In her I saw a chance of doing something different. Always being a heroine becomes pretty dull."

The "box-office poison" label had stuck to Crawford for most of 1938, and she was no longer a contender. "At this critical moment," said Crawford, "I set my sights on Crystal." Crawford would have to convince not only Cukor but also Louis B. Mayer, the big boss. Mayer was sympathetic to a point. "You know I regard you as my youngest daughter," said Mayer. "I want the right thing for you. But I don't know that you should play a heavy, Joan. It might hurt your career. You're the American girl. The public thinks of you as Cinderella."

Stromberg said the part was too small for a star, and besides, there was no danc-

ing in it. "You!" said Cukor, when Crawford entered his office. He remembered the time he had come to the set of *No More Ladies* to fill in for an ailing director and fought with Crawford for hours over a line reading. "I wanted this role more than anything in my life," recalled Crawford. She kept after the three executives. "It's going to be a good picture. I need a good picture. If I can't get one of my own, let me sneak into someone else's." That "someone else" was Shearer, who had made headlines six months earlier by turning down the role of Scarlett O'Hara in *Gone With the Wind*. That may have been a publicity ploy to benefit both

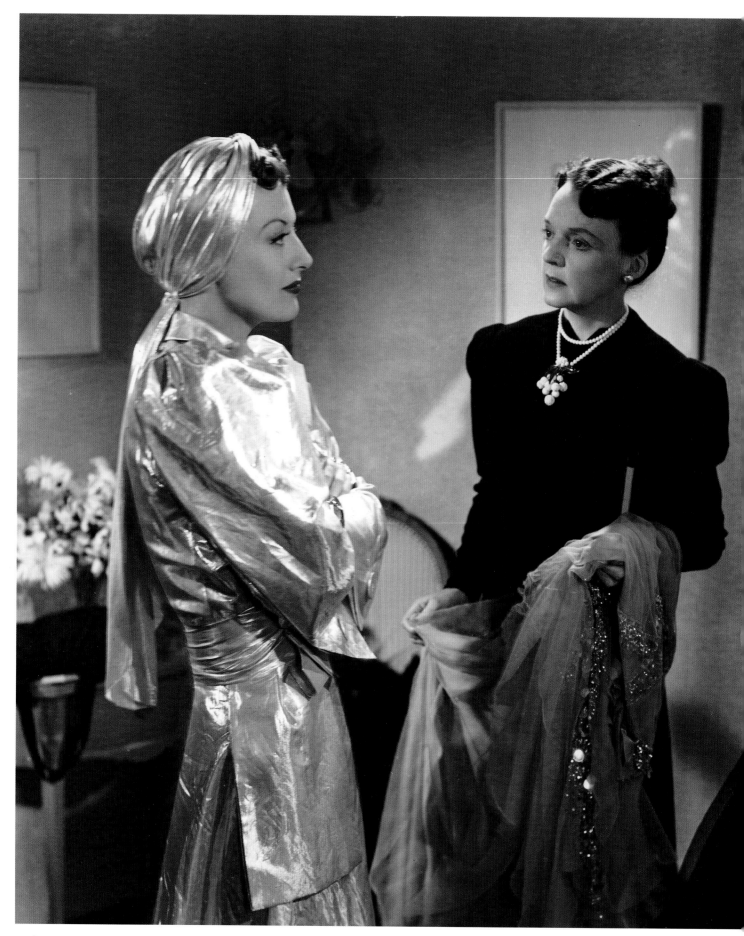

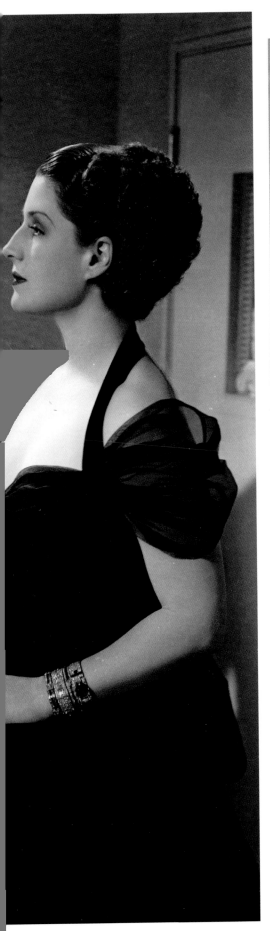

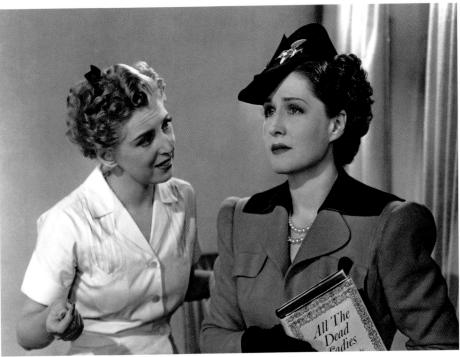

Left: Joan Crawford, Frederika Brown, and Norma Shearer *Above:* Dennie Moore and Norma Shearer

her and David Selznick. Crawford kept calling Cukor. "I must have convinced him," she said, "because suddenly the part was mine."

The Women went before the cameras on April 25, 1939. Its all-female cast of 135 (including dogs and monkeys) was unprecedented. The most newsworthy occurrences, however, were kept out of print. As might be expected with a project of this importance and a cast of Hollywood veterans whose shared history reached back to the founding of M-G-M, there were conflicts, and they occurred at the highest echelon. Rosalind Russell was giving her all, creating a star performance, when it dawned on her that she was regarded solely as a supporting player. "Norma had it in her contract," said Russell. "No woman's name could be up there with hers. She'd capitulated and said Joan Crawford might also be starred above the title, but when it came to me, that was another story." Russell resolved to do something about it. She waited until

the film had passed the point of no return and then called in sick. After four days, the studio got the message. On June 15 an item appeared in the Los Angeles Times: "Norma Shearer is chucking a clause in her contract which guarantees that her name will be featured above that of any other woman in her pictures, and stipulating that both Joan Crawford and Rosalind Russell shall be given equal billing with her in The Women."

The item also mentioned that Shearer was tired of the title "First Lady of Hollywood." She may have been tired of the title, but she was still defending the position. One of her costars, on seeing the rushes, said: "While I'm sitting beside Norma, my face looks as though it had been shot in a dark closet." Shearer only had two scenes with Crawford, and Crawford determined to make the most of them. For years the press had played up rumors of a feud between them, saying that Crawford was jealous of the pref- erential treatment Shearer had gotten

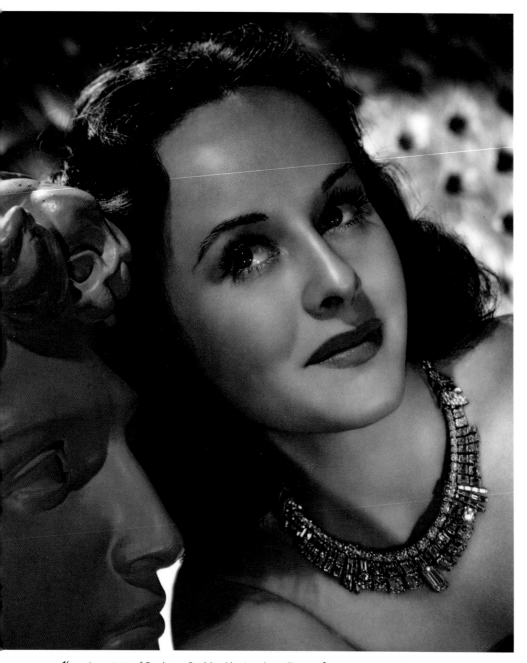

was, according to her custom, knitting. The needles were clicking. "Joan, darling," said Shearer, "I find your knitting distracting." She received no response from Crawford. The knitting persisted. Shearer tried to say her lines. Finally she turned to Cukor. "Mr. Cukor," said Shearer, "Miss Crawford can go home now and you can give me her lines." Cukor jumped up and headed for Crawford. He took her by the arm and walked her off the set. "How dare you behave so rudely?"

"I'm just paying her back for all the rudeness she and Irving gave me!" said Crawford.

"I will not allow such unprofessional behavior on my set," said Cukor. "You are dismissed for the day. And when you come back tomorrow, I want you to apologize to Norma." When Cukor got back to the set, crew members were gathered around Shearer, congratulating her. Crawford did not wait. She sent a telegram. It was not an apology. It was a catalog of what she felt she had endured from the Thalbergs. When Crawford returned to the set of *The Women*, Shearer did not acknowledge her. Sad to say, they did not share the triumph that *The Women* became. At the completion of filming, Shearer threw a party. Crawford did not attend. When Crawford attended the Los Angeles premiere of *The Women*, Shearer did not attend. All of Hollywood was talking about their squabble. Even Bette Davis went on record about it. On the set of *The Private Lives of Elizabeth and Essex*, she filmed a scene in which she threw a screaming fit. Upon completing it, she said: "I've got to show *The Women* that Queen Liz was one of them!" *The Women* did not need the extra publicity. It was one of the year's top-grossing films. And by the time it was being referred to as a classic, Shearer and Crawford had mended fences, and another Hollywood legend was put to rest.

Above: A portrait of Paulette Goddard by Laszlo Willinger *Opposite:* A Laszlo Willinger portrait of Joan Crawford, Norma Shearer, and Rosalind Russell for *The Women*

at M-G-M from Irving Thalberg, who was not only head of production but also her husband. In March 1939 *Look* magazine devoted a cover to the feud. "They don't like each other!" said the tagline over profile-to-profile pictures of the actresses. The feud was a matter of opinion; the jealousy was fact. Crawford's first appearance in an M-G-M film (in December 1924) was as Shearer's double. Crawford's feeling of being second-best simmered for fifteen

years and then, on the set of *The Women*, it came to a boil.

The scene, appropriately enough, was the confrontation between Mary and Crystal. Shearer and Crawford had completed the master shot successfully, and Cukor was shooting close-ups of Shearer. Crawford was off camera, feeding Shearer lines for her reaction shots. As Shearer spoke her lines, she heard a clicking sound. What was it? Crawford

Critical Reaction

"The tonic effect of *The Women* is so marvelous we believe every studio in Hollywood should make at least one thoroughly nasty picture a year. The saccharine is too much with us. Happily, Miss Boothe has dipped her pen in venom and Metro, without alkalizing it too much, has fed it to a company of actresses who normally are so sweet that butter (as the man says) would not melt in their mouths. The most heartening part of it all is the way Norma Shearer, Joan Crawford, Rosalind Rus-

sell, Paulette Goddard, and the others have leaped at the chance to be vixens. Miss Shearer, as the Mary Haines whose divorce and matrimonial comeback keep the cat fight going, is virtually the only member of the all-feminine cast who behaves as a leading lady is supposed to. And even Miss Shearer sharpens her talons and joins the birds of prey. It is, parenthetically, one of the best performances she has given."

—FRANK S. NUGENT,
THE NEW YORK TIMES

"*The Women* is a vitriolic masterpiece, its fumigation by the Hays office notwithstanding. The players, nearly all of them associated with sympathetic roles, attack their parts as though they had been waiting all their lives for this chance to be vicious, depraved, and spiteful. The Capitol Theater isn't big enough to hold all the people who want to see this exposé of feminine character. *The Women* will probably run forever."

—*LOS ANGELES TIMES*
(NEW YORK CORRESPONDENT)

THE OLD MAID

RELEASED SEPTEMBER 2, 1939

"Tonight she belongs to me. Tonight I want her to call me mother."

THE STORY

A woman spares her daughter the stigma of illegitimacy by letting her cousin pretend to be her mother, but jealousy and resentment threaten the well-kept secret.

PRODUCTION HIGHLIGHTS

Bette Davis had fewer scenes than usual in *Juarez*, and her next project was also a break from the norm. She would be costarred with an actress; and not just any actress. She would have to share the screen for the running time of an entire feature with the most difficult actress in Hollywood. Miriam Hopkins had burned bridges first at Paramount and then at Goldwyn, driving her coworkers and bosses to distraction with endless complaints, demands, and displays of temperament. She was not camera-proof. She was not young. She was not popular. She did have one thing going for her: she gave the most powerful, watchable performances of any leading lady in films. The only actress who had surpassed her weird intensity was the superb, tormented Jeanne Eagels. Why Jack Warner signed Hopkins in 1939 was anyone's guess. Her husband was the director Anatole Litvak, so there may have been some politicking. In the spring of 1939, what mattered was that Warner had bought the rights to a Pulitzer Prize-winning play from Paramount, Zoe Akins's *The Old Maid*, and no one could realize the characters but Bette Davis and Miriam Hopkins. Davis tried to be objective about Hopkins. "She'll be trouble," Davis predicted. "But she'll be worth it."

Davis got Edmund Goulding to direct *The Old Maid*. She respected his clever, sensitive work and knew that he had handled difficult performers before—Nancy Carroll, Wallace Beery, and Constance Bennett. He would be able to manage Hopkins. The film was written by Casey Robinson, who suggested that the play's theme of a sad old woman should be changed to something more vital: "A hatred-jealousy theme should be seized upon, enlarged and built into the basic treatment of the story." As it worked out, life imitated art. Hopkins came to the set on the first day of shooting in an exact duplicate of a gown Davis had worn in *Jezebel*. There was a message. Hopkins had starred in the play *Jezebel* on Broadway. It had flopped. Davis had starred in it at Warners. She had gotten an Academy Award. Davis had also been friendly with Hopkins's husband, Litvak. Hopkins was firing a warning shot at Davis, whom she described as a "greedy little girl who

Left: A George Hurrell portrait of Bette Davis, George Brent, and Miriam Hopkins for *The Old Maid Opposite:* Bette Davis and Miriam Hopkins

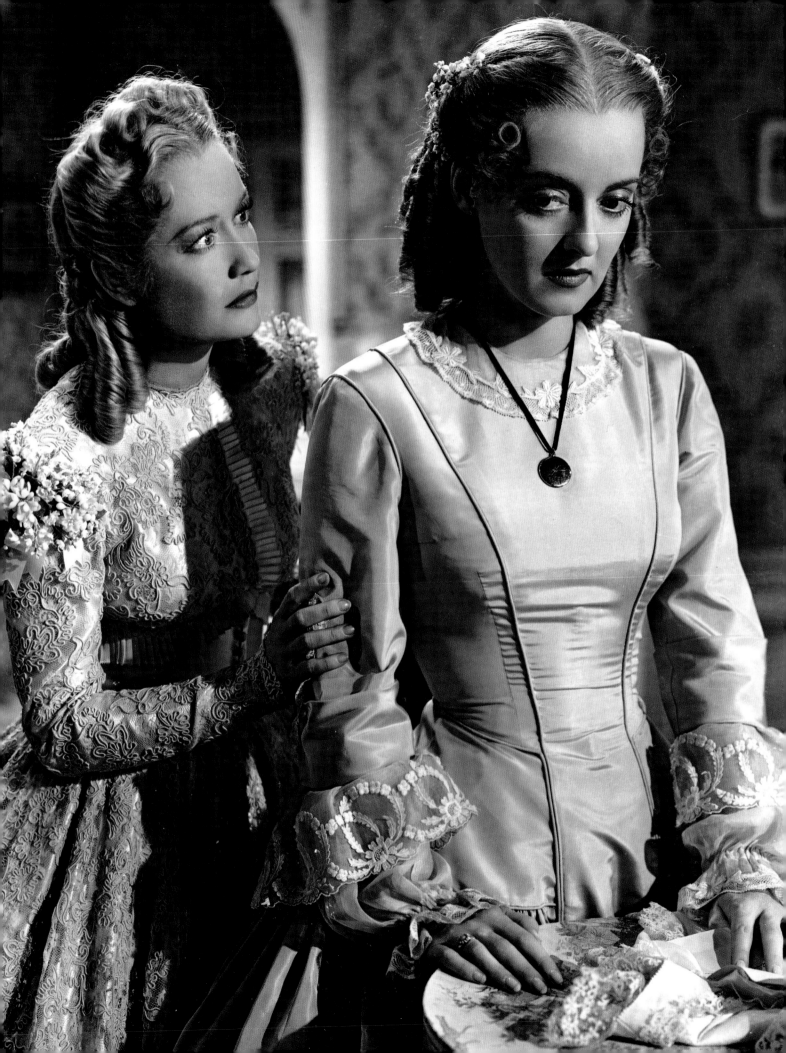

Opposite: Miriam Hopkins and Bette Davis *Above:* Miriam Hopkins, Edmund Goulding, and Bette Davis on the set of *The Old Maid*

Critical Reaction

"As the old maid, Miss Davis has given a poignant and wise performance, hard and austere of surface, yet communicating through it the deep tenderness, the hidden anguish of the heart-broken mother. Miss Hopkins's Delia is a less certain characterization, gentler than Miss Akins had contrived her, suggesting but seldom the malignance lurking beneath a charming manner."

—**FRANK S. NUGENT,**
THE NEW YORK TIMES

"The most striking thing to be remarked is, naturally, the almost ideal balance maintained by the two feminine stars. Each treads different terrain in this picture. I believe that Miss Hopkins may be said to surpass almost anything she has played since the days of *Dr. Jekyll and Mr. Hyde.*"

—**EDWIN SCHALLERT,**
LOS ANGELES TIMES

"People usually do best the things they enjoy most. Bette Davis, who vastly enjoys cinematic miseries and would scorn to appear as a happy ingénue, does a brilliant job in the title role of *The Old Maid.* That Miss Davis and Miss Hopkins dislike each other intensely not only added to their pleasure in making the picture but also proved so mutually stimulating that Warners' production chief Hal Wallis plans to team them again." —*LIFE*

just has to sample other women's cupcakes." Davis was gracious to Hopkins but made sure that the scene with the copied gown did not go into the finished film. The hatred-jealousy theme was being seized upon. "Whatever respect Bette and Miriam had for each other as professionals was quickly thrown out of the window when one or the other didn't get her way," recalled Goulding. "If it wasn't costuming, it was lines or lighting or camera angles."

Davis had never seen anyone as relentless as Hopkins. "Miriam knew and—I must give her credit—used every trick in the book," said Davis. "Once in a two-shot favoring both of us, she kept inching her way toward the back of the couch we were sitting on so that I would have to turn away from the camera in order to look at her. She almost col-

lapsed the couch." As the filming continued, Goulding was refereeing more than he was directing. Executive producer Hal Wallis began to wonder why the filming was going so slowly. "All Goulding got the whole day was the scene with Davis coming to say goodnight to the girl," he wrote to supervisor Henry Blanke. "What does he do the rest of the day?" Blanke got unit manager Al Alleborn to testify. "Working with these two ladies is a slow drag," Alleborn reported. "Every scene has to be rehearsed well and certain things ironed out. Goulding has a tough job with these two. Each one is fighting for a scene when she goes into it." Years later, Goulding said, "There were times when they behaved like perfect little bitches, but I loved them both and I think the admiration was mutual."

GOLDEN BOY

RELEASED SEPTEMBER 5, 1939

"Bury me in good times and silk shirts."

THE STORY

An aspiring violinist finds unexpected success as a prizefighter but risks damage to his hands—and an affair with his manager's girlfriend.

Opposite: A portrait of Adolphe Menjou and William Holden made for *Golden Boy*

PRODUCTION HIGHLIGHTS

The great films of 1939 boosted the careers of players like Rita Hayworth and Lucille Ball; yet few films put an unknown and untried player in the top spot. *Golden Boy* was Clifford Odets's play about a conflicted young musician. Luther Adler had done well in the part but was not the handsome face that Columbia Pictures needed, so producer William Perlberg and director Rouben Mamoulian took a cue from David Selznick's well-known talent search for the widely anticipated *Gone With the Wind*. Thousands of tests were made. Ironically, the role was cast from a test that had been made for another purpose and screened in error. The actor was a twenty-year-old Paramount contractee named William Holden. His experience consisted of a couple of walk-ons, but Mamoulian believed he could handle the lead. "Up to a certain point, an actor must fit a part," said Mamoulian. "Beyond that point, the part must be made to fit him. We made changes in *Golden Boy* to fit Bill Holden."

There were changes made in Holden, too—eleven weeks of boxing lessons, violin lessons, and dramatic coaching. By the time he started filming, he was exhausted. He had problems with both energy and concentration. "It was a dreadful period," said Holden, who expected to be replaced at any moment. "I was going nuts from the intense strain, and it was evident from the daily rushes." Just when it looked like Holden would be sacked, the star of the film went to Columbia boss Harry Cohn. "Look," said Barbara Stanwyck, "he's everything you want. But you haven't given him a chance. Leave him alone and I'll work with him." Stanwyck coached Holden, restored his confidence, and enabled him to take direction from Mamoulian.

"Holden was bewildered, nervous, and awkward," said Mamoulian. "I took advantage of his tiredness, his irritability, and his exhaustion from long hours of work to shoot the tense scenes." A characterization began to emerge. "Mr. Mamoulian was very patient," said Holden. "Whenever I couldn't get the feel of a character, he would take me aside and interpret it, as near as he could come, in terms of something that had happened to me." *Golden Boy* was a moderate success, but William Holden was talked up around town and was suddenly in demand. He went to Warners for *Invisible Stripes* and then to United Artists for *Our Town*. He was on his way. In years to come, he would always send Stanwyck flowers on April 1, the anniversary of *Golden Boy*'s first shooting day.

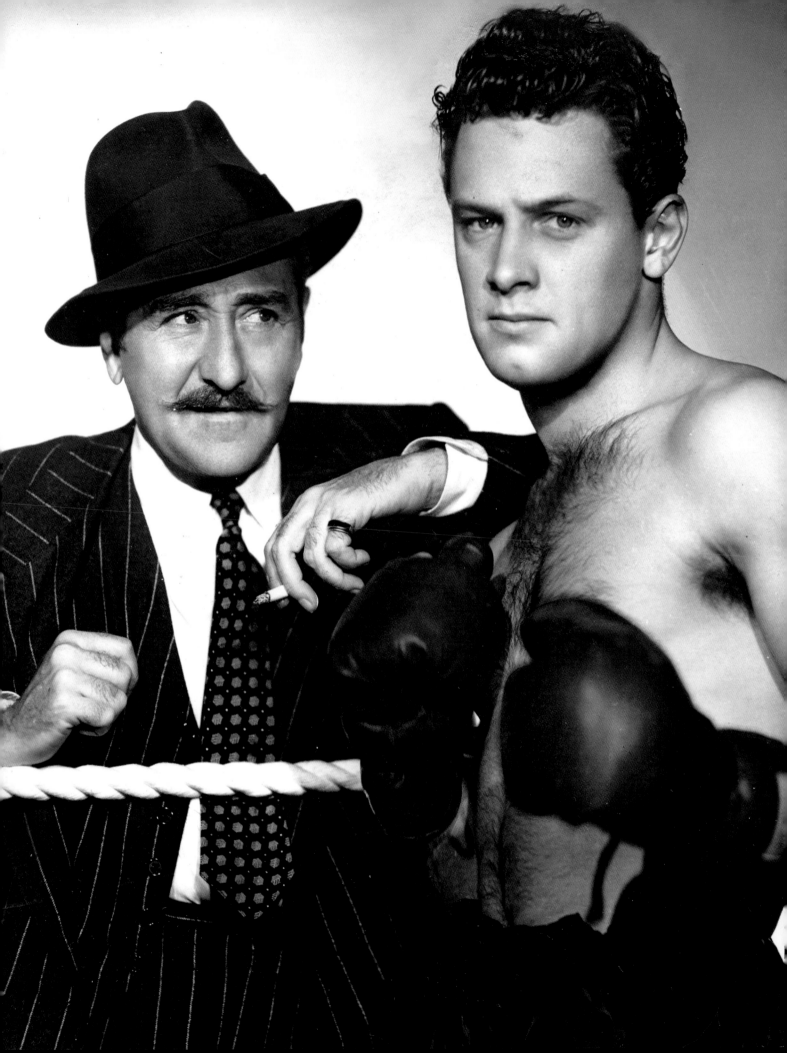

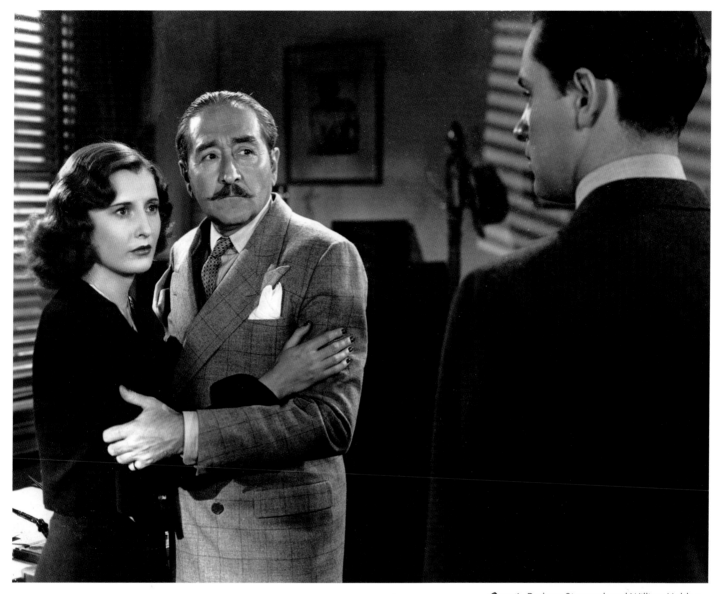

Opposite: Barbara Stanwyck and William Holden on the set of *Golden Boy* *Above:* Barbara Stanwyck, Adolphe Menjou, and William Holden

Critical Reaction

"We intend Mr. Odets no discredit when we offer the opinion that the picture is at its best when it cuts loose from his play. Rouben Mamoulian uses his camera as a scalpel to dissect a Madison Square Garden fight crowd: the mugs, the gamblers, the fashionable set, the race groups, the sadists, the broken-down stumble-bums rolling their heads with the punches. Mr. Odets was writing about a fighter, but he couldn't have written, in a dozen plays, the things that the camera has told in this single scene."
—FRANK S. NUGENT, *THE NEW YORK TIMES*

"Mamoulian has taken a play that ranged from the sketchiest 10-20-30 writing to the stabbing beauty of poetry on the wing, and has filled in the hollows between so that the film emerges a full-fledged work—and a tremendously gutsy one. William Holden before your eyes gets a grip on himself as this, his first picture, unfolds."
—PHILIP K. SCHEUER, *LOS ANGELES TIMES*

137

THE RAINS CAME

RELEASED SEPTEMBER 15, 1939

"I suppose this is the way it feels to repent and get religion. Giving away my worldly goods. Anyway, it's a nice feeling."

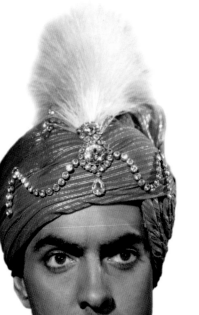

THE STORY

A cynical British noblewoman seeks a romance with an idealistic East Indian doctor, but her plans are interrupted by a catastrophic earthquake and flood.

Left: A portrait of Tyrone Power made for *The Rains Came* *Opposite:* A scene from *The Rains Came*

PRODUCTION HIGHLIGHTS

The big films of 1939 could boast of sequences that were more spectacular than those of previous years, but for depictions of disasters, *San Francisco* (1936), *The Good Earth* (1937), and *The Hurricane* (1937) had not been surpassed. That was about to change. Darryl Zanuck had bought Louis Bromfield's *The Rains Came*, a novel of colonial life redefined by an act of God. As one reviewer pointed out, Zanuck changed the "biography-romance-social treatise" into a conventional love story, with emphasis on the disaster.

In fairness to Zanuck, it is obvious that he put a great deal into this project. He borrowed George Brent from Warner Bros., Myrna Loy from M-G-M, and, when he could not find the right ingénue anywhere, he recruited a college girl named Brenda Joyce. He borrowed director Clarence Brown from M-G-M. And after filming commenced, he replaced cinematographer Bert Glennon, who had shot *The Hurricane* and *Stagecoach*, with Arthur Miller. "Glennon had been shooting the Maharani's dinner-party," recalled Miller. "It was shadowy and soft. Brown, who had been an engineer and was a smart

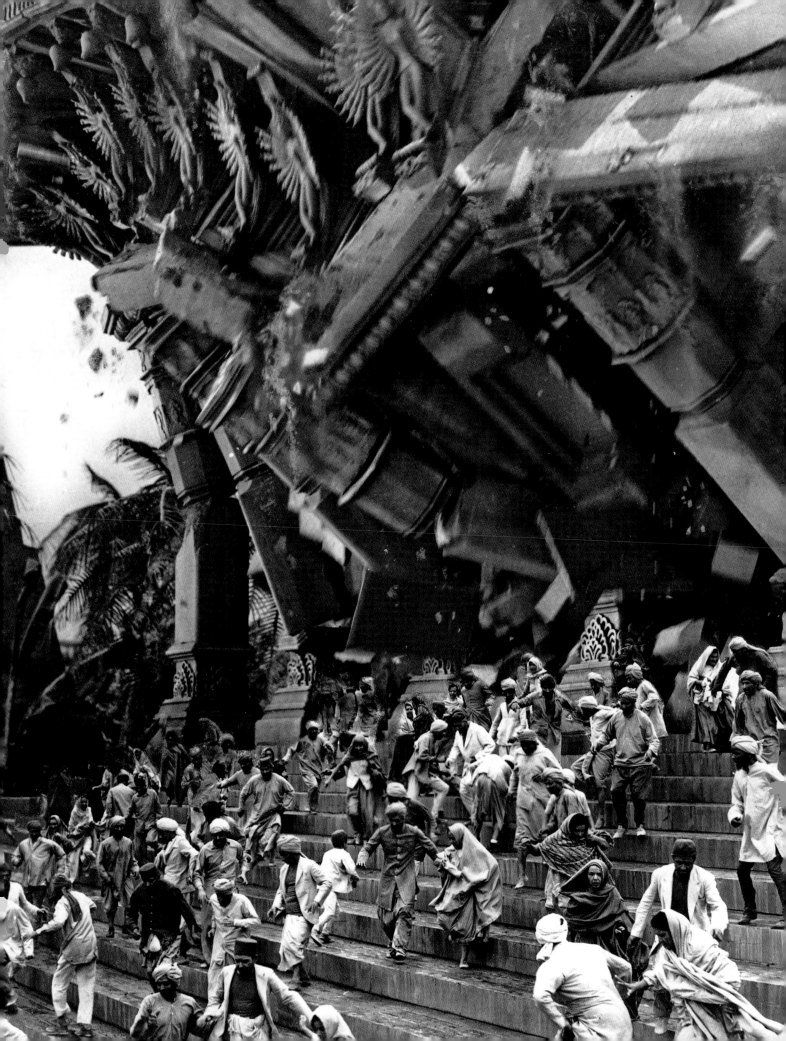

Above: George Brent in a scene from *The Rains Came*

cookie, wanted the whole thing to shine. I sprayed all the tables with oil and got the 'brilliant' look that Brown was after."

Fred Sersen, who had re-created the Chicago Fire for Henry King's *In Old Chicago* a year earlier, was planning the cataclysm for *The Rains Came*. "The real stars of this picture were the guys in the Twentieth Century-Fox special effects department," said Brown. After being at Metro for thirteen years, Brown was

used to a feudal system. At Twentieth every department wanted to work with him. "They weren't fighting you or trying to outdo the other departments," he said. "They worked together."

One of the few Zanuck stars cast in the film was Tyrone Power, playing a high-caste Indian doctor. "Ty Power was one of the nicest human beings I've ever known," said Loy. "A really divine man, perceptive and thoughtful. That happened to be a

bad time for me; he sensed it and made it his business to cheer me up." Loy's bad time was with Zanuck. "A quarter of the way through *The Rains Came*," said Loy, "he called me up to his office and started in on me. Questioning my interpretation, but never being specific, he offered no constructive alternatives. That's a terrible thing to do to an actress."

"Zanuck loved to play games," said screenwriter Philip Dunne. "He could be

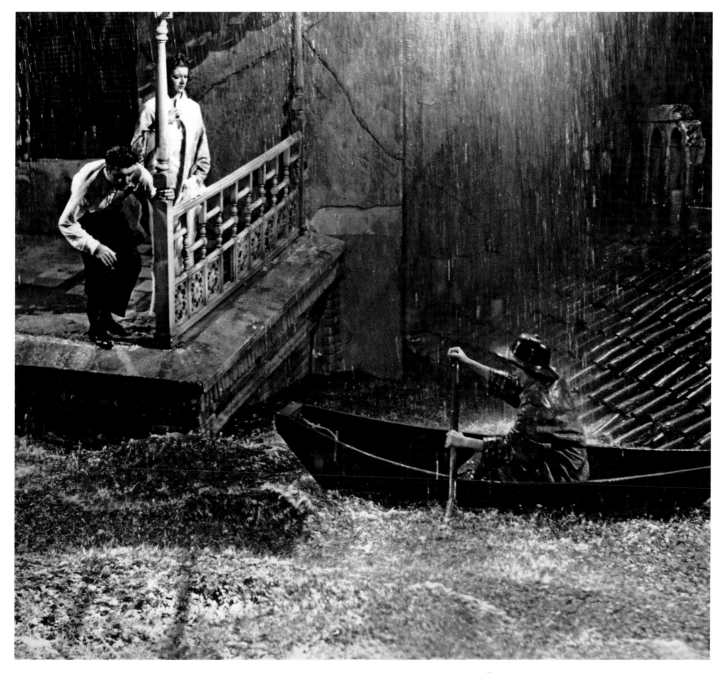

Above: Myrna Loy, George Brent, and Brenda Joyce

cruel." Loy checked with Brown. "Forget it," said Brown. "Don't let Darryl upset you." Then she checked with Bromfield. "I think you're giving the best performance of your career," he told her. "So I stuck to my guns," said Loy. "Despite Darryl's machinations, it was a happy film."

The Rains Came was also an expensive film. Mayer charged Zanuck hefty sums to borrow Loy and Brown. In addition, the special effects, even before the earthquake

and flood, were costly. "Rain always falls at an angle," said Miller. "I made the prop department adjust the spouts accordingly. I even shot the raindrops so they seemed much larger." The scenes of the earthquake and flood were almost biblical in scope, inundating huge areas of the backlot. "Oh my God," said Miller. "You never saw such water in your life! Brent and the others took a hell of a beating in that water." The special effects budget swelled to half a

million, bringing the total cost of the film to $1.8 million. In spite of unfriendly reviews, *The Rains Came* was well received and well attended, but, like *Marie Antoinette* a year earlier, it had cost too much. Moreover, war had been declared on September 3, and there were fewer theaters in Europe. Not until it was reissued years later would *The Rains Came* show a profit.

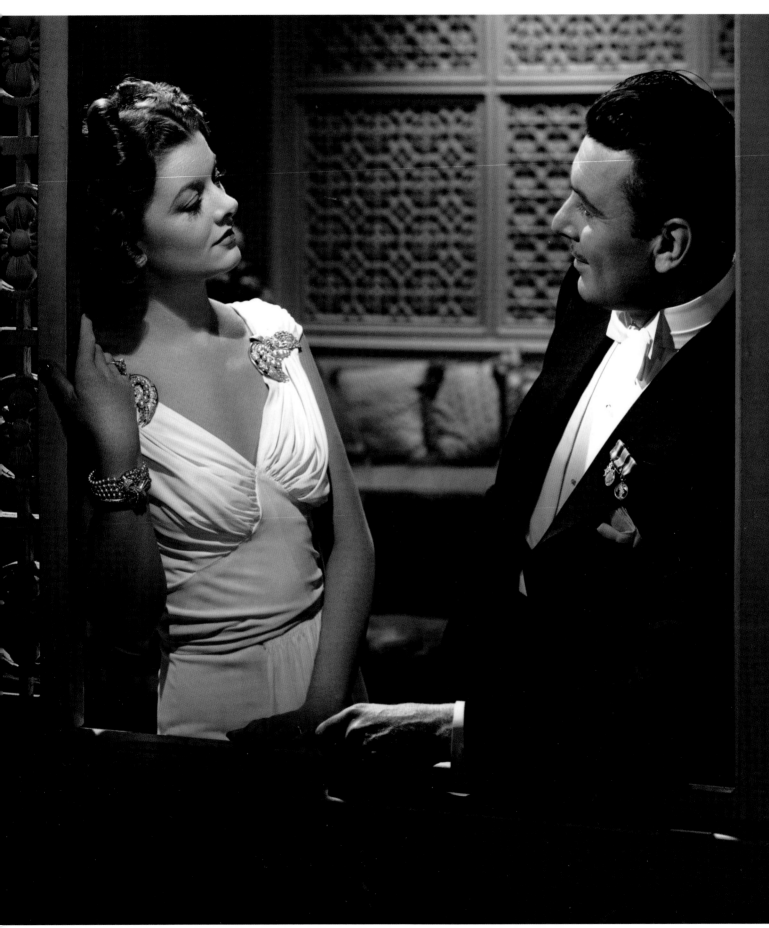

Opposite: Myrna Loy and George Brent *Above:* Tyrone Power and Myrna Loy

Critical Reaction

"Myrna Loy, heretofore the 'perfect wife,' is chosen to enact the promiscuous
Lady Esketh, and beautifully renders the episode where she chooses to become
something more than a mere transitory butterfly and take a genuine part in the
rehabilitation of a disease-stricken city. Tyrone Power is strangely cast as an East
Indian, but then Tyrone Power is nearly always strangely cast."

—LOS ANGELES TIMES (NEW YORK CORRESPONDENT)

"*The Rains Came*, which was made by Clarence Brown, a reliable old-timer, is a
very 'seeable' picture about a native state in India, in spite of the stock characters
who all 'find themselves' with the help of an earthquake, a flood, and a cholera
epidemic. All these characters are either very explicit or very pent-up. Sentences
like 'May I have a cigarette?' convey all sorts of classy emotions."

—GRAHAM GREENE, THE SPECTATOR

FIFTH AVENUE GIRL

RELEASED SEPTEMBER 22, 1939

"I guess rich people are just poor people with money."

THE STORY

An unemployed woman meets a millionaire who will pay her to pretend that she's after his fortune.

Opposite: Walter Connolly and Ginger Rogers in a scene from Gregory La Cava's *Fifth Avenue Girl*

PRODUCTION HIGHLIGHTS

Ginger Rogers had been a star since the release of *The Gay Divorcee* in 1934. That was with Fred Astaire. In 1939 she became a star in her own right. *The Story of Vernon and Irene Castle* was her good-bye to Astaire. *Bachelor Mother* was her hello to solo comedy. *Fifth Avenue Girl* was her super hit. "Ginger Rogers is the top box-office attraction in New York, surpassing even the phenomenal *Wizard of Oz* in drawing power," wrote the *Los Angeles Times* on September 3, 1939. "*Fifth Avenue Girl* will gross $100,000 in its first week at Radio City Music Hall, far outdistancing *In Name Only*, its smash predecessor." What magic formula created this?

Rogers had worked with director Gregory La Cava two years earlier, in the critically acclaimed *Stage Door*. "I had been very impressed with Greg's innovative direction," wrote Rogers. "He brought a humanistic feeling to everything." La Cava was an intuitive director, beloved by performers. "More than anybody else I ever met in this business," said RKO production chief Pandro Berman, "La Cava was capable of exploiting the personality of an actor." One reason for his rapport with performers was his respect for their intuition. He felt that once they were in character,

they could improvise a scene as well as any writer could write it. *Stage Door*, for example, bore only a slight resemblance to the original play. Much of it had been improvised. This was La Cava's method. His final draft did not have the customary "Approved" stamp on it. It was stamped: "As shot."

La Cava signed Allan Scott to work with him on a new idea. "*Fifth Avenue Girl* was an original script," said Scott. "Here's this kid in the Depression, doesn't know where her next meal is coming from, and by chance she sits next to this millionaire. He admires her spunkiness and says, 'Tell you what. You have dinner with me at my house.' It isn't a come-on, and she doesn't take it as a come-on, but everybody in the house—the wife, daughter, the son—thinks the worst." This was only the setup.

"We would write six or seven versions of each scene," said Scott. "Then, with all these versions, we would go to the studio about 8:30 in the morning and La Cava would pick up a page from all these papers scattered around, and he would say, 'Okay, fade in.' And he'd start dictating. And I would be there reminding him of this line and that." As the actors arrived, they would be given the new pages of the day's scene. "Greg

believed," said Scott, "that if the actors had a script, they'd get stale. He'd give them these few pages and a half-hour later he would start shooting. And it worked. The actors were so full of trepidation that they played it off the top of their heads. This gave the films a kind of spontaneity."

A *Los Angeles Times* reporter visited RKO and saw La Cava directing Rogers and Walter Connolly on a Central Park set. There was something going on, a kind of recklessness. And a script was nowhere in sight. "The story got in the way of characterization," admitted La Cava. "I threw the story out." No one appeared to be concerned. But what was the movie about? "Ginger plays a composite Miss America," said La Cava. "Recently, in New York, a civil service commission advertised for applicants. Twelve were needed. 5,000 applied. It was the losers who interested me. Their pluck, their philosophical spirit. 'We'll get a job tomorrow. And if we don't, so what?' The funny part of it is, tomorrow they usually do."

La Cava's technique was not infallible, as he and Scott discovered at a preview of *Fifth Avenue Girl*. The fadeout had Rogers leaving the family to its newfound happiness and walking off into the sunset, alone. "A man in the audience got up and shouted, 'No! No!'" recalled Scott. "They wanted her to get together with the boy at the end. So we had to go back and reshoot the ending." Even with La Cava's unorthodox technique, the film had only cost $607,000. It grossed $1.37 million. And it confirmed that Ginger Rogers was a comedienne.

Opposite: Tim Holt and Ginger Rogers *Above:* A portrait of Ginger Rogers made for *Fifth Avenue Girl*

Critical Reaction

"Although this is no part of the stern, critical attitude, we confess a charitable disposition these days toward anything that serves as an anodyne, however fleeting, to such seasonal discomforts as the heat and Hitler. The Music Hall is cool and comfortable, and *Fifth Avenue Girl* isn't militantly bad, so we have no compunction about putting our name on a non-aggression pact. Gregory La Cava had no territorial ambitions when he offered the film, that its players had no designs on the partition of the Academy's Oscar." **—FRANK S. NUGENT, *THE NEW YORK TIMES***

INTERMEZZO: A LOVE STORY

RELEASED SEPTEMBER 22, 1939

"Tonight I will dare anything."

THE STORY

A mature, married concert violinist begins a romance with a pupil against his better judgment.

PRODUCTION HIGHLIGHTS

In May 1939 David Selznick was still shooting *Gone With the Wind*. When he put *Intermezzo* into production, he turned his attention from the greatest project Hollywood had known to a shot-for-shot remake of an obscure Swedish film. There were two significant things about *Intermezzo*. First, Leslie Howard was producing it; that was his perquisite for appearing in *Gone With the Wind*. Second, Ingrid Bergman was playing the lead, which she had played in the Swedish film. With the hullabaloo about Vivien Leigh and *Gone With the Wind*, would anyone notice? How many actresses had been brought from Europe since Greta Garbo and Marlene Dietrich? Where were Anna Sten, Gwili Andre, and Tala Birell? When Selznick signed young Miss Bergman to repeat her *Intermezzo* performance, he had not met her. In point of fact, the "young

Miss" Bergman was married to a neurosurgeon, Dr. Petter Lindström, and had a daughter. When Bergman arrived in Hollywood, Selznick was taken aback by her appearance. She was nearly five foot nine. Selznick started enumerating changes he would make, starting with her name. "Bergman sounds German," he said. The actress cut him off.

"You saw me in *Intermezzo* and liked me," said Bergman. "Now you want to change everything. If that's the case, I'd rather not do a movie with you. We'll just forget it. I'll take the next train home."

Selznick was stunned. No starlet had ever spoken to him this way. He paused to think. "No, I've got an idea," he said. "It's so simple and yet no one in Hollywood has tried it before. Nothing about you is going to be touched. Nothing altered. You remain yourself. You are going to be the first 'natural' actress."

Above: Leslie Howard and Ingrid Bergman in Gregory Ratoff's *Intermezzo: A Love Story*

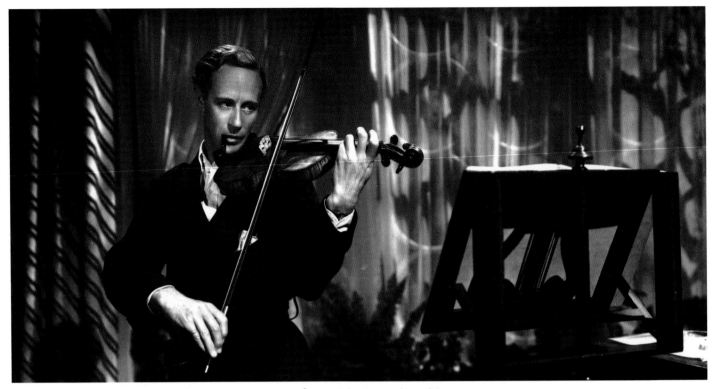

Above: Leslie Howard in a scene from *Intermezzo: A Love Story* *Opposite:* Edna Best and Ingrid Bergman

Selznick introduced Bergman to Hollywood society at an exclusive party. "Look!" she cooed to a newfound friend. "Look who's coming in. Norma Shearer. Claudette Colbert. Ronald Colman. I just can't believe I'm here!" For more than one female star, the feeling was mutual. What was this ungainly girl doing there? What was David thinking? "We have enough trouble getting jobs as it is," sniped Joan Bennett. "Does he have to import a Swedish maid?" Her friends laughed with her at the idea that Bergman could be made a star.

On the set of *Intermezzo*, Selznick pushed aside director Gregory Ratoff and made Bergman do her entrance over and over. "This is your first impact on the American audience," said Selznick. "It's got to be sensational—sensational! I've got to have the impact of a new face so that the audience will suddenly be aware and go 'Ahhh.'" After a few days, Selznick saw that cinematographer Harry Stradling was not photographing Bergman properly. "He's missing the curious

charm that she had in the Swedish version," said Selznick, "the combination of exciting beauty and fresh purity." Selznick replaced Stradling with Gregg Toland. "The most important thing of all is the proper shading of her face with effect lighting," said Selznick. "He's found it. Lighting is as important as dialogue if we are to get an artistic gem out of our simple little story."

In early August Selznick previewed *Intermezzo*. The audience in Huntington Park liked Bergman but found 103 minutes too long for the thin story. On August 17 in Santa Barbara, the film ran eighty minutes; it was still too long. On August 31 a Santa Barbara preview saw seventy minutes of romance and pronounced it excellent. If only the entire country had agreed. The film lost $300,000. Even so, Selznick had accomplished what he set out to do. He had introduced Ingrid Bergman to the public. When the rave reviews started piling up, he quickly signed her to a long-term contract. Then he went back to work on *Gone With the Wind*.

Critical Reaction

"*Intermezzo* has the unusual attribute of seeming to be, in itself, an intermezzo in the lives of people who existed before the camera found them and who will continue to live after it has turned away. Miss Bergman's acting is pallid one moment, vivacious the next, yet always consistent, a lamp whose wick burns bright or dull, but always burns. There is that incandescence about Miss Bergman, that spiritual spark which makes us believe that Mr. Selznick has found another great lady of the screen."

—FRANK S. NUGENT, *THE NEW YORK TIMES*

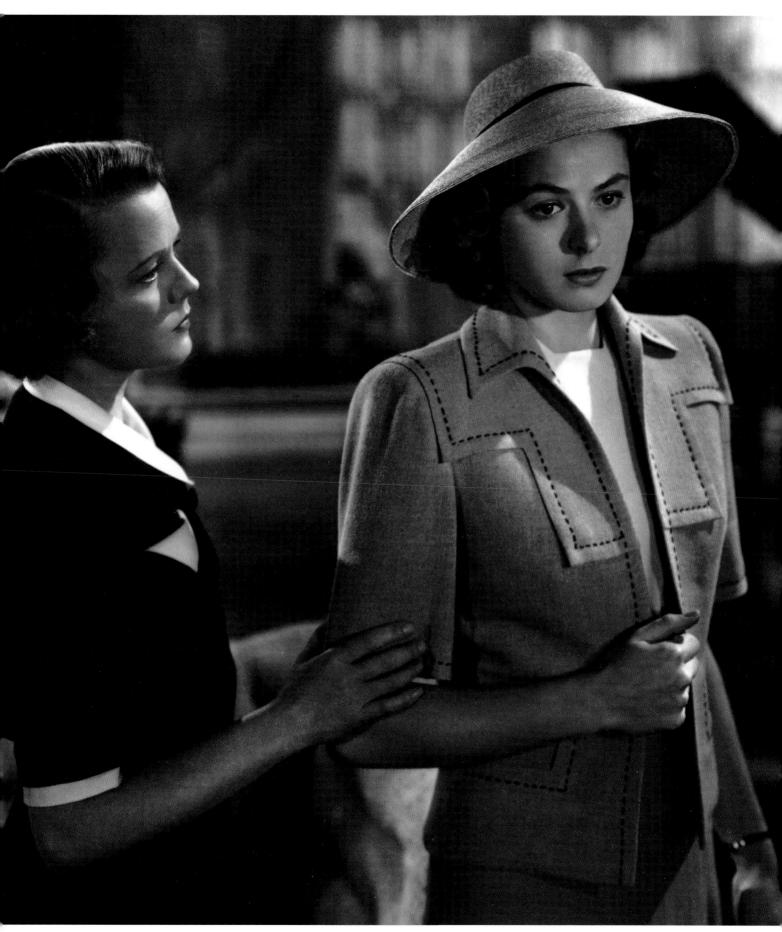

BABES IN ARMS

RELEASED OCTOBER 13, 1939

"There's a little stardust left on life's dirty old pan."

THE STORY

The talented children of unemployed vaude-villians want to put on a show to help their parents but have no money to produce it.

PRODUCTION HIGHLIGHTS

The highest-grossing major studio film of 1939 starred two teenagers who were best known for a B-picture series, the *Andy Hardy* films. Judy Garland and Mickey Rooney had appeared in A films like *Captains Courageous* and *Broadway Melody of 1938* but were working more often in films that were the forerunners of television's situation comedies. The *Andy Hardy* series was a staple of M-G-M production, and tremendously popular. These little films were inexpensive to make, taught young performers the ropes, and filled the theaters. But there was competition for their audience. It was not just radio or live theater. It was a host of activities, and it was serious enough to spark some marketing research.

"For several years," wrote John L. Scott in the *Los Angeles Times*, "young people from 15 to 24 years of age have constituted thirty-one percent of the total film-going audience. This is exceeded only by that of 25 to 44, which constitutes forty-three percent. It was recently discovered that the 15–24 group was falling off to the extent of thirty-three percent." Where were these youngsters going? Research showed

that the distracting diversions included pee-wee golf, dance marathons, and walkathons. There were also night sports like softball, ice rinks, and bowling. "It is up to us to develop entice-ments which can compete with these nighttime attractions," said M-G-M pro-ducer Arthur Freed. "Youth is important to the screen, and not only because of its attendance now. Five years from now the young people who were lured away may stay away, unless we provide pictures to keep them interested."

The artistic intuition that Freed had brought to such song standards as "Temp-tation" put him in good stead. He was also a skilled manager and story construc-tionist. If anyone could devise a product to bring back fallen-away fans, he could. "Human interest stories, melodramas with lots of action, and light musical pictures have youth appeal as well as general appeal," said Freed. "*Babes in Arms* will bring young people in and still appeal to other ages." This project was significant for other reasons. It convinced Louis B. Mayer to move Freed out of the music department and give him his own produc-tion unit. Likewise, *Babes in Arms* made Garland and Rooney a musical team.

Opposite: A Clarence Bull portrait of Mickey Rooney, Judy Garland, Grace Hayes, and Charles Winninger for Busby Berkeley's *Babes in Arms*

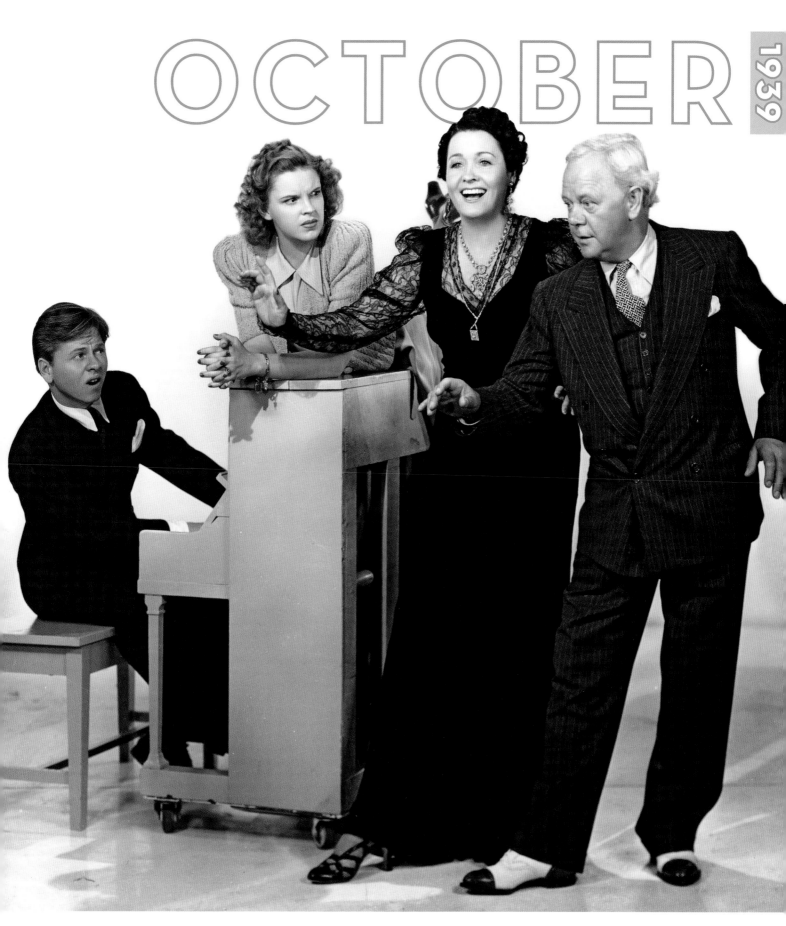

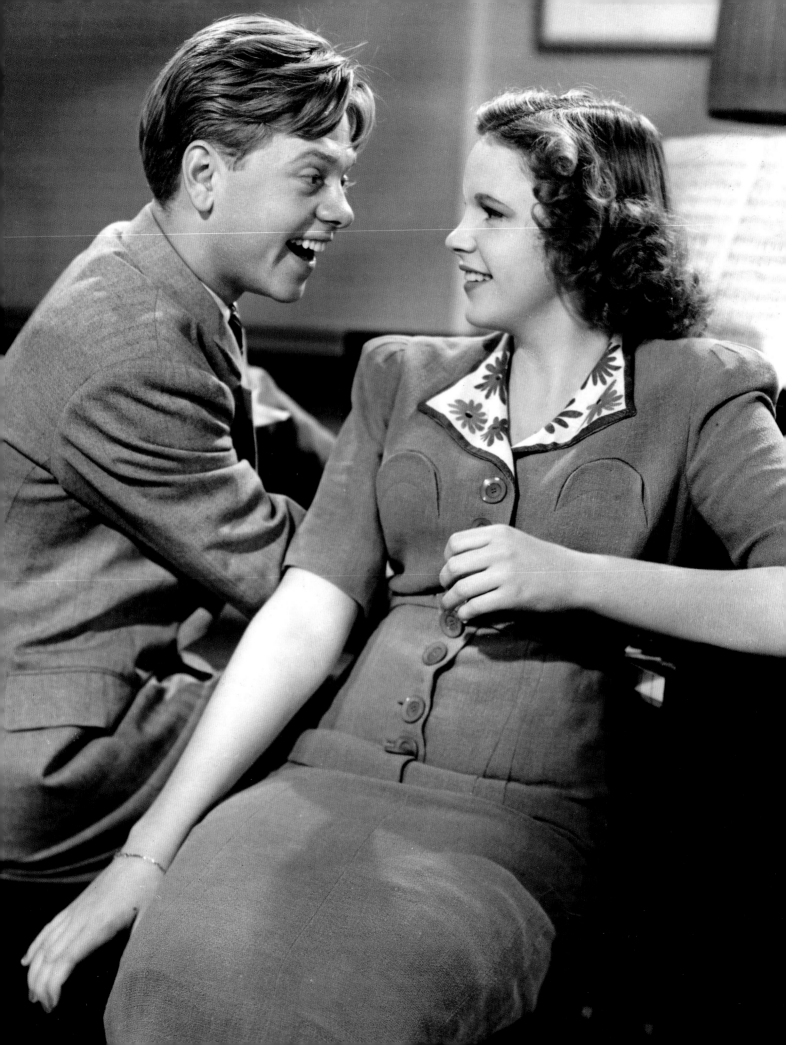

Babes in Arms was based on a hit Broadway musical by Richard Rodgers and Lorenz Hart. Freed got M-G-M to pay $21,000 for the rights and then threw out most of its songs; "My Funny Valentine," "Johnny One Note," and "I Wish I Were in Love Again" among them. He retained the title song and "Where or When," and then wrote (with his usual partner Nacio Herb Brown) his own addition to the score, "Good Morning." To write the script, he used some of the screenwriters who had worked on *The Wizard of Oz*: Florence Ryerson, Edgar Allan Woolf, Noel Langley, and Jack McGowan. Freed told them that *Babes in Arms* would work better if the young people were loyal to their show-biz parents. "In the play none of the older people appear," he told McGowan. "I want to show these vaudevillians. We see that time has passed them by. I got to remembering George M. Cohan. He was always thinking about his father and mother, trying to do things for them. So in the last scene, when Mickey Rooney gets his big chance at success, I want him to send right away for his father."

To direct *Babes in Arms*, Freed hired Busby Berkeley. "He was tough on all of us," recalled Rooney. "He was always screaming at Judy, 'Eyes! Eyes! Open them wide! I want to see your eyes.'" Berkeley had good memories of the film. "Judy was sixteen when we started *Babes in Arms*," said Berkeley. "She called me Uncle and always wanted me right there when the camera was photographing her. She would not do a scene unless I stood by the camera, and afterward she would ask me how she looked and if she had done all right."

Freed had demonstrated in *The Wizard of Oz* that numbers should never stop the show but should keep

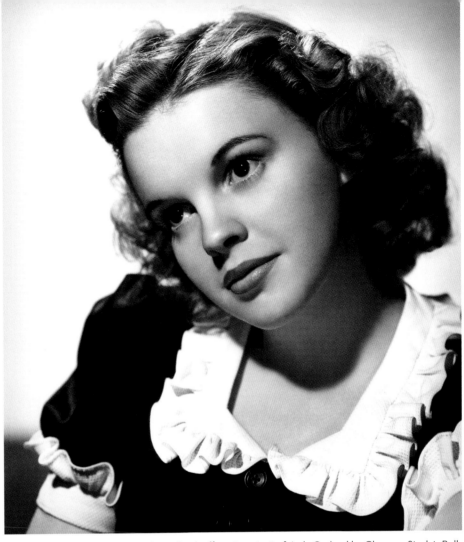

Opposite: Mickey Rooney and Judy Garland *Above:* A portrait of Judy Garland by Clarence Sinclair Bull

it rolling. Every song in *Babes in Arms* advanced the plot, even if it served as a virtuoso piece for the super-energetic Garland and Rooney. For the finale Freed adapted the E. Y. Harburg-Harold Arlen song, "God's Country," which had been composed for a Broadway show titled *Hooray for What!* The spectacular number required one day of prerecording, five days of rehearsal, and three days of shooting. This number alone cost $32,970. The film itself, organized to the minute, only cost $748,000. Boosted by Garland and Rooney's personal appearance tour, *Babes in Arms* earned an astonishing $3.3 million. To make that kind of money, Freed must have brought back the young audience and more. Someone was paying to see *Babes in Arms*. By the end of 1939, Mickey Rooney was America's number-one box-office draw.

Critical Reaction

"To us who have watched Mickey Rooney grow from a cloud no bigger than a man's hand on the horizon into a juvenile institution on whom Metro-Goldwyn-Mayer leans as the Ibsen drama used to lean on Mrs. Fiske, the screen version of *Babes in Arms* will come as no surprise. This motion picture—to express it in two words—is Mickey Rooney. Now, it probably isn't Master Rooney's fault if he dominates the picture as John Barrymore was accused by Mr. Shaw of dominating *Hamlet*—even to the exclusion of Shakespeare. But it is a fact which should at least be given out—like the government's periodical weather reports—to guide the unwary."

—FRANK S. NUGENT, *THE NEW YORK TIMES*

HOLLYWOOD CAVALCADE

RELEASED OCTOBER 13, 1939

"In this business, sweetheart, not all the acting's done by the actors."

THE STORY

A stage actress accepts an invitation from a lowly employee to go to California and act in moving pictures but finds that she has walked into a comedy factory.

Opposite: Alice Faye in Irving Cummings's *Hollywood Cavalcade*

PRODUCTION HIGHLIGHTS

Since 1935, Alice Faye had been the top female star at Twentieth Century-Fox. Shirley Temple made more money but was, after all, a child. Faye was an adult, a smoky-voiced singer, and a sincere actress. She had been a teenage chorus girl in vaudeville. "The cold facts are," she said, "that I started with virtually nothing and made it to the point where I was the number-one female box-office star in America." Darryl Zanuck was planning a special project and only Alice Faye could play it.

The *Los Angeles Times* columnist John L. Scott wrote: "On October 6, 1889, Thomas A. Edison gave movies their first real push forward by developing the Kinetoscope, a venerable forebear of the modern movie projector. Properly to honor this event, filmdom will review its past. Twentieth Century-Fox is producing *Hollywood Cavalcade*, which resurrects the old silent days."

Hollywood Cavalcade was Zanuck's salute to the town as it had been before he arrived, and the film would be Faye's first in Technicolor. It would be different in another way. "Audiences have seen enough pictures that open with Alice Faye singing an old-fashioned tune," said Zanuck. "We do not have to resort to the formula pattern of providing a frame-up for a few numbers for Alice Faye. It reduces our picture, pulls it down." There were no songs in the film.

The legendary Buster Keaton had never been connected with Sennett or the Keystone Cops brand of comedy, but he was brought to Fox for scenes with Faye. She found him respectful but distant. "I was never too outgoing myself," Faye said, "so the result was that we were polite and friendly, but nothing beyond that. I could have learned a great deal from him if only I had tried a little harder to draw him out of his shell." They did, however, connect in another way. Keaton threw a pie in her face. Faye was not expecting it. Once she regained her balance, she found one of her own and chased Keaton around the set with it until she smashed it into his face. "I never had so much fun in my life," she said. "I guess deep down inside every one of us lurks the urge to smack somebody in the face with a lemon meringue pie."

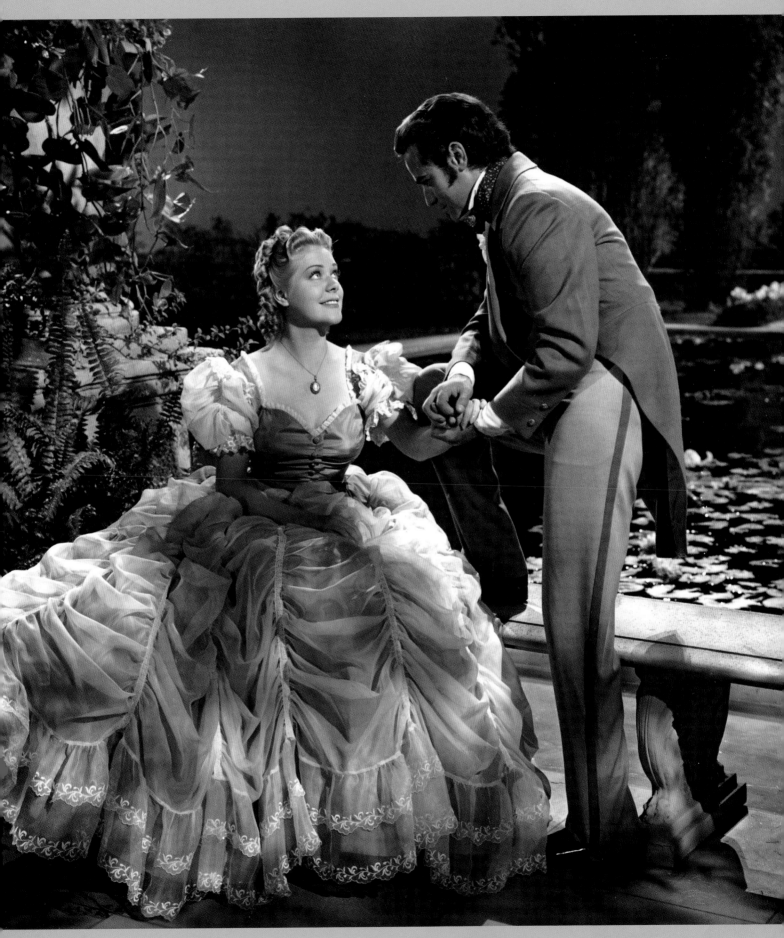

Above: Buster Keaton and Willie Fung *Right:* Hank Mann and the Keystone Cops

Critical Reaction

"Neatly timed to coincide with the American screen's fiftieth anniversary celebration, Twentieth Century-Fox's *Hollywood Cavalcade* was presented at the Roxy yesterday as the motion picture's first large-scale attempt to dramatize its own history. It has been, by and large, a successful attempt, although the history is more effective than the drama. Perhaps this was inevitable, for the march of the movies is more fascinating than the personal histories of those who led, or fell in with, the parade. That is especially true here, where the private lives in question are a synthesis, a composite, not only of fact and fiction but of identities. Alice Faye (our composite Pickford-Normand-Bennett) goes off to marry Alan Curtis (our composite Valentino-Fairbanks Sr.-Reid) leaving Don Ameche (our composite Sennett-Griffith-Goldwyn-DeMille) to hit the downward path that does not bend upward again until he hears, actually hears! Al Jolson singing 'Kol Nidre' in *The Jazz Singer* in a re-enactment, by the way, not the original."

—FRANK S. NUGENT, *THE NEW YORK TIMES*

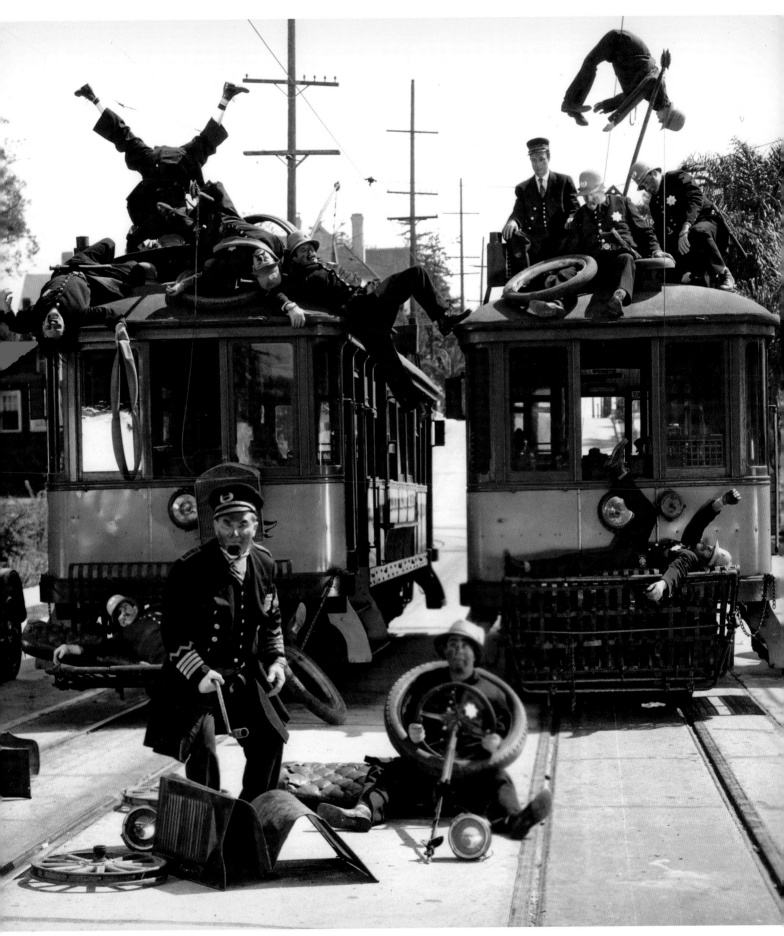

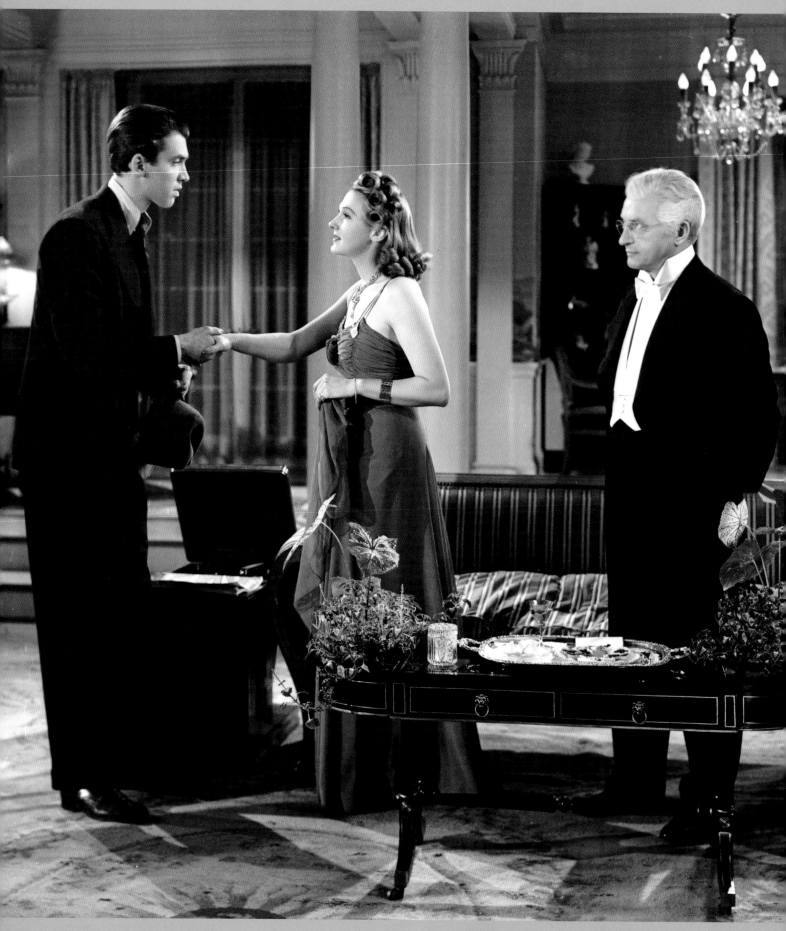

MR. SMITH GOES TO WASHINGTON

RELEASED OCTOBER 19, 1939

"Liberty's too precious a thing to be buried in books. . . . Men should hold it up in front of them every single day of their lives and say: 'I'm free to think and to speak. My ancestors couldn't. I can. And my children will'."

THE STORY

When a starry-eyed young senator discovers he's being used to help a political machine "pork barrel" a bill through Congress, he vows to expose the scheme.

Opposite: James Stewart, Astrid Allwyn, and Claude Rains *Overleaf:* A scene from Frank Capra's *Mr. Smith Goes to Washington*

PRODUCTION HIGHLIGHTS

The history of Hollywood is full of stories about projects that almost happened. In the summer of 1938, Frank Capra was finishing *You Can't Take It with You* and could not wait to start on his next project, a biography of Frédéric Chopin that would star Spencer Tracy as the Polish composer and Marlene Dietrich as George Sand. Columbia Pictures boss Harry Cohn told Capra that Tracy was unavailable and Dietrich was undesirable. There would be no Chopin film. To make Capra feel better, his assistants brought him a two-page synopsis of a Lewis R. Foster novel called *The Gentleman from Montana*. Capra took a look at it and forgot all about Chopin. Foster's novel told the story of a naive young man who is drafted into the Senate, where his ideals are tested by cynicism and corruption. This was Capra's favorite theme. "Nothing earth-shaking," he wrote. "Just this. A simple, honest man, driven into a corner by predatory sophisticates, can reach into his God-given resources and come up with enough courage, wit, and love to triumph."

When Capra began to prepare the project, he learned why it had lain unproduced. Both Paramount and M-G-M had submitted it to the PCA and been turned down. "This generally unflattering portrayal of our system of government," wrote Joseph Breen, "might be considered, both here and particularly abroad, a covert attack on the democratic form of government." He would only approve the project if its script showed American senators as "fine, upstanding citizens, who labor long and tirelessly for the best interests of the nation." Capra's usual screenwriter, Robert Riskin, had gone to work for Samuel Goldwyn, as had his second choice, Jo Swerling. Capra was left with Sidney Buchman, who had done some work on *Lost Horizon*. Capra was lucky to get him. Buchman made each character's voice distinctive and vivid; there were 182 of them. And he softened the story enough to get a tentative okay from Breen.

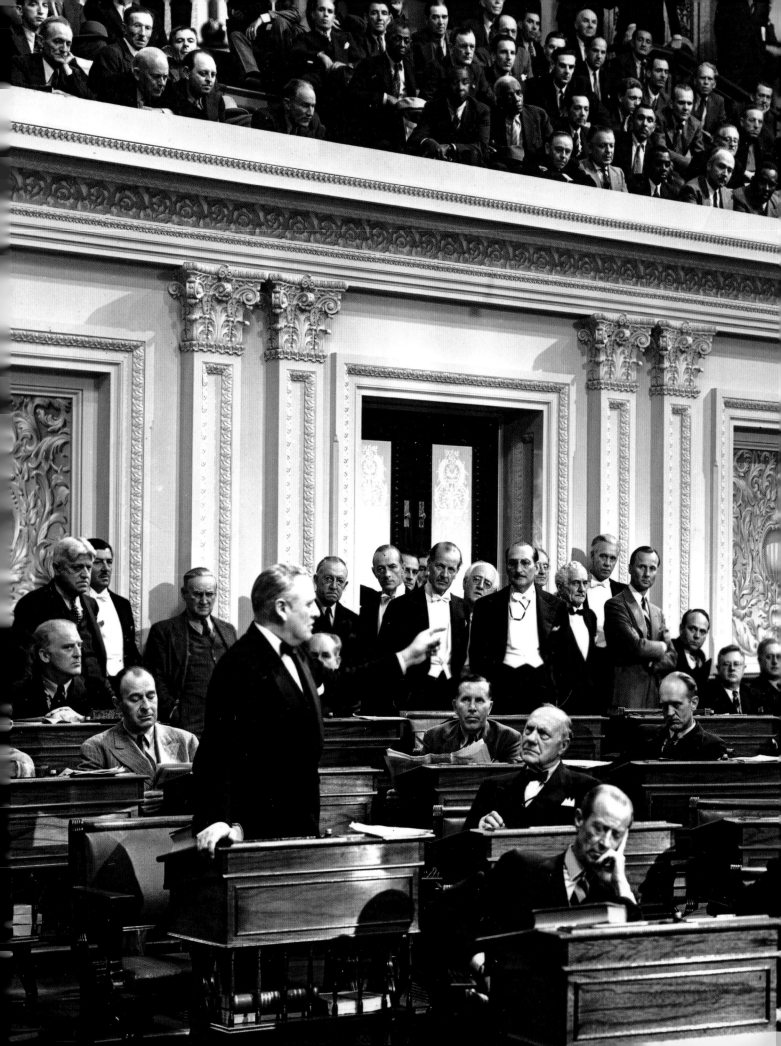

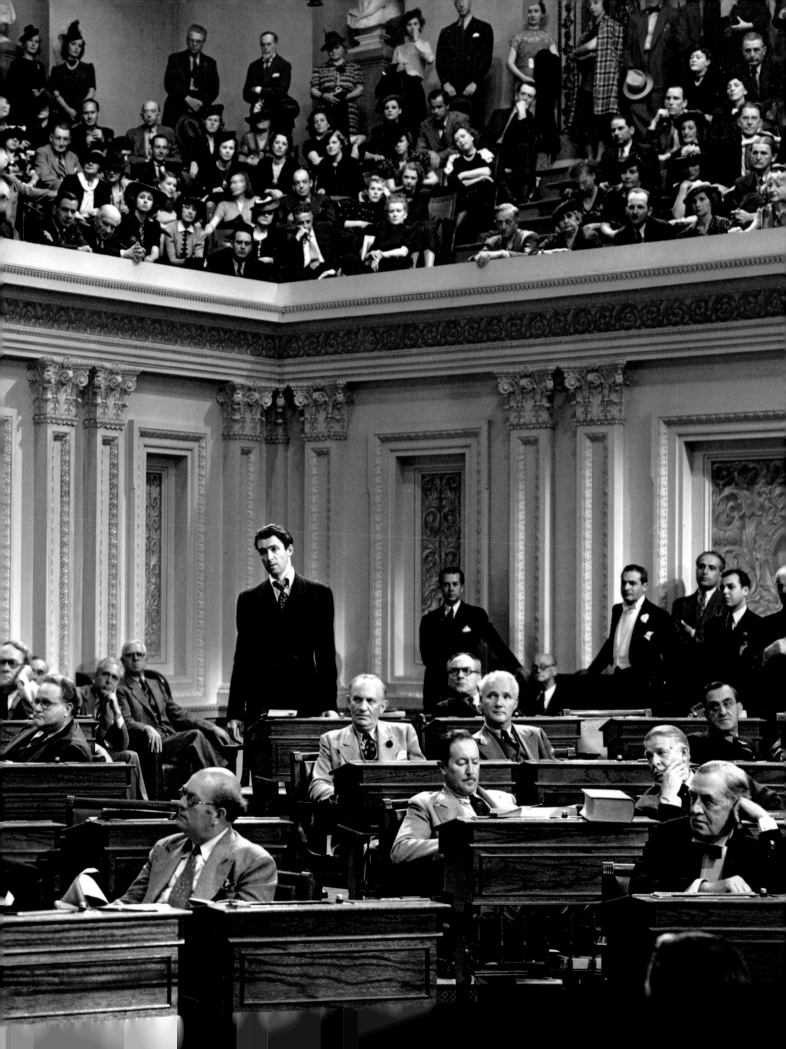

Capra's concept was in part influenced by the success of his 1936 Gary Cooper film, *Mr. Deeds Goes to Town*, which had made Jean Arthur a star. Cooper was unavailable. The next choice was an M-G-M actor who showed promise but had not gotten a star-making role. Capra settled for James Stewart. "I knew he would make a hell of a Mr. Smith," said Capra. "He looked like the country kid, the idealist."

In the fall of 1938 Capra took Stewart, Buchman, and cinematographer Joseph Walker to Washington, D.C., to shoot backgrounds. "We had with us," wrote Walker, "a unit to photograph stills of every possible detail that might be needed to recreate the Senate Chambers—chairs, desks, even door knobs." Walker did some location scouting on his own at night. "I took an exhilarating walk alone, pausing with a surge of patriotic fervor to gaze at the lighted Capitol dome, the stately Lincoln Memorial, the soft glow on the Washington monument." What he saw influenced the scenes Capra made of Stewart's own exploration. "In order to get a certain light," said Stewart, "we made a shot of me in the Lincoln Memorial at four in the morning."

Being in Washington afforded Capra the opportunity to sit in on a Franklin D. Roosevelt press conference. When he heard the president discussing world conditions, Capra panicked. "Nazi panzers had rolled into Austria and Czechoslovakia," he wrote. "England and France were shuddering. Official Washington was in the process of making hard, torturing decisions. And here was I, in the process of making a satire about government officials; a comedy about a callow hayseed who disrupts deliberations with a filibuster. Wasn't this the most untimely time for me to make a film about Washington?"

Capra visited the Lincoln Memorial again. While there, he saw a child holding the hand of his sight-impaired grandfather, who wanted to hear the words that were engraved in the walls. "The boy read Lincoln's words in a voice as clear and innocent as a bell," said Capra. "And the old man smiled to himself, nodding after each sentence. I left the Lincoln Memorial with a growing conviction about our film. The more uncertain are the people of the world, the more their hard-won freedoms are scattered and lost in the winds of chance, the more they need a ringing statement of America's democratic ideals."

Those ideals would only look pure if contrasted with corruption, so the script was adjusted. "It was created by Sidney and me, out of writing and rewriting, out of sweating and head-banging," said Capra. *Mr. Smith Goes to Washington* started shooting on April 3, 1939. "Once filming began," said Capra, "I never left the set, never took phone calls, never heard or saw anything unless it pertained to the scene we were shooting. I was a tuning fork that vibrated only to the wave length of Mr. Smith."

The film's centerpiece was a frighteningly accurate reproduction of the Senate chambers. It presented a problem. Its accuracy did not allow for easy setup changes; it was cramped. Capra brought in eight cameras and instituted a system of sound playbacks to speed the shooting of reaction close-ups. "With the exposure of so much film," said Walker, "looking at the rushes kept me in the projection room 'til midnight. Then it was back to work early the next day. Some weeks I felt that I'd never left the Senate."

Stewart worked long hours, too, eager to make the most of a very important film. "Jimmy was so serious when he was working on that picture," recalled Jean

Arthur. "He used to get up at five o'clock in the morning and drive slowly, slowly to the studio. He was so terrified something was going to happen to him that he wouldn't go fast." Stewart's dedication even allowed for an unpleasant procedure. In his big filibuster scene he had to look and sound as if he had been talking for hours. His voice had to be hoarse. He got a doctor to come to the set. "He dropped dichloride of mercury into my throat," said Stewart. "Not near my vocal chords, but just in around there. It wasn't dangerous." Capra was at first alarmed but then pleased. "No amount of acting," he said, "could have simulated Jimmy's intense, pathetic efforts to speak through swollen chords."

Filming was completed on July 7. As Capra edited the film, he received an invitation from the National Press Club to participate in an event that would make previous on-location premieres—Dodge City, San Francisco, and Omaha—pale by comparison. October 16 would be designated "Mr. Smith" day in Washington. There would be a cocktail party and formal dinner in the Press Club (with a special exemption to allow women to enter); a marching band; speeches; and the premiere screening in Constitution Hall. This was an honor for Capra, who had immigrated to the United States from Sicily with his family at the age of six.

On the great evening, Capra and his wife, Lu, sat in an official box. "The great Hall glittered with all the opulence of a new season's opening at the Met," said Capra. "Supreme Court Justices, Cabinet officers, Senators, Congressmen, generals, pundits, and Georgetown's social aristocracy—four thousand in all—buzzed, chatted, and waved at each other." After a spotlight hit Capra and he acknowledged the applause, the film was started. "About two-thirds of the way into the picture,"

said Capra, "the ominous signs that strike terror into the hearts of filmmakers—whispering and fidgeting—became evident. A couple rose, headed for the exit, the man making thumbs down motions with his hand. Another twosome followed suit, then a foursome. By the time *Mr. Smith* sputtered to the end music, about a third of Washington's finest had left. Of those who remained, some applauded, some laughed, but most pressed grimly for the doors."

"*Mr. Smith Goes to Washington*," said Senator Alben W. Barkley (D) of Kentucky, "is a grotesque distortion of Senatorial protocol. As grotesque as anything I have ever seen!" For weeks following the premiere, Capra and his heartfelt project were vilified and castigated. The most awful attack came from Joseph P. Kennedy, the ambassador to England. He said *Mr. Smith* ridiculed democracy. Such a charge was serious, given what was happening in the world. "In less than a month since the declaration of war," said Capra, "Hitler had destroyed the Polish armies, and sunk ships without warning. Our nation was divided between those who urged, 'Join the fight against the Nazis!' and those who exhorted, 'Stay the hell out of Europe!'"

Cohn was reeling from Kennedy's charges, but Capra was obdurate. "Why do guys like Joe Kennedy stop trusting the people?" asked Capra. "Don't they know that America is the envy and hope of the world because we *can* make pictures like this and show them to ordinary citizens? That's why fascists hate us. Don't answer Kennedy. Let the public answer him, just like in the picture!" So Columbia Pictures created a book of positive reviews and mail from both exhibitors and moviegoers. One of the best reviews was an editorial in the *New York Daily Mirror*: "Frank Capra does with a movie what Sinclair Lewis does with books, what Arthur Brisbane did with a column, what Will Rogers did with his wit. He holds a mirror up to America."

Kennedy and a few angry senators could not suppress *Mr. Smith Goes to Washington*. It was booked in two Los Angeles first-run theaters for a week, the most a major film could expect to play. In November the *Los Angeles Times* reported: "*Mr. Smith Goes to Washington* is writing motion picture history. It is breaking box-office marks in its fourth week at the RKO-Hillstreet Theater and the Pantages Hollywood." The public had answered. Capra was vindicated.

Above: A portrait of James Stewart and Jean Arthur for *Mr. Smith Goes to Washington*

Critical Reaction

"For those who still ask the question: 'Why do movies talk?' I can answer it, truthfully. 'So Frank Capra could make *Mr. Smith Goes to Washington*.' It's entertainment, not preachment, and yet it does what few schoolbooks can do. It makes you think; it makes you prize liberty above everything. Everybody who sat in that theater the other night wanted to get a soapbox and go out before their friends and say: 'You mustn't miss it!'" **—HEDDA HOPPER**

"Frank Capra, with a facility that is akin to wizardry, has again welded all the human elements in a story of politics into a compact and effective tale of heroism. He has centered his plot around a character that expresses devotion to ideals, old ideals that might be taken right from the pages of a child's history book."

—EDWIN SCHALLERT, *LOS ANGELES TIMES*

AT THE CIRCUS

RELEASED OCTOBER 20, 1939

"I bet your father spent the first year of your life throwing rocks at the stork."

THE STORY

When the Marx Brothers try to keep a circus from falling into the hands of crooked promoters, there is more chaos than progress.

PRODUCTION HIGHLIGHTS

When Mervyn LeRoy came to M-G-M to become a producer in November 1937, he brought screenwriter Irving Brecher with him. One of Brecher's assignments in his first year at Metro was additional dialogue on *The Wizard of Oz.* "I wrote some amusing stuff for the Cowardly Lion," recalled Brecher. "I made, overall, a small contribution. After that LeRoy assigned me to what was my life's dream." Louis B. Mayer wanted to make a third film with Groucho, Harpo, and Chico Marx. A new writer was needed. Brecher had idolized the Marx Brothers for a decade. "I was a big fan of their movies," said Brecher. "To me they were the funniest men in the world." He would be working with Groucho to create an original screenplay; Harpo and Chico would only be consulting on their own gags. "Groucho was tough, acerbic," said Brecher. "He was not a very secure person, and he always feared making a movie, that it wouldn't turn out right, that it wouldn't be funny enough." Curiously, Groucho, who was capable of devastating one person—or an audience—with an improvised one-liner, was not capable of sustained writing. He was more than capable of criticism. "I would read the scenes to Mervyn first,"

Right: Groucho Marx and Eve Arden in a scene from Edward Buzzell's *At the Circus*

said Brecher. "He would love them, and say, go ahead, write the script. Then we would read it to Groucho. He would nod. 'Pretty good . . . well, I'm not sure.' There would be a week or two of limbo. Then Groucho came in again. 'Don't you think this section needs something?'"

The film started shooting in June 1939, titled *A Day at the Circus*. Brecher was on call in case rewriting was needed. Groucho was uncharacteristically sanguine. "*A Day at the Circus* is progressing rather rapidly," he told a friend, "considering it's our picture. I believe it will be much better than I thought." Edward Buzzell was directing. The former Broadway star was not happy with the Marxes. "The Marxes are wild," said Buzzell. "They never hit their marks for a moving shot. It isn't that they don't know better or are uncooperative. It's just that their comedy is spontaneous." One day LeRoy had Brecher write a line to smooth a transition in a scene. Groucho was trying to get his wallet back from the villainess, who was played by Eve Arden. She had picked his pocket and then dropped his wallet down the front of her leotard. "Now," said Brecher, "what I wrote was that Groucho sees this out of the corner of his eye. He steps out of character, looks into the camera, and says to the audience, 'There must be some way I can get that wallet back without getting into trouble with the Hays Office.'" Buzzell looked at the script. "What the hell are you talking about?" he asked Brecher.

"The *Hays Office*? That's ridiculous. Nobody will understand it." He handed it back to Brecher. "I won't shoot it."

"LeRoy heard the line," said Brecher. "He wants you to shoot it."

"To hell with LeRoy," said Buzzell. "I'm not going to shoot it."

LeRoy gave Buzzell a day off (without pay) and had S. Sylvan Simon come to the set with Brecher and Groucho. "I don't know," said Simon. "I don't know if anyone knows what the Hays Office is." Simon made the shot. The film was previewed. "Groucho said that line was not only the biggest laugh he ever got but also the biggest laugh he ever heard in a theater," recalled Brecher. "And it showed something, it told us all something, that the audience was way ahead of us."

Groucho may have been pleased at the line but he was less than pleased with the film, which was retitled *At the Circus*. "I'm not much of a judge," he said shortly afterward, "but I'm kind of sick of the whole thing." Later he said to his family, "Why should I let myself get upset over a movie—a movie that in three months will wind up on a double bill at the Oriental Theatre, with bingo and free dishes?" That did not happen. "*At the Circus* is breaking records at Grauman's Chinese Theatre," wrote Hedda Hopper two weeks after the film's release. "So, how can you tell what the public will like? Maybe I don't like the brothers. All right, I don't. Except when Harpo harps. Then he's divine."

Critical Reaction

"The new Marx frolic is not exactly frolicsome; it is, in cruel fact, a rather dispirited imitation of former Marx successes, a matter more of perspiration than inspiration and not at all up to the Marx standards (foot-high though they may be) of daffy comedy."

—FRANK S. NUGENT, *THE NEW YORK TIMES*

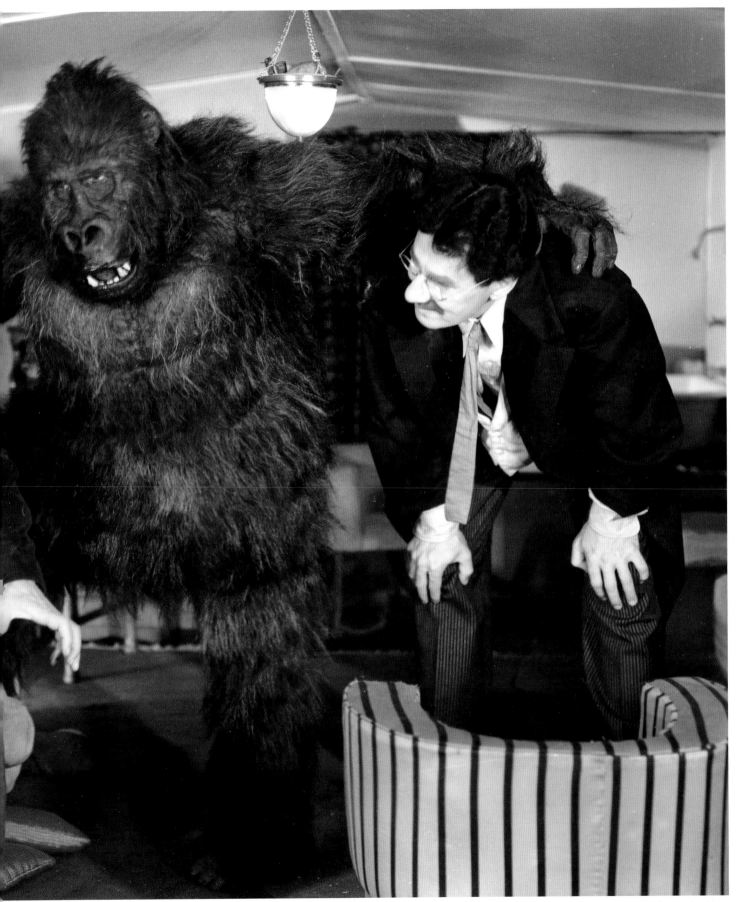

Above: Chico Marx, Charles Gemora, and Groucho Marx

THE ROARING TWENTIES

RELEASED OCTOBER 28, 1939

"I always say, when you got a job to do, get somebody else to do it."

THE STORY

When a World War I veteran finds there's no work for him at home, he begins a career as a bootlegger and gangster.

PRODUCTION HIGHLIGHTS

Mark Hellinger was a syndicated columnist for the legendary New York dailies when they were glamorous, respected, and powerful. Unlike most journalists, he stepped back from the hurly burly of his Manhattan subjects and sentimentalized them in fiction. This led to playwriting, screenwriting, and finally to producing at Warner Bros. In 1939 he conceived *The World Moves On*, a story that would span the decades since the Great War, with emphasis on the "Era of Wonderful Nonsense." He drafted a proposal for Hal Wallis, describing the scope of his idea: "The youth in your audience of 1939— ages fifteen to twenty-one—never knew what Prohibition was! The youth of today has no conception of the speakeasy era. He might think he knows, but he doesn't. It's difficult to believe, but there it is." Hellinger's project became *The Roaring Twenties*, James Cagney's last gangster role of the 1930s.

When Raoul Walsh began directing Cagney and his good friend Frank McHugh, none of them felt that the scenes in 1919 New York were plausibly

Right: Frank McHugh and James Cagney in Raoul Walsh's *The Roaring Twenties*
Overleaf: James Cagney and Gladys George

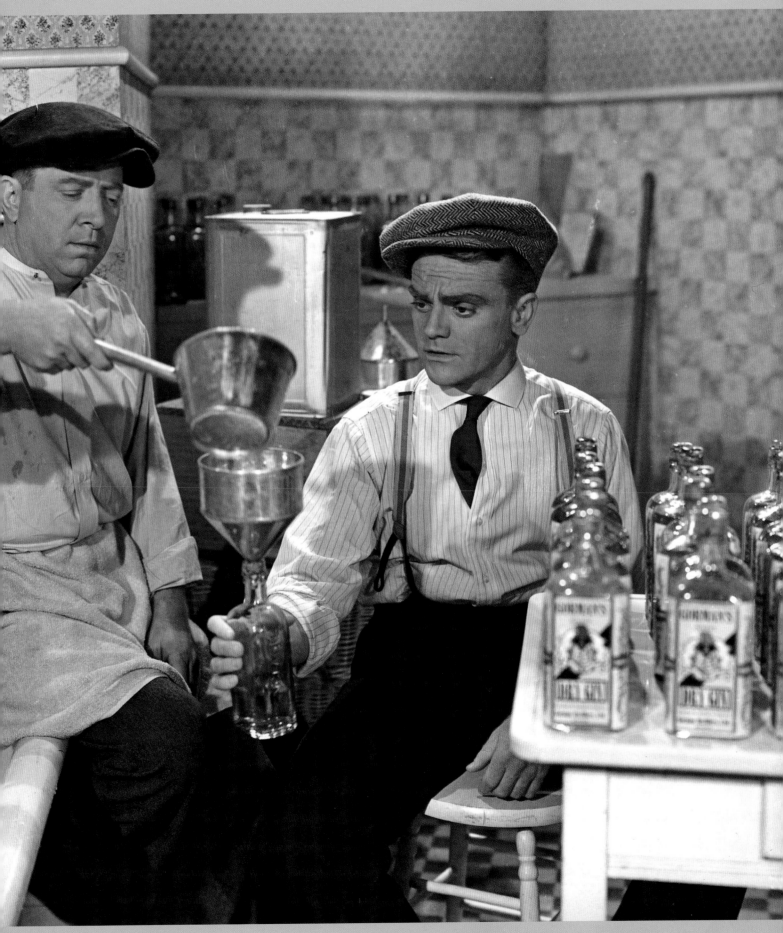

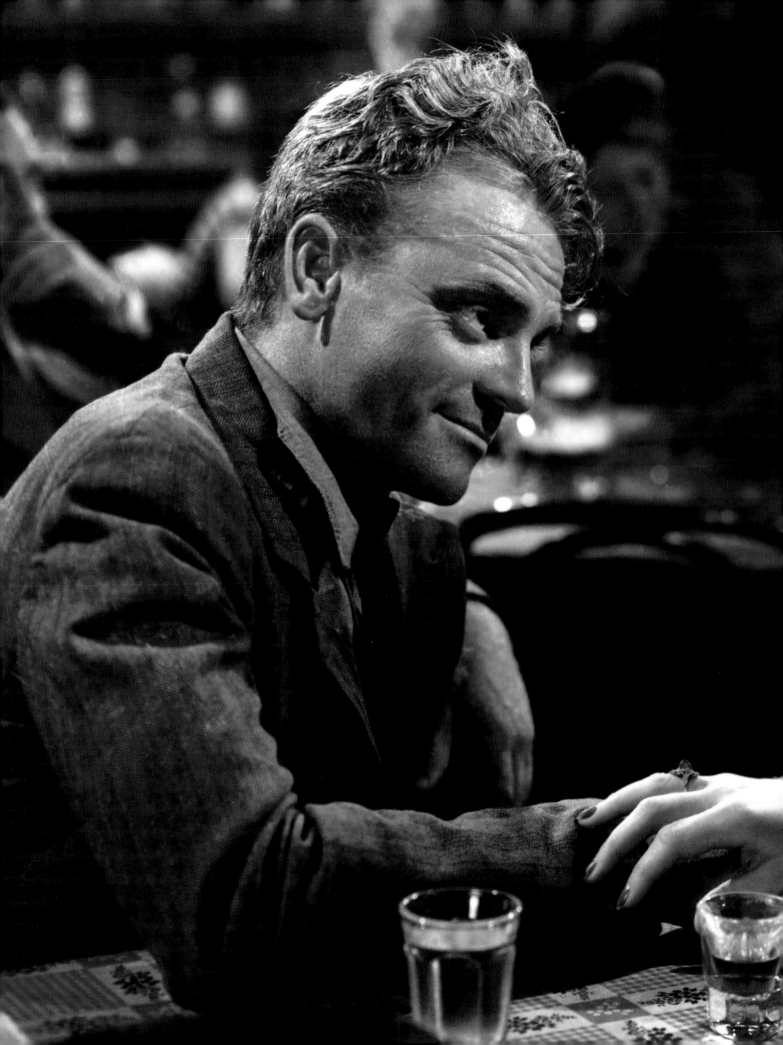

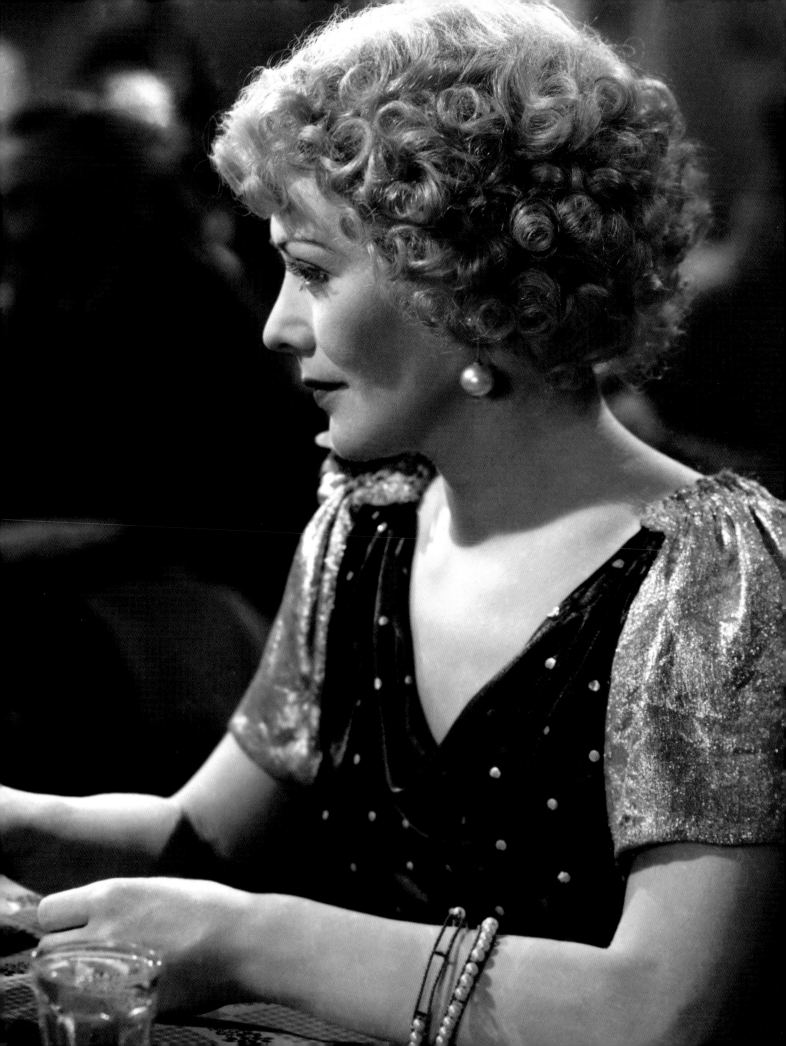

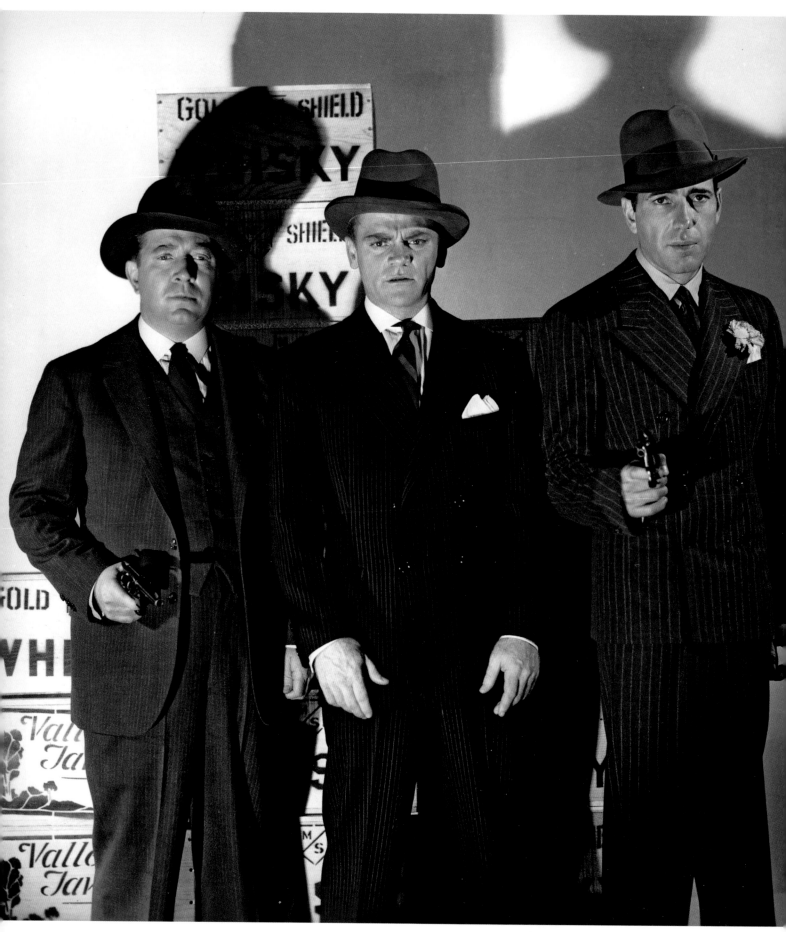

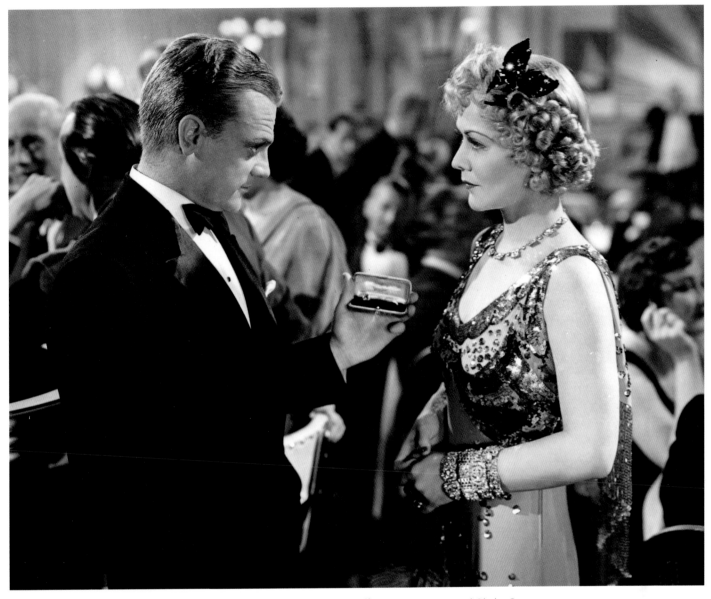

Opposite: A portrait of Frank McHugh, James Cagney, and Humphrey Bogart *Above:* James Cagney and Gladys George

written, so they did some rewriting. When executive producer Hal Wallis saw the rushes, he immediately spotted the changes. "When the script comes to Walsh as 'Final,' it is to be shot that way," Wallis wrote associate producer Sam Bischoff. "I do not want him to rewrite complete scenes on the set." Cagney did not want his character to be without sympathy, so he continued changing lines. "Cagney is playing a tough guy in a tough racket," Wallis told Walsh. "If he occa-sionally does have tough lines, he must deliver them. You cut the speech where he told the three henchmen he was hiring never to try and pull anything on him or he'd take care of them. I assume you cut it because Cagney didn't want to be the tough guy again. You must keep these things because they are part of the characterization." *The Roaring Twenties* became a balanced portrait of a good cit-izen gone wrong, because of both social conditions and character flaws.

Critical Reaction

"The most prosperous and decadent decade in American history provides material for the latest gangster film. Warners have provided plenty of atmo-sphere of the period. Songs, slanguage, costumes, etc. weren't hard to resurrect. But just why the production doesn't reach the status of 'epic gangster pic-ture' is hard to explain. Perhaps the 'Roaring '20s' are still too fresh in our minds. Maybe too much was expected."

—JOHN L. SCOTT, *LOS ANGELES TIMES*

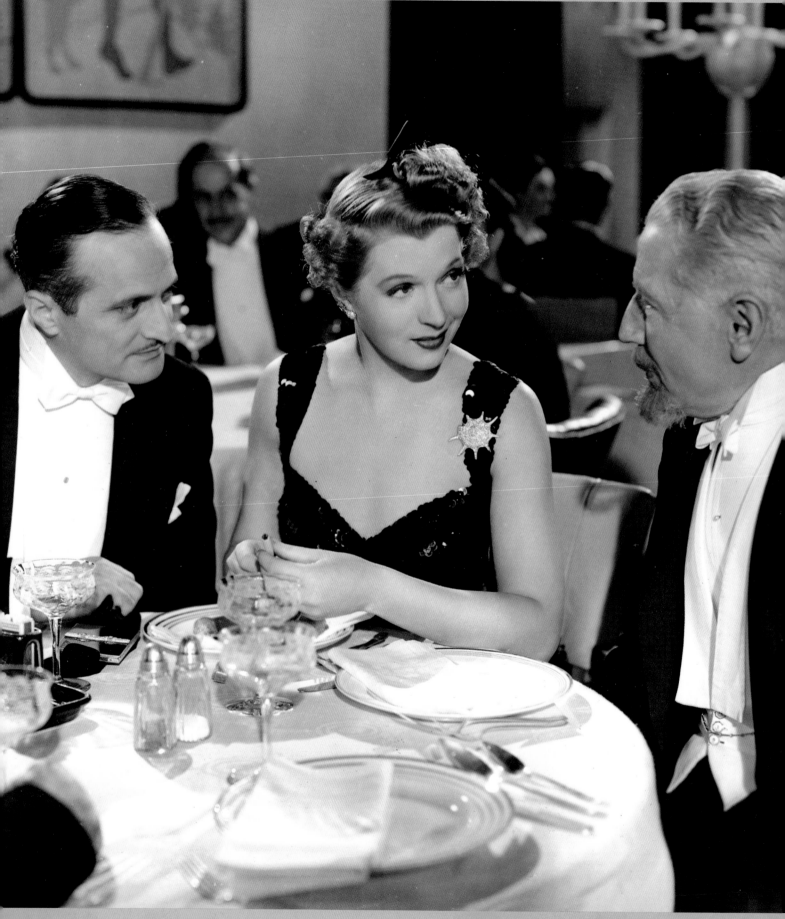

NINOTCHKA

RELEASED NOVEMBER 3, 1939

"Bombs will fall. Civilization will crumble. But not yet. Wait. Please. What's the hurry? Give us our moment. Let's be happy."

THE STORY

A Communist envoy comes to Paris to discipline delinquent party members, but she finds capitalism more appealing than she expected.

Opposite: George Sorel, Ina Claire, and Lawrence Grant in a scene from Ernst Lubitsch's *Ninotchka*

PRODUCTION HIGHLIGHTS

On May 3, 1938, the Independent Theater Owners of America took out full-page ads in numerous trade papers stating: "The following stars are Box-Office Poison: Joan Crawford, Bette Davis, Marlene Dietrich, Greta Garbo, Katharine Hepburn, Mae West, Edward Arnold, and Fred Astaire." All of these stars would recover from this unhappy category, most of them by the end of 1939. One of them was indifferent. Greta Garbo had not made a film since 1937. She had little interest in making a comeback.

"It never pleased me to act all the time," said Garbo. "In fact, I tried to make only one picture every two years so that for months on end I could go to Sweden, or walk in the mountains, and not think about motion pictures." Garbo had been an M-G-M star since 1927, but had achieved a status that few other stars had. Her celebrity was of a kind reserved for sports figures or religious leaders. She had inspired a cult. Though she was unwilling to cooperate with the press, her stature grew to mythic proportions. As the 1930s wore on, she made fewer films yet became more popular. The American theater owners were accurate in only one respect. Her last film, *Conquest*, had been a gigantic flop, but then it cost too much and had an unengaging story. "Who cares about Napoleon?" costume designer Gilbert Adrian asked Garbo during a fitting. He was right. But people cared about Garbo. "She had a fanatical following in the United States," said director Clarence Brown. "On the other hand, in Europe, Garbo was queen. Over there, Garbo was first, second, third, and fourth." If that market was diminished by border problems or lost to an all-out war, a Garbo comeback would be impossible.

Producer Sidney Franklin, who was an Irving Thalberg alumnus, had M-G-M buy a story from a Hungarian playwright named Melchior Lengyel. It was a variation of the formula Thalberg had devised for Garbo in the silent era. Instead of

177

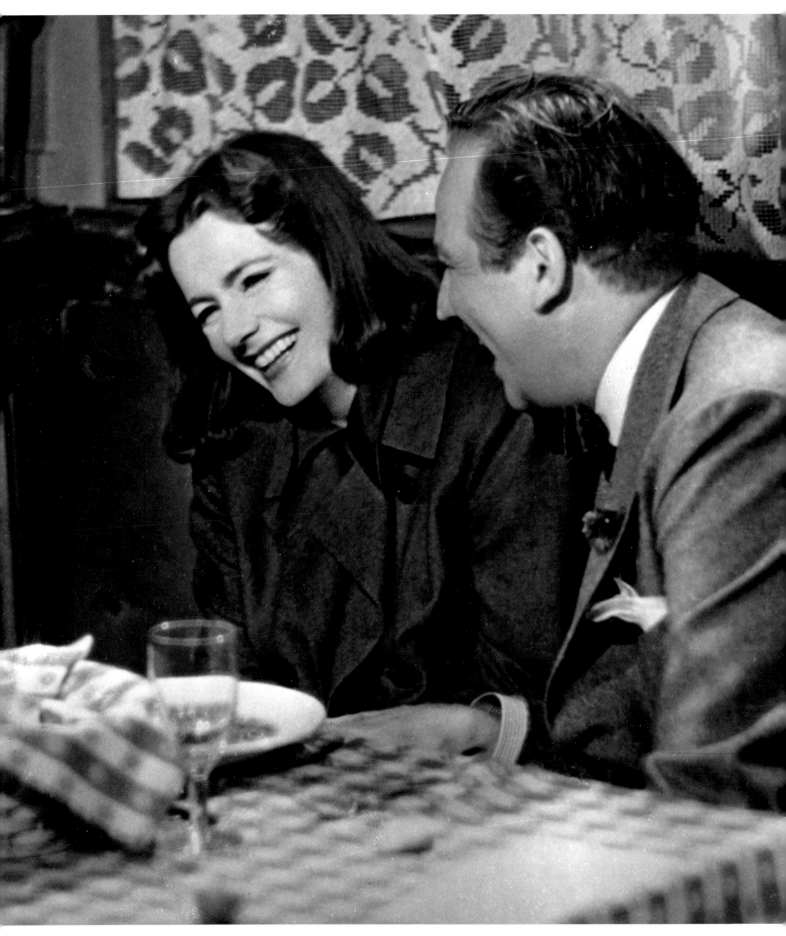

having the world-weary Garbo rescued from a cynical older man by a romantic younger man, Lengyel would have Garbo rescued from communism by a young sophisticate. It might just work. Lengyel's treatment was called *Ninotchka: (Love Is Not So Simple)*. It was turned into a feature-length screenplay by the distinguished playwright S. N. Behrman, who had written Garbo dramas like *Anna Karenina* and *Camille*. "Don't you think it is high time they let me end a picture happily with a kiss?" Garbo asked. "I do. I seem to have lost so many attractive men in the final scenes."

Franklin brought the famous director Ernst Lubitsch onto the project and the *Ninotchka* script, which was one-third Lengyel (funny), one-third Behrman (funnier), now gained Charles Brackett, Billy Wilder, and, as story editor, Lubitsch (the funniest director in the world). "*Ninotchka* was so much Ernst Lubitsch's own baby," said Brackett. "Everything he did was wonderful and funny and stimulating." Wilder was in awe of Lubitsch's capacity for invention. "He wasn't just a gagman, he was the best creator of toppers," said Wilder. "You would come up with a funny bit to end a scene, and he would create a better one."

"On her first day's work before the cameras in two years, Greta Garbo had a beautiful case of jitters," reported Harrison Carroll on May 31, 1939, in the *Evening Herald Express*. "She came onto the *Ninotchka* set wearing a blue robe over blue pajamas, gave a nervous good morning to Lubitsch and to cameraman Bill Daniels, and said: 'Let's start right away.'" Working with Garbo were the urbane leading man Melvyn Douglas and

the scintillating stage star Ina Claire. Often moody and reclusive, Garbo was in fine fettle during the filming. "The most hilarious moment on the set came when Garbo read the line to Douglas's butler, 'Go to bed, little father. We want to be alone.' The star herself gave vent to a loud laugh and everyone else on the set joined in." Curiously, the upbeat tone of the film affected Garbo. "Greta was a changed person," wrote her friend Mercedes de Acosta. "She laughed constantly and she would imitate Lubitsch's accent and ask over and over again 'Vhy? Vhy?' as she did in the picture." Then came the preview.

"Unless *Ninotchka* is slashed and parts redone," wrote Hedda Hopper, "Ina Claire steals it." Franklin and Lubitsch cut two of Ina Claire's scenes and then brought her back to shoot transitional material. The next preview took place in Long Beach. Garbo had to stand in line with a group of sailors until the manager recognized her and brought her to a roped-off section inside. As the film played, people began hooting and hollering and clapping. "Greta was so excited," said Lubitsch. "When people started to laugh, it was the most amazing thing! She looked around like she'd heard thunder claps!"

Ninotchka premiered on October 26, 1939, at Grauman's Chinese Theatre, and two weeks later in New York, vying with war news for attention. On November 22, a *New York Times* item reported that 300,000 people had seen *Ninotchka* in its first two weeks at the Music Hall. Frank Nugent wrote that he had received "forlorn expressions of regret from the persons who have gone to see *Ninotchka* and couldn't hear half the picture for the

Left: Greta Garbo and Melvyn Douglas

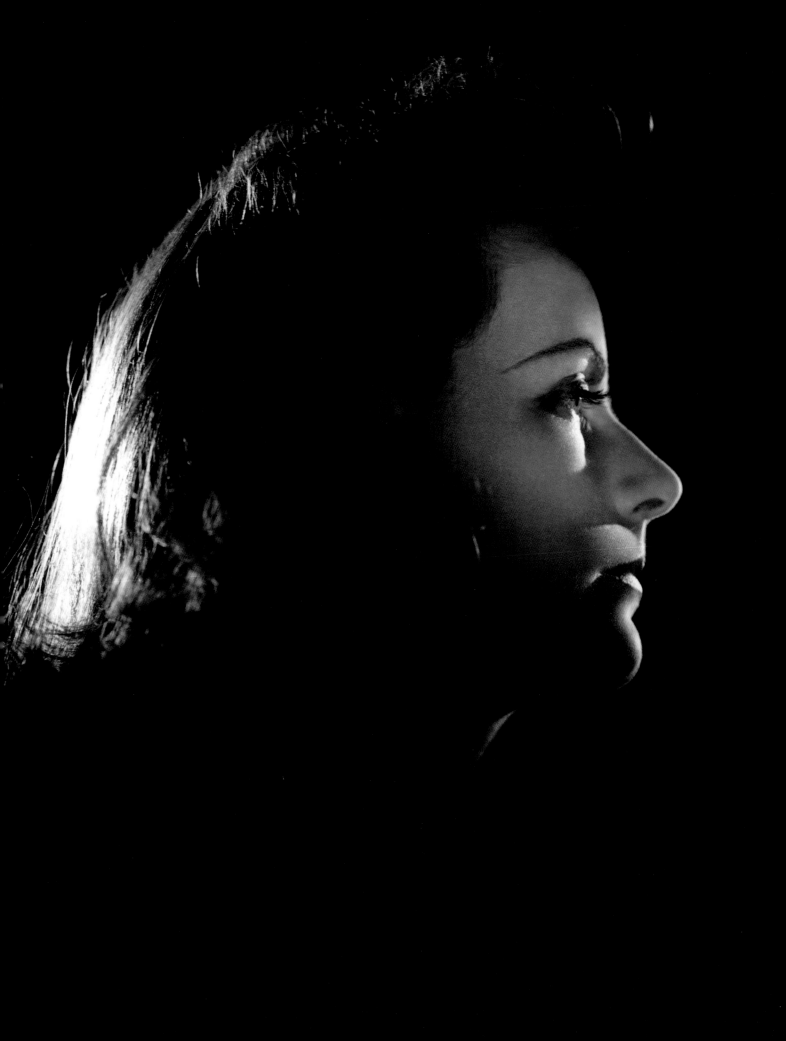

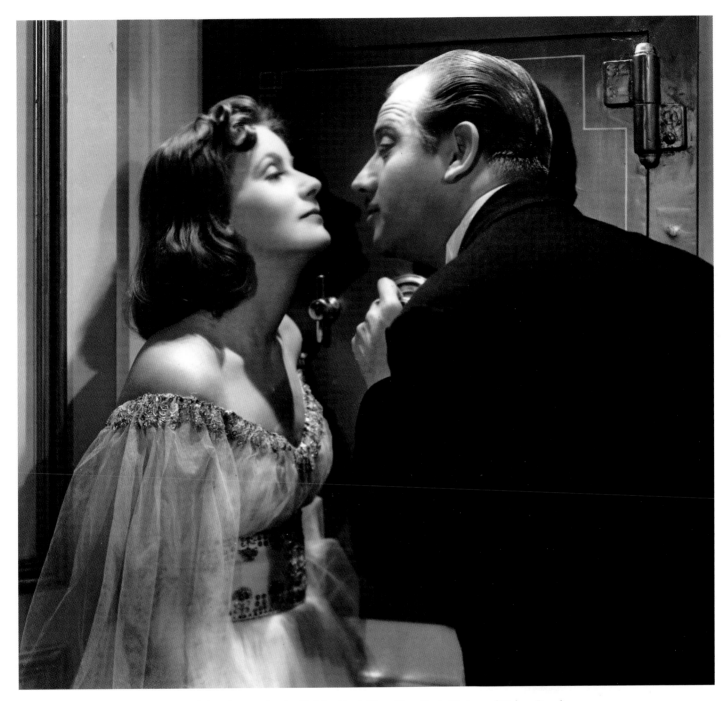

Opposite: A portrait of Greta Garbo made by Clarence Sinclair Bull for *Ninotchka* *Above:* Greta Garbo and Melvyn Douglas

audience laughter and applause." When the applause faded and the returns were tallied, *Ninotchka* had done very well, grossing nearly $1.2 million domestically, and, even without Europe, close to $1.1 million overseas. Hollywood's greatest year included a Garbo film.

Critical Reaction

"It seems incredible that Greta Garbo has never appeared in a comedy before *Ninotchka*. The great actress reveals a command of comic inflection which fully matches the emotional depth or tragic power of her earlier triumphs. It is a joyous, subtly shaded, and utterly enchanting portrayal which she creates to illuminate a rather slight satire and make it the year's most captivating screen comedy."

—HOWARD BARNES, *NEW YORK HERALD-TRIBUNE*

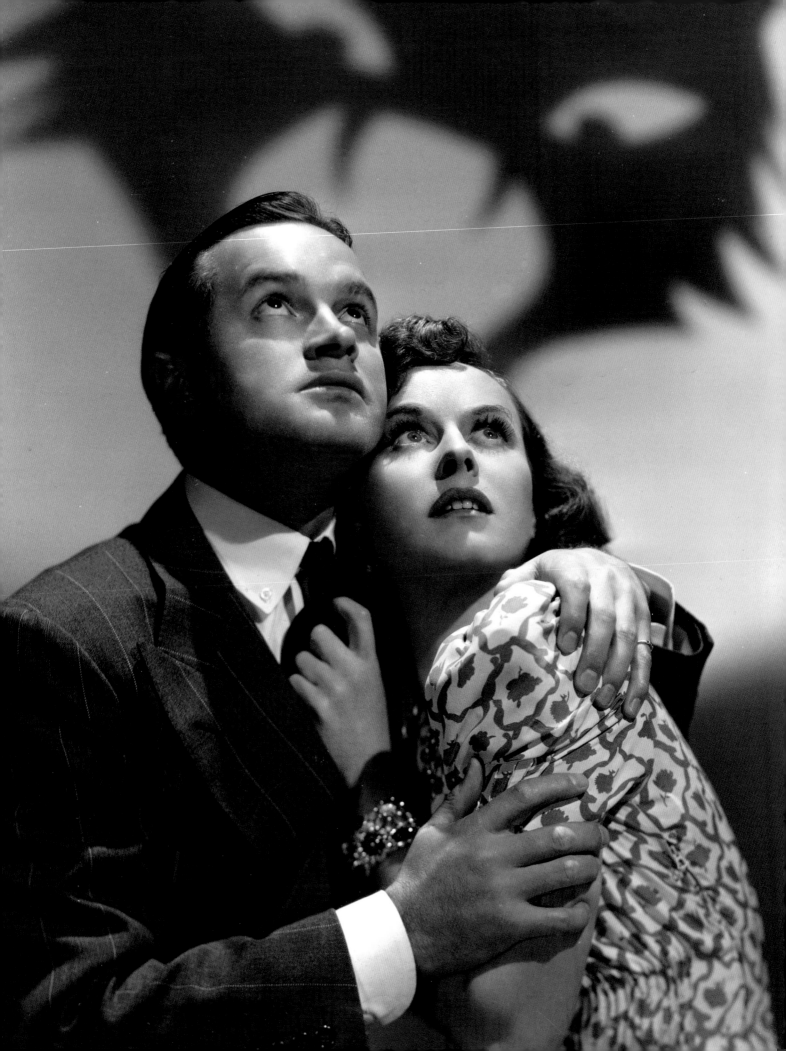

THE CAT AND THE CANARY

RELEASED NOVEMBER 10, 1939

"I'll bring a bottle of Scotch from the dining room and we can sit around and drink scotch and make wry faces. You get it? Scotch and rye?"

"Here. I don't need a gun with jokes like that."

THE STORY

A pretty young heiress must stay in a creepy old house to collect her inheritance.

Opposite: A portrait of Bob Hope and Paulette Goddard made for Elliott Nugent's *The Cat and the Canary*

PRODUCTION HIGHLIGHTS

In the 1930s there was a code of etiquette in movie theaters. Audience members did not wear hats, talk, or put gum under theater seats. It was customary to applaud when "The End" flashed on the screen. It was also customary to applaud at the end of a satisfying or well-acted scene. In 1939 there appeared a troubling trend. Moviegoers were laughing at serious scenes. Perhaps it was giddiness at the new prosperity. Or perhaps it was a release for anxiety about the world situation. Whatever was causing it, there was laughter at the wrong time. When moviegoers began laughing at horror films such as *Tower of London* and *Son of Frankenstein*, producer Arthur Hornblow got the idea of packaging horror with comedy.

The Cat and the Canary had been a Broadway perennial since 1922 and a silent-movie hit for Universal in 1927. In 1939 the marquee value of a silent title was nil, *Beau Geste* notwithstanding. One

critic remarked on Hollywood's attitude toward the silent era: "Obviously no one remembers what an eerie masterpiece the late Paul Leni, artist in light and shade, made from *The Cat and the Canary* in 1927." Silent films were objects of derision in 1939, so why not play this story for laughs?

After a splashy debut in Charles Chaplin's *Modern Times* three years earlier, Paulette Goddard had not found the right role in which to exert her hard-edged sweetness. Her chorus girl in *The Women* showed what she could do with comedy. Likewise, Bob Hope had been at Paramount for two years and six films without hitting pay dirt. He could go back to Broadway or simply continue with his popular *Pepsodent Show* on radio, but he had movie-star potential. Hornblow and director Elliott Nugent, who had also been an actor and playwright, dropped Goddard and Hope in a spooky setting and a cast of eccentrics and let the film

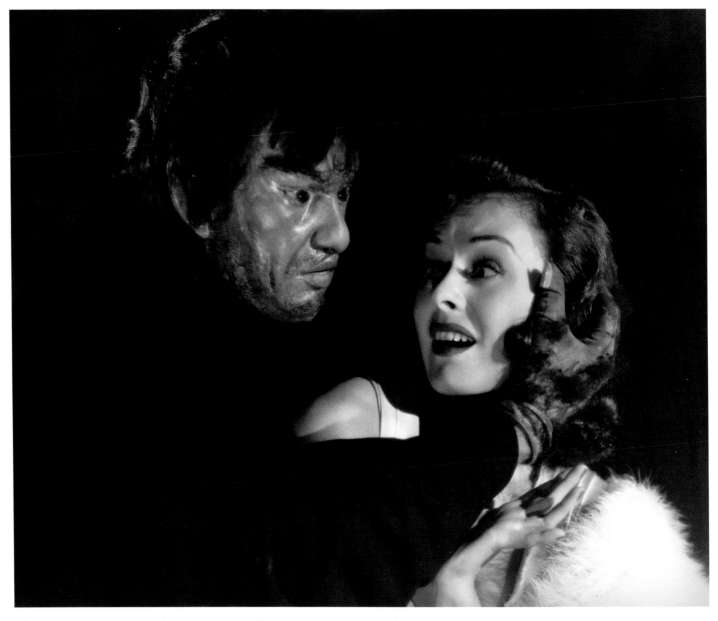

Above: Douglass Montgomery and Paulette Goddard *Opposite:* George Zucco and Paulette Goddard

find its way. "Paramount apparently got the message about my radio show and decided to put me in an A picture tailored for me," wrote Hope. "*The Cat and the Canary* was the turning point for my movie career." As a result of the well-liked film, both Hope and Goddard ended 1939 as stars.

Critical Reaction

"Mr. Hope's comic style is so perfidious we think it should be exposed for the fraud it is. His little trick is to deliver his jests timidly, forlornly, with the air of a man who sees no good in them. When they are terrible, as they frequently are, he can retreat in good order with an 'I told you so' expression. When they click, he can cut a little caper and pretend he is surprised and delighted too. It's not cricket but it is fun."
—FRANK S. NUGENT, *THE NEW YORK TIMES*

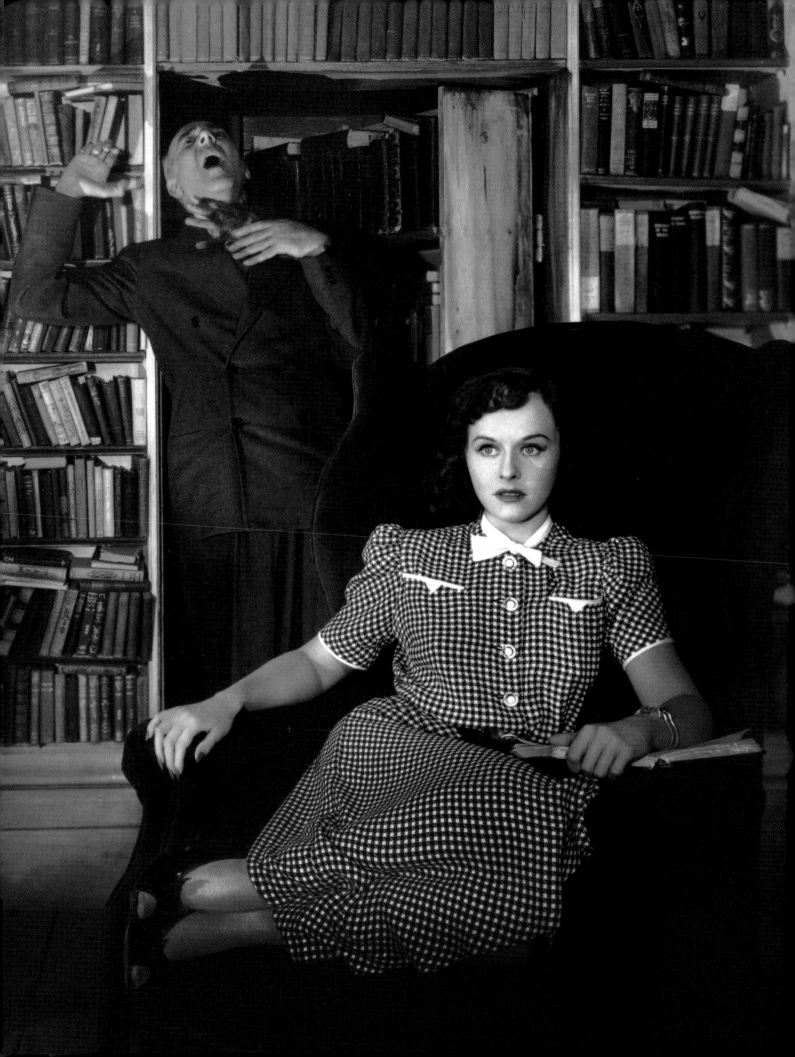

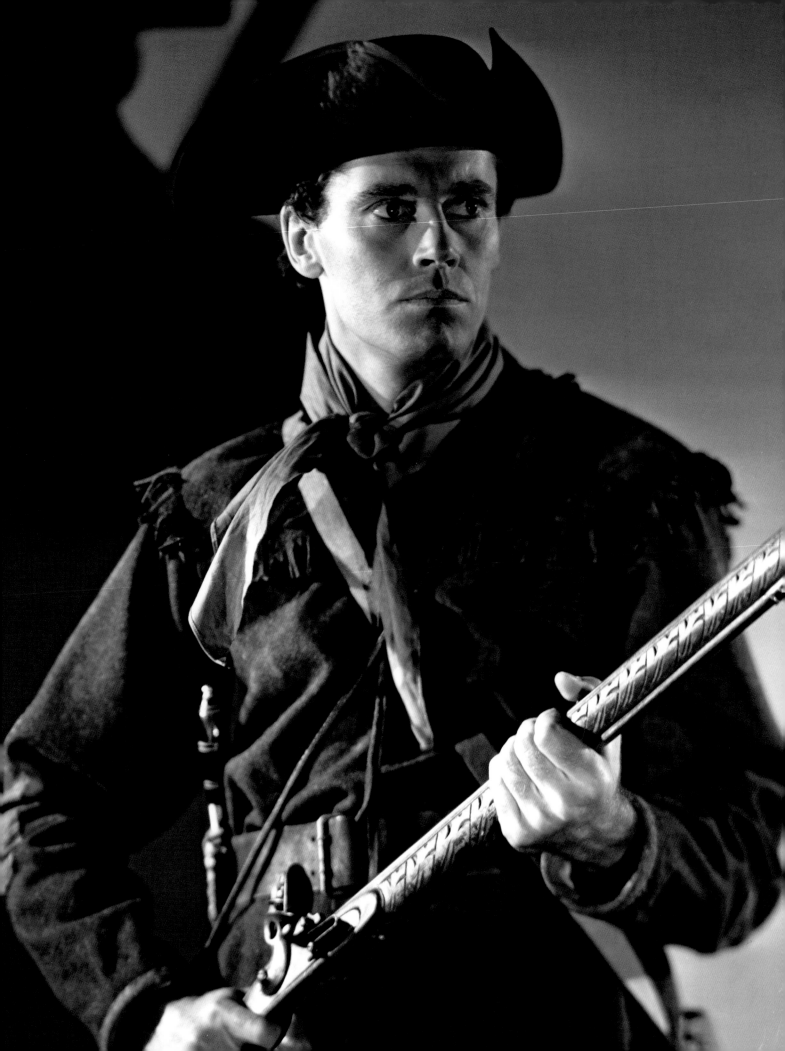

DRUMS ALONG THE MOHAWK

RELEASED NOVEMBER 10, 1939

"Any man failing to report to duty will be promptly hanged. Amen."

THE STORY

In 1776 New York, a young couple begins life on a farm, but they soon have to defend themselves from both Tories and Indians.

Opposite: A portrait of Henry Fonda for John Ford's *Drums Along the Mohawk*

PRODUCTION HIGHLIGHTS

John Ford's third 1939 release was his third film in a row to treat American history. The Wild West and Lincoln's Illinois were familiar settings, but the American Revolution was not. *Drums Along the Mohawk* was based on a best-selling 1936 novel by Walter D. Edmonds which showed that in 1776, the denizens of the Mohawk Valley were more concerned with Indians than with King George. As usual, Darryl Zanuck involved himself with the script. One of the novel's standout episodes had the hero, Gil Martin, and a friend run twenty miles—while pursued by Indians—to secure help. Zanuck wanted to be sure that the sequence was as effective as it could be. "Establish early that Gil is a great runner," Zanuck told Lamar Trotti. "And it will be far more exciting to have the run made by one person rather than by two. This can be whipped into one of the most unusual and exciting climaxes ever seen on the screen."

Ford cast Henry Fonda as Gil and Zanuck made Ford accept Claudette Colbert, who was on loan from Paramount, as Lana, the well-bred young wife who has to adjust to the rigors of farm life. *Drums Along the Mohawk* was Ford's first film in Technicolor, so it was shot on location in Utah's Wasatch Valley. The location was remote and primitive, which required all members of the company to use wooden outhouses. This irked Colbert, who was accustomed to star treatment. She was also used to getting her way on the set, lining up the best angles and lighting. Ford had no time for this. "They pay *me* to direct, honey," said Ford. "What do they pay *you* to do?"

Ford's ingenuity came into play in the filming of the twenty-mile run. "That run was done over a period of about twenty-seven days that we were on location," recalled Fonda. "While we were shooting some other scene, Ford would see a possible site for me to be running

through as part of that chase sequence. So he would holler at the wardrobe man to change my wardrobe. I would drop whatever I was doing and go over and do a running shot, jumping over a log and ducking under something. Then I'd change back into my wardrobe for the scene we'd been filming."

Drums Along the Mohawk was highly praised. Coming as it did at the end of 1939, it had to compete with numerous blockbusters, and it earned less than it could have. But Ford was acknowledged a master. "You can talk about Ford forever and not repeat yourself," said Fonda. "When he was cooking on all burners, there was nobody like him. He was certainly one of our giants."

Critical Reaction

"Drums Along the Mohawk was tailored to director John Ford's measure. It has its humor, its sentiment, its full complement of blood and thunder. About the only Ford staple we miss is a fog scene. Rain, gun smoke, and stockade burnings have to compensate."
—FRANK S. NUGENT, THE NEW YORK TIMES

"For the first time, frontiersmen and revolutionaries are shown, not as statuesque patriots, but as a rabble in arms. Fans who aren't interested in history find themselves fascinated by the romance between Henry Fonda and Claudette Colbert. Rarely has married love been so touchingly treated on the screen." **—LOS ANGELES TIMES (NEW YORK CORRESPONDENT)**

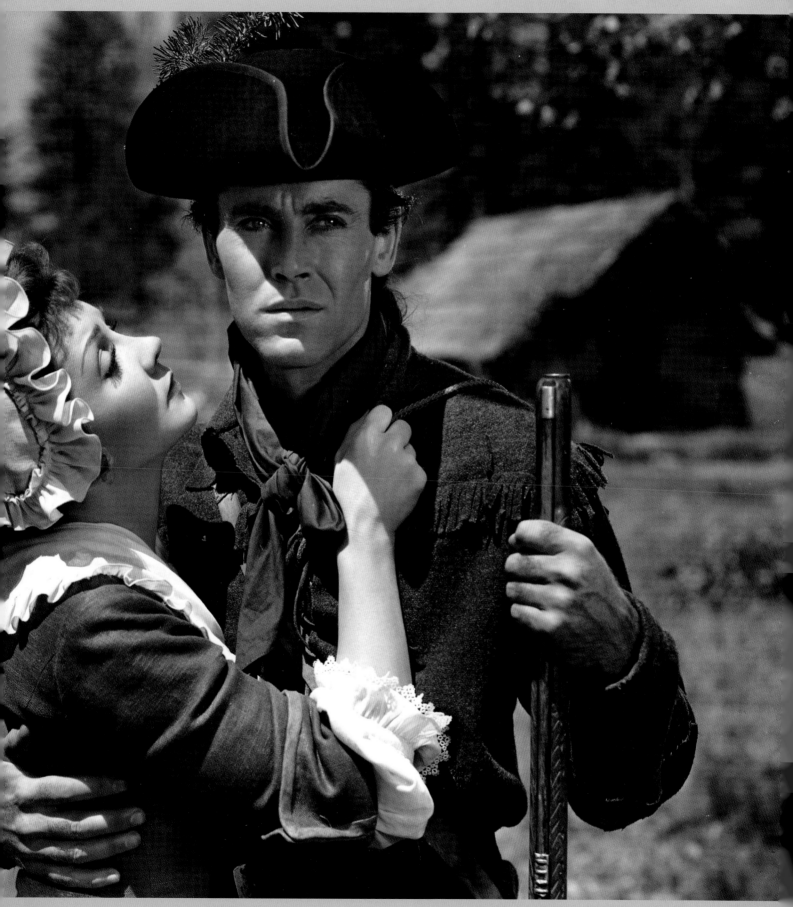

Above: Claudette Colbert and Henry Fonda

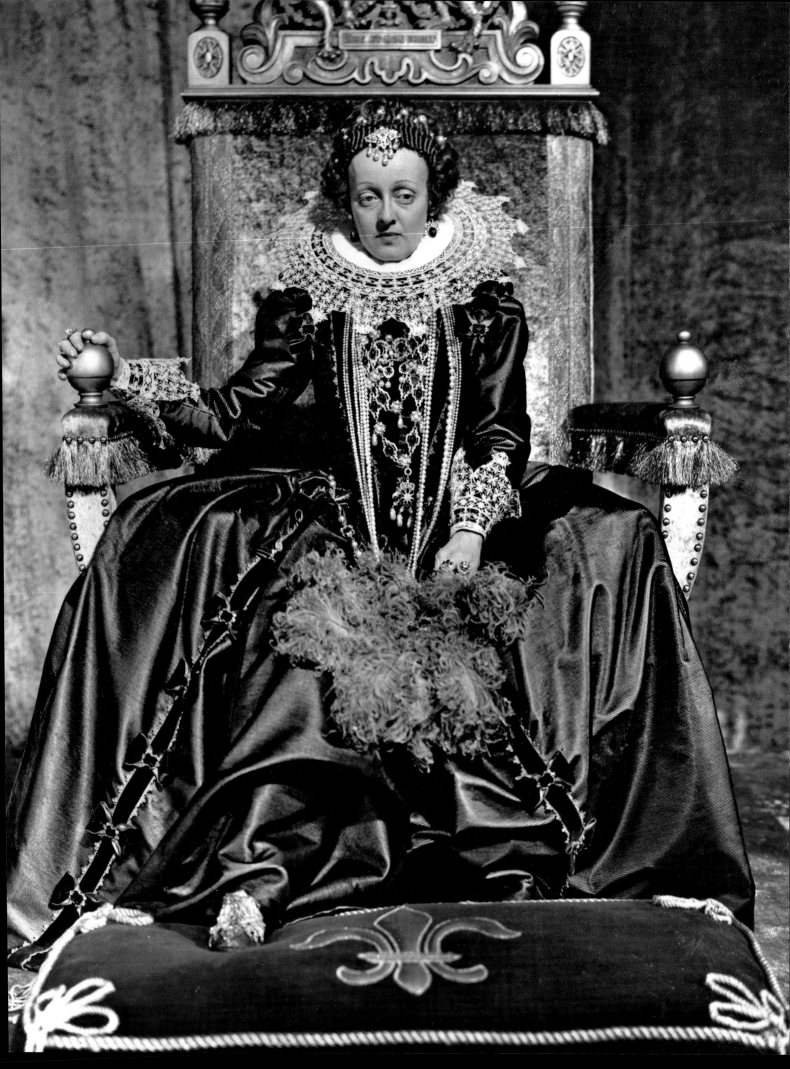

THE PRIVATE LIVES OF ELIZABETH AND ESSEX

RELEASED NOVEMBER 11, 1939

*"The sun will be empty and circle around an empty earth.
And I will be queen of emptiness and death."*

THE STORY

An aging monarch fancies a headstrong nobleman, but their romance is doomed by a struggle for dominance.

PRODUCTION HIGHLIGHTS

As Bette Davis began filming her fourth release of 1939, the syndicated columnist Jimmie Fidler expressed a minority opinion. "After a preview the other night," he wrote, "someone mentioned the performance of the leading lady and instantly provoked a chorus of: 'Yeah, swell piece of work, but, say, wouldn't you have liked Bette Davis better?' Bette has become a handicap, our ne plus ultra, the sacred yardstick by which all other actresses are measured—and found wanting—even before the trial begins. She is a great actress, but she is also a fad."

Bette Davis was not a fad to her costar, Errol Flynn. He had worked with her a year earlier, in *The Sisters*, and knew what to expect. "Bette was a dynamic creature," he recalled, "the great big star of the Warners lot, but not physically my type. She was used to dominating everybody around, and especially me; or trying to." Their new project was an adaptation of *Elizabeth the Queen*. Maxwell Anderson's play had been a landmark hit for Alfred Lunt and Lynn Fontanne in 1930, and, as the saying

goes, it would be a tough act to follow. Davis had seen *Fire Over England* and wanted Laurence Olivier to play the Earl of Essex to her Elizabeth I. Jack Warner preferred, logically, to cast his two biggest box-office draws. "Something else was annoying Bette very much," wrote Flynn. "Although she was crowned the queen of

Opposite: A portrait of Bette Davis by George Hurrell for *The Private Lives of Elizabeth and Essex* *Right:* A portrait of Bette Davis and Errol Flynn made by George Hurrell for Michael Curtiz's *The Private Lives of Elizabeth and Essex*

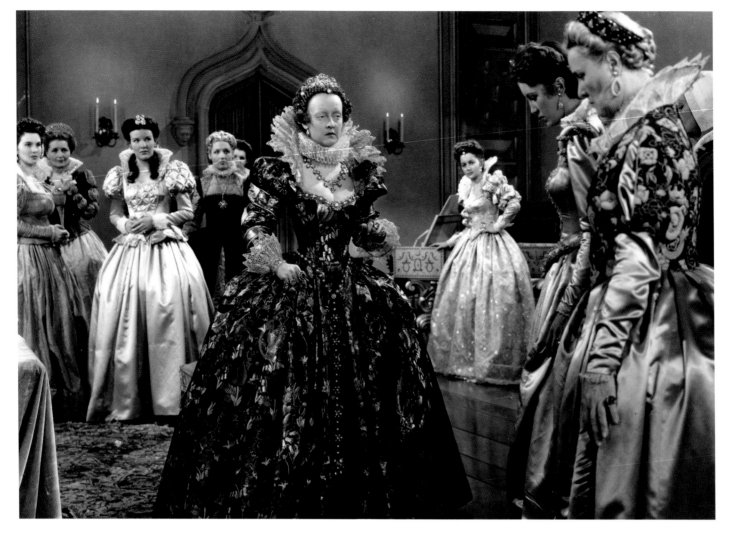

Hollywood as an actress, she had heard that I was getting more money, even though she had been in the business longer and was a far better actor than I." As the queen of Hollywood prepared to play the queen of England, tension mounted. Associate producer Robert Lord saw the warning signs. "Bette Davis is in a serious condition of nerves," Lord told Warner. "She's going into a very tough picture when she's a long way from her best. If she folds up, we stop shooting."

Since the film would co-star Flynn and Davis, it could not be called *Elizabeth the Queen*. The working title on the script was *The Knight and the Lady*. Davis expected this to be corrected; when it was not, she grew angry. "To call a queen of England a 'lady' was horrific," recalled Davis. "A more undignified title could not

have been found. It was cheap, hoping to disguise that the film was to be of historical importance." Worse, it gave Flynn top billing. "I must refuse to make the picture unless the billing is mine," Davis wrote Warner. He agreed. But newspapers began referring to the film as *The Lady and the Knight*.

On May 11, only a week after she had completed *The Old Maid*, Davis went to work with Flynn and director Michael Curtiz. Davis had the most extreme makeup and costuming she had ever worn. This was her first Technicolor film, but she was not being filmed as her glamorous self. She was made up to look thirty years older, and her hairline had been shaved to accommodate a carrot-orange wig. She complained that she felt unattractive. When the exceedingly

good-looking Flynn showed up late and unprepared, Davis tried to suppress her anger. Curtiz had Vincent Price, who had played Essex in a Broadway revival of the play, feed lines to Flynn. Davis tried to put an imaginary image of Olivier over Flynn's face.

Curtiz was not particularly patient with either star. He thought Flynn's accent was too broad. "Errol," said Curtiz, "you're talking with too much 'afternoon tea.'" He thought Davis was taking history too seriously. "Seventeenth-century love was just like now," Curtiz told her, "but without the highballs and the rah-rahs."

On June 19 Flynn rammed his car into a brick wall on the Sunset Strip. He was out for a week while facial scratches healed. Then Davis ruptured a blood vessel in her throat. Since she couldn't

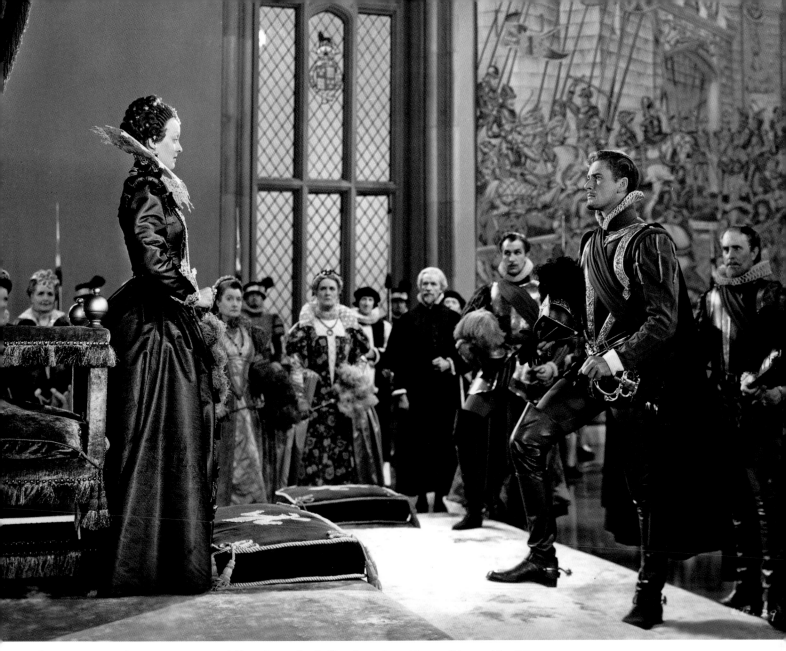

Opposite: Nanette Fabares, Bette Davis, and Olivia de Havilland *Above:* Bette Davis, Vincent Price, and Errol Flynn

speak, she sent a letter to Warner. Once again, the title was the issue. "I find myself so upset mentally and physically at the prospect of this title," she wrote, "that unless this matter is settled in writing, I cannot without serious impairment to my health finish the picture." This time Warner did change the title, much to the annoyance of his publicity department. Davis and Flynn came back. The atmosphere on the set did not improve. In a scene where Davis had to slap Flynn, she did not fake it. "She gave me that little dainty hand, laden with a pound of costume jewelry, right across

the ear," said Flynn. "It wasn't a very pleasant picture to make."

The Private Lives of Elizabeth and Essex was not the success that Warner had hoped. Perhaps four Davis films in one year was too much of a good thing. The actress thought so. "For the first time in my life," she wrote Warner, "I don't care whether I ever make another picture or not. I am that overworked. Health is one thing that can't be manufactured. Working almost forty weeks of the year does not make sense. And from your standpoint, a star's box office can be ruined by too many pictures."

Critical Reaction

"*Elizabeth and Essex* enables Errol Flynn to attain his highest estate. The climaxing scenes are among the best he has ever interpreted, and he cuts a splendid figure as the impetuous and heroic lover of Elizabeth. The comedy between the two when they meet after an estrangement is made particularly delightful by his performance, and that is not taking one whit away from the subtleties of Miss Davis."

—EDWIN SCHALLERT, *LOS ANGELES TIMES*

TOWER OF LONDON

RELEASED NOVEMBER 17, 1939

"You've made a choice between head and heart. But, I assure you, your heart will not be worth much when your head falls."

THE STORY

In 1471 London, the ruthless Duke Richard plans to become king by murdering every nobleman who precedes him in line for the throne.

Opposite: A portrait of Basil Rathbone by Ray Jones for Rowland V. Lee's *Tower of London*

PRODUCTION HIGHLIGHTS

Horror films were enjoying a comeback in 1939. If Paramount could package a comedy as a horror film, Universal could package a historical saga as a horror film. Rowland V. Lee was riding high on his *Son of Frankenstein*; he was the obvious choice for director. He and his brother, Robert N. Lee, had been looking into British history. "We agreed that we wanted to use the roughest, most hard-boiled period of all time," said Robert. "Row was for the Stuart era, but I held out for the time of Richard." With no apologies to Shakespeare (or history), the brothers Lee wrote a script that portrayed Richard III as a stylish murderer, a perfect role for Basil Rathbone. The horror component was found in the role of Mord, Richard's trusty executioner, who wields an axe with the skill of an Olympic athlete.

This project was an odd one, but not for Universal, the studio that carefully controlled its B pictures but let its A pictures run over budgets and schedules. *Tower of London* was conceived as an A picture with Rathbone as its star, even though Karloff was the bigger name. (In the film's credits Karloff would have only featured billing, but in the ads he was front and center with Rathbone.) Lee was given

$500,000 and thirty-six days to make his mini-epic. This was a quixotic gesture; he had exceeded both budget and schedule on his last two films.

The first expense was, of course, the star salaries paid to Rathbone and Karloff. The next was the construction of a castle set so large that it remained in use for the next fifty years. Then there were numerous sets designed by Jack Otterson, including a torture chamber outfitted with gauntlets, brakes, and bilboes. Extras had to be costumed as soldiers for the battle of Tewkesbury. To save money, their shields were made of cardboard.

In late August, just as a historic heat wave settled on Southern California, Universal trucked three hundred extras to a ranch in Tarzana. (The city had been named for Tarzan, the fictional character created by a resident, Edgar Rice Burroughs.) The ranch was dressed as a battlefield. The real battle was with technology, temperament, and nature, as location manager M. F. Murphy reported to Universal: "Difficulties with a special fog effect which we could not control on account of wind, the breakdown of a pump when we switched to a rain

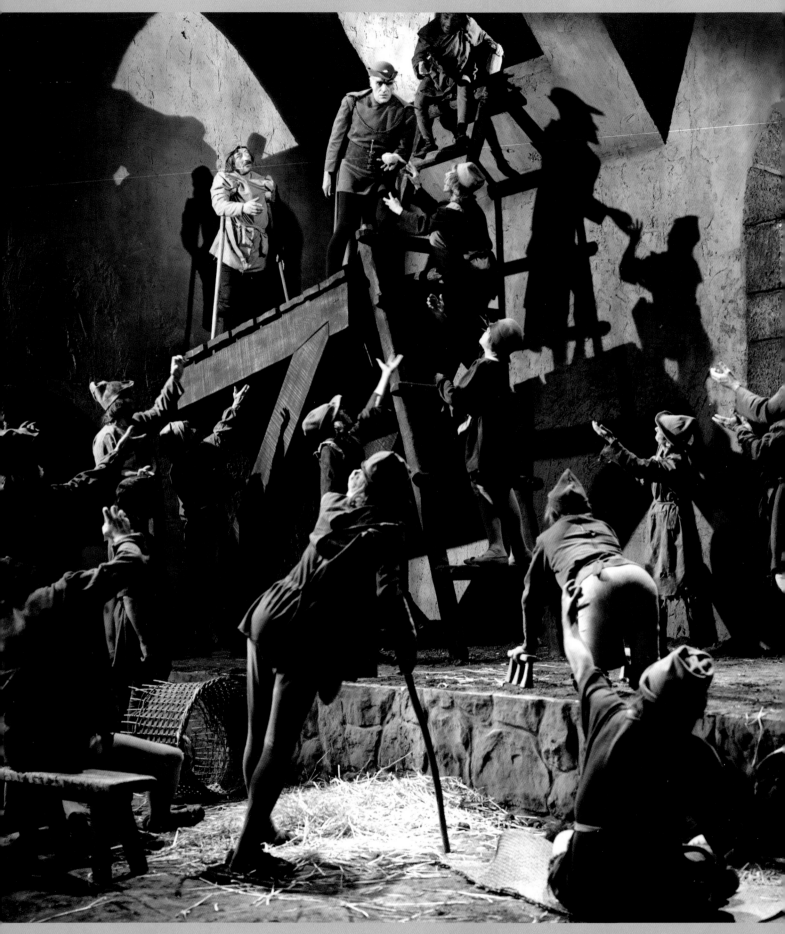

sequence, a particularly hot day, plus a group of unruly, uncooperative, and destructive extras clothed in helmets and armor, all added to make this one of the most unsuccessful days we have had with a large crowd of people in many years." The end of a perfect day came when the rain machine caused soggy cardboard shields to fall apart. There were attempts to reshoot the battle on succeeding days, but the heat wave intensified. Extras fainted. (Several hundred Los Angeles residents were ultimately declared fatalities of the freak weather.) To complete the sequence, Lee finally had to restage action details on a sound stage in front of a rear projection screen.

Tower of London gave Hollywood newcomer Vincent Price the opportunity to work with two great actors. "Boris and Basil introduced me to a kind of joyousness of picture making," said Price. "The crew on that picture loved Basil." Price's big scene with Rathbone and Karloff was the one in which Price, as the Duke of Clarence, is murdered by Richard and Mord during a drinking bout. To act the scene, Price had to swig glass after glass of wine. "It was only Coca-Cola," said Price. "But Coke is stimulating too. Well, over in one corner was a huge vat of Malmsey wine, in which I was to be drowned. Boris and Basil, knowing I was new to the business, thought it was great fun to throw everything they could into that vat of wine, which was just water. You know, old Coca-Cola bottles, cigarette butts, anything they could find to dirty it up, because they knew at the end of the scene I had to get into it." To simulate drowning, Price had to be submerged in the vat by the veteran actors, and then hold his breath until the crew pulled him out. He survived, was dried off, and was then given a gift by Karloff and Rathbone. "They congratulated me," recalled Price, "and then they presented me with a case of Coca-Cola!" *Tower of London* went ten days over schedule and $80,000 over budget. No one suffered. Universal had the situation in hand. It ended the year with a profit of $1.5 million.

Critical Reaction

"Boris Karloff presides over the Tower's torture chamber with the air of a celebrated maître d'hôtel, adding a soupçon of hot lead here, a twist of the rack there, pausing between corpses to toss a fifty-pound weight on the chest of a stalwart whose ribs have already begun to crack under the load they are bearing. Basil Rathbone plays it straighter. Even the Rialto's audience, which no one dare accuse of hypersensitivity, grew silent after a while and stopped applauding Mr. Rathbone's villainies. Death lingers longer at the Rialto. Brrrr!"

—FRANK S. NUGENT, *THE NEW YORK TIMES*

Left: Boris Karloff

OF MICE AND MEN

NEW YORK PREMIERE DECEMBER 24, 1939

"I don't need no fancy foods like beans with ketchup."

THE STORY

Two itinerant laborers, one of whom is a big man with the mind of a child, dream of owning a farm, but a new job puts them in conflict with a brutal foreman.

Opposite: A portrait of Lon Chaney Jr. and Bob Steele made for Lewis Milestone's *Of Mice and Men*

PRODUCTION HIGHLIGHTS

The most unlikely hit of 1939 had no stars. It was a tragedy made by a company that specialized in comedies. Hal Roach was famed for the ensemble laugh-getting of the Little Rascals and Laurel and Hardy. His was hardly the studio for a film of mental retardation and brutality. Roach produced *Of Mice and Men* because the package that director Lewis Milestone brought him was too good to pass up. Milestone was someone to be reckoned with. The three-time Academy Award winner had directed *All Quiet on the Western Front*, *The Front Page*, and *The General Died at Dawn*. The John Steinbeck novella *Of Mice and Men* was published in 1937. It sold 300,000 copies and quickly became a Broadway play, directed by George S. Kaufman and produced by Sam Harris. Through a misunderstanding with Columbia's Harry Cohn, the property became undesirable in Hollywood. Kaufman and Harris were stuck with it. "Harris gave me a free option to develop the story into a movie script," said Milestone, "on the understanding that once studio financing had been obtained, we would open formal negotiations."

Milestone wisely took a trip to Salinas, California to get Steinbeck's cooperation. "Although Steinbeck said he was delighted with my screenplay," said Milestone, "I persuaded him to revise it personally; and before my very eyes, by the alteration of a comma or a phrase, it became his." Meanwhile, Milestone was involved in a breach of contract suit against Roach. Milestone won. "Roach persuaded me to accept part finance on a production of *Of Mice and Men* in lieu of damages," said Milestone. "My salary, determined in proportion to the rest of the capital invested, emerged as 18 percent of the gross." At this point, Milestone was able to finalize the deal with Kaufman and Harris.

The play had starred Wallace Ford as George and Broderick Crawford as Lennie. "I cast the picture myself," said

Milestone. "Lon Chaney Jr. had played Lennie in *Of Mice and Men* on the stage in Los Angeles, and Burgess Meredith had been in several Maxwell Anderson plays before doing the Norma Shearer picture *Idiot's Delight*." For both Chaney and Meredith, Milestone's project was a lucky break. "He let me play Lennie my own way," said Chaney, who had been languishing for eight years as Creighton Chaney, an underused supporting player. With his illustrious father's name, he had new hope. "Maybe I can get the name of Chaney back up in the theater lights across America again." *Of Mice and Men* had to buck *Gone With the Wind* in December, but the strange and touching film held its own.

Critical Reaction

"Tragedy dignifies people, even such little people as Lennie and George. Mr. Steinbeck and his adapters have seen the end all too clearly, the end of George's dream and Lennie's life. With sound dramatic instinct they have not sought to hasten the inevitable, or stave it off. Doom takes its course and bides its moment; there is hysteria in waiting for the crisis to come. And during the waiting there is the rewarding opportunity to meet Steinbeck's people, to listen to them talk, to be amused—and moved—by the things they say."
—**FRANK S. NUGENT,** *THE NEW YORK TIMES*

Left: Lon Chaney Jr. and Betty Field

DESTRY RIDES AGAIN

RELEASED DECEMBER 29, 1939

"I'll bet you've got a lovely face under all that paint, huh? Why don't you wipe it off someday and have a good look—and figure out how you can live up to it."

THE STORY

A drunken failure of a sheriff deputizes a peace-loving young man to save a frontier town from a corrupt gang, but a dance-hall singer resolves to stop the new deputy.

Opposite: A portrait of Marlene Dietrich and James Stewart by Ray Jones for George Marshall's *Destry Rides Again*

PRODUCTION HIGHLIGHTS

In 1939, Marlene Dietrich was a dethroned goddess. After the failure of her last three films and the cruel label of "box-office poison," she had decamped to Europe, with no movie contract or project in prospect. She was the richest unemployed movie star in the world. While she waited to see what Hollywood (and Hitler) would do next, she stayed at the Hôtel du Cap at Eden Roc, in the south of France. Her entourage included her daughter Maria, her husband Rudolph Sieber, director Josef von Sternberg, and writer Erich Maria Remarque. It was assumed that Dietrich had given up on Hollywood and was considering a French film project with director Pierre Chénal.

Over at "major minor" Universal, producer Joe Pasternak and writer Felix Jackson were remaking a low-budget 1932 western, *Destry Rides Again*. Pasternak borrowed James Stewart from M-G-M to play Destry, but needed to balance the whimsical tale of a nonviolent sheriff with a strong female role. "The girl in the original picture was dull," said Jackson, referring to an actress named Claudia Dell. "The girl was a frail, silly child waiting for her man to come home," said Pasternak. He and Jackson changed the sweetheart to a dance-hall girl with as much star power as the hero, "the equal of Destry in looks, drive, and personality. She should be more than able to take care of herself, but she must be unpredictable underneath, like a cat." Pasternak had tried to sign Dietrich for Universal in 1928. "The Marlene I knew in Berlin was full of humor," said Pasternak. "The Marlene I saw in Sternberg's films was a mannequin. I'd been toying with doing a comedy western and I felt it would be great by reversing the roles. She'd be the aggressor and Jimmy Stewart would, in effect, play the shy ingénue. Marlene had been voted box office poison and was vacationing in Monte Carlo when I put through the call. The line crackled!"

'Why do you want me?' asked Dietrich.

"Because of the wonderful work you have done," answered Pasternak, "I know you'll be great in this picture I have for you."

"Okay," said Dietrich. "What is it?"

"It's a western."

"Oh, no! You must be crazy!"

"Darling, please trust me," said Pasternak. "It's a marvelous part. You'll be sensational."

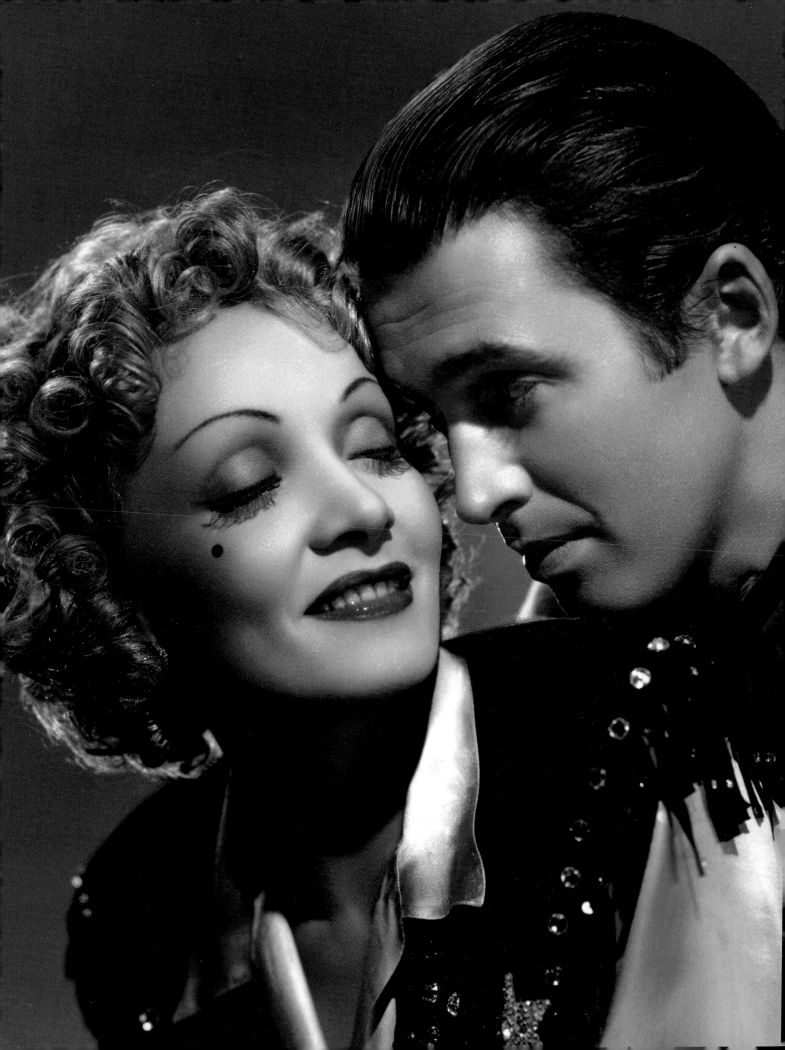

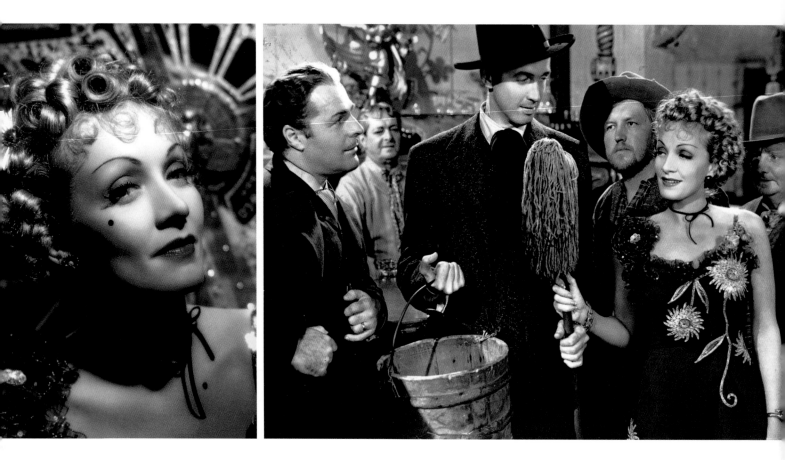

"I guess you haven't heard, my friend," said Dietrich. "I'm box-office poison."

"You won't be after this picture is finished."

Dietrich thought the whole idea far-fetched, but she asked Sternberg and Remarque what they thought. They told her not to hesitate; she should make the film. "I put you on a pedestal, the untouchable goddess," said Sternberg. "Pasternak wants to drag you down into the mud, very touchable. A bona fide goddess with feet of clay. Very good salesmanship."

"She hemmed and hawed and finally I got her to agree," said Pasternak. "When she arrived at the Pasadena rail station there were no photographers, just me. She was truly forgotten." Filming with director George Marshall and costar James Stewart went well. "Marshall kept

Marlene off guard with his practical jokes," said Pasternak. "She didn't have time to gaze in the mirror." Dietrich was known to be a lighting expert. No one knew that she could also handle a fight scene. Una Merkel, with whom she engaged in a brutal brawl, found out. "I had never met Miss Dietrich until that day," said Merkel. "They outlined exactly what places they'd like us to hit on the set. We were not supposed to do anything but a few feet of film, and they had the stunt girls there to take over. Mr. Marshall said: 'Once you get started on this, just keep going as long as you can. Don't worry. The camera will follow you.' We did the whole battle! I went to the hospital. I was a mess of bruises, because I had little flat heels on, and Marlene had high spiked heels. All through the fight scene we were whispering to each other, 'Are you all right?' 'Can you finish it?' 'Are

you OK?' I thought they'd never call 'Cut.'"

Destry Rides Again was greeted with skepticism. Dietrich in a Universal western? "Marlene might be called 'the girl who came back,'" wrote Hedda Hopper. "You've got to admire her courage. She left at $250,000 a picture and came back to $75,000. That ain't hay, but a western? Even a glorified one? Yes, that takes courage. She'll show them that she's an actress with this picture, just as her *Blue Angel* did."

"It was Marlene who made *Destry Rides Again* a hit," Stewart said much later. "She was beautiful, friendly, enchanting and as expert at movie acting as anyone I'd ever known. After a week's work on the picture, I fell in love with her. The director, cameraman, cast and crew felt the same way. We all fell in love with her."

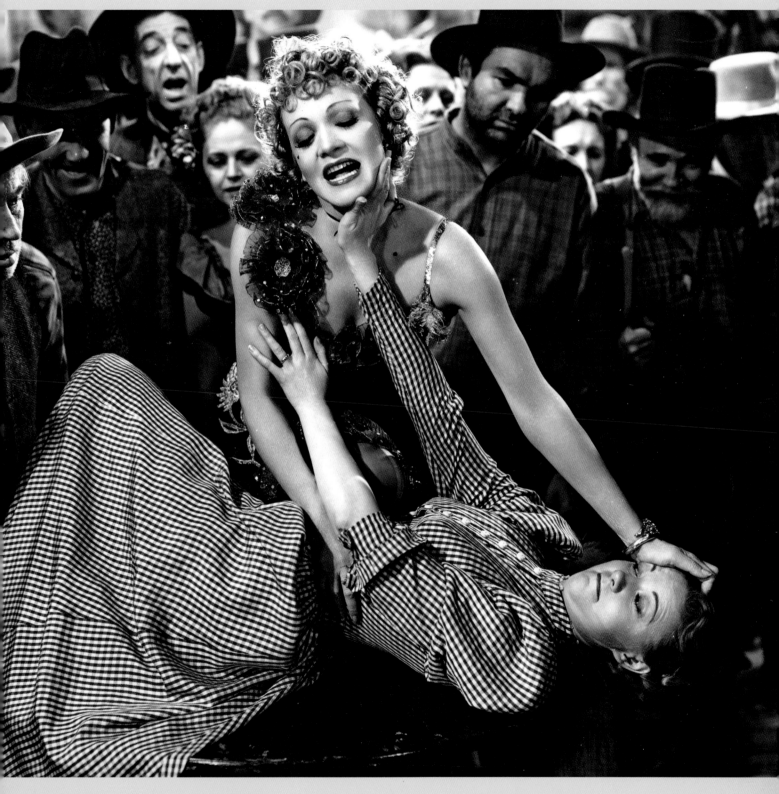

Opposite from left: A Ray Jones portrait of Marlene Dietrich ✴ Brian Donlevy, James Stewart, and Marlene Dietrich *Above:* Marlene Dietrich and Una Merkel

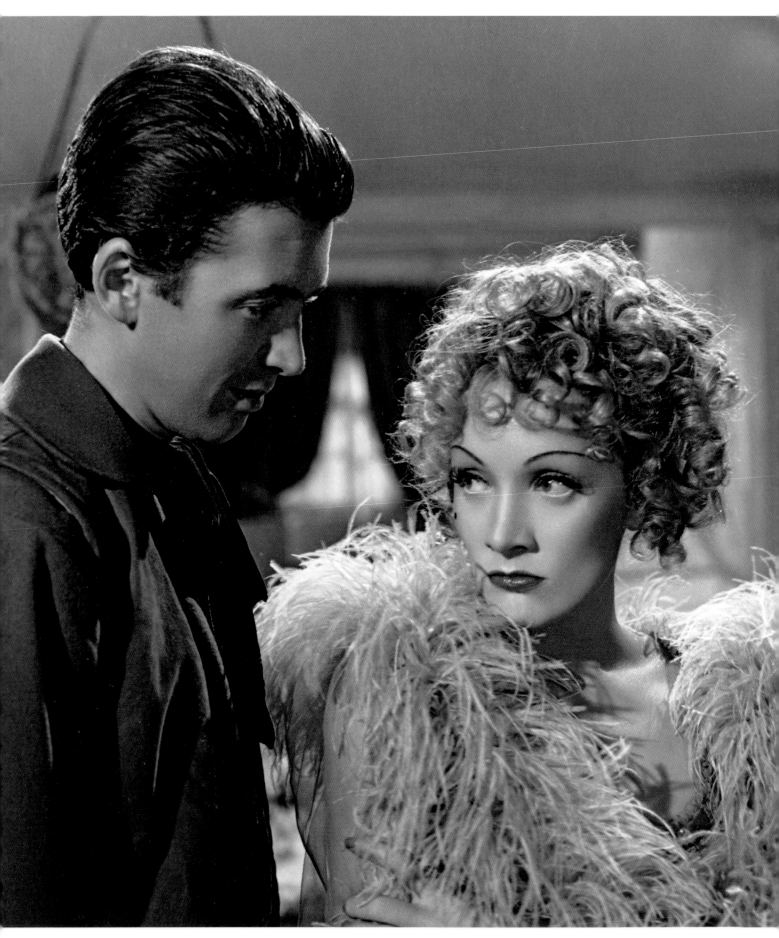

Critical Reaction

"Greta Garbo and Marlene Dietrich are rivals once more—rivals in change! Both register new personalities in their lately previewed pictures."

—EDWIN SCHALLERT, *LOS ANGELES TIMES*

"The scene that really counts is the cat-fight between Miss Dietrich's Frenchy and Una Merkel's outraged Mrs. Callahan. We thought the battle between Paulette Goddard and Rosalind Russell in *The Women* was an eye-opener; that was shadow-clawing. For the real thing, with no holds barred and full access to chairs, tables, glasses, bottles, water buckets, and as much hair as may be conveniently snatched from the opponent's scalp, we give you not *The Women*, but the two women who fight it out in the Bloody Gulch."

—FRANK S. NUGENT, *THE NEW YORK TIMES*

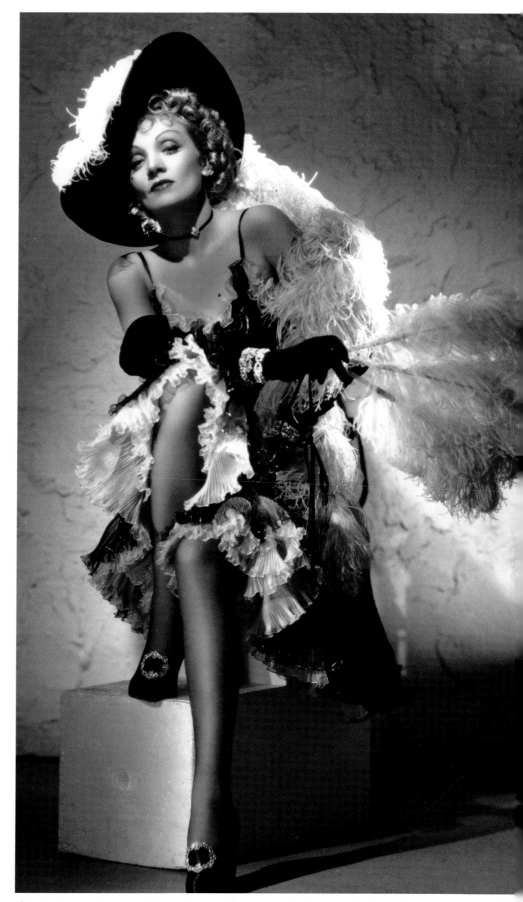

Opposite: Marlene Dietrich and James Stewart *Above:* A portrait of Marlene Dietrich by Ray Jones for *Destry Rides Again*

THE HUNCHBACK OF NOTRE DAME

RELEASED DECEMBER 29, 1939

"Why was I not made of stone like thee?"

THE STORY

When a misshapen bell ringer at the great cathedral shelters a gypsy girl, people from all levels of Paris society besiege the sanctuary.

Opposite and above: Scene stills of Charles Laughton by Gaston Longet for William Dieterle's *The Hunchback of Notre Dame*

PRODUCTION HIGHLIGHTS

Pandro Berman's program for RKO Radio in 1939 was to compete with the big-budget projects of the four other "Major Majors." He had done well with *Gunga Din, The Story of Vernon and Irene Castle,* and *Love Affair,* so he was justified in ending the year with a spectacle. Since George Schaefer had become the head of RKO, the studio was releasing for Walt Disney and other independent producers. Berman was leaving and he wanted his last production at the studio to be worthy competition for the December release of *Gone With the Wind.* Only *The Hunchback of Notre Dame* qualified. The 1831 Victor Hugo novel was in the public domain yet RKO had to pay M-G-M $125,000 for a clear title to *The Hunchback of Notre Dame,* in part because M-G-M was claiming that there had been a verbal agreement between Irving Thal-

berg and Charles Laughton for a package production. Berman obviously wanted to make the film, because the rights purchase was one of several expenditures he authorized. There was Laughton's fee of $150,000; there was $250,000 for an outdoor set on the RKO ranch in Encino that included the cathedral façade and the public square; and there was a fee of $10,000 to Warner Bros. for the services of makeup artist Perc Westmore.

"I had a plaster cast made of Laughton's face," said Westmore. "I made twelve copies and molded twelve different makeup ideas for the character on them. Laughton came in and looked at these heads. One, two, three. That quickly. I had spent about two weeks, day and night, doing all this modeling and coloring, and he looked at it for three minutes." Westmore got revenge of a

kind by imitating Laughton at parties. "Am I repulsive enough?" he would say. "Am I obnoxious enough?"

Laughton had a well-known history of artistic temperament. Producers and directors were expected to indulge his bizarre rites of preparation. There was much to indulge. To get into character, he would go through all manner of dilatory exercises, playing phonograph records at full volume and having stagehands and masseurs twist his limbs. William Dieterle was directing *The Hunchback of Notre Dame.* "Charles started the part with a kind of theatrical idea," recalled Dieterle. "He carried it inside him as a pregnant woman does her baby. He was not able to play his part until it was ripe." Dieterle's own quirks included wearing white gloves and consulting an astrologer on what day to start shooting. When he was ready

Above, from left: A portrait of Charles Laughton by Gaston Longet for *The Hunchback of Notre Dame* • Harry Davenport, Etienne Girardot, Sir Cedric Hardwicke, and Maureen O'Hara

to start, Laughton was not. Hundreds of extras milled about in the hot sun while Laughton searched for words. "I am sorry," he whimpered to Dieterle. "I am so sorry. I thought I was ready, but it just did not come. But it will come. And it will be good." When he did manage to get going, Dieterle disliked what he did. Laughton stood his ground. This was what he and Thalberg wanted. "This is the way we visualized it," said Laughton.

"*The Hunchback of Notre Dame* was filmed during one of the hottest summers in Southern California," wrote Elsa Lanchester. "The temperature rose—107, 108, and 109, 110 degrees—for about ten days. They kept saying that this brutal summer of 1939 was a record. There were ten deaths blamed on heatstroke. We were staying at the Garden of Allah and

Charles had to get up at 4:00 A.M. for the makeup ordeal. On his back he had about four or five inches of foam rubber for the hump, with a thin layer of rubber on top to make it resemble skin." On one of the hottest days, Laughton played the scene in which Quasimodo is whipped on the pillory. "When Laughton acted the scene on the wheel, enduring the terrible torture," said Dieterle, "he was not the poor crippled creature expecting compassion from the mob. He was oppressed and enslaved mankind, suffering the most awful injustice."

September 1939 was brutal in another way. "When England and France declared war on the Third Reich," Dieterle recalled, "the tension on the soundstage was unbearable." The scene in which Laughton rings the huge cathedral bells became a

catharsis. "It developed into something so powerful that everybody, including myself, forgot that we were shooting a film. Something superdimensional happened at that moment, so that I forgot to call 'cut.'" After moments of silence, Laughton spoke. "I couldn't think of Esmeralda in that scene," he whispered. "I could only think of the poor people out there, going to fight that bloody, bloody war! To arouse the world, to stop that terrible butchery! Awake! Awake! That's what I felt when I was ringing the bells!"

As Berman had hoped, Laughton, Dieterle, and the rest of the company made a magnificent film. *The Hunchback of Notre Dame* did have to compete with *Gone With the Wind*, but it did so admirably, grossing more than $3 million.

Above: Maureen O'Hara and Minna Gombell in a scene from *The Hunchback of Notre Dame*

Critical Reaction

"Those who relish the more intellectual portrayals of Mr. Laughton will not react as favorably to his hunchback as others; yet even they must admit that his is a startling technical feat, and that there is a moving emotional quality to his later, very appealing scenes. This lifts the whole interpretation to a high level. It's a Class A, super-plus picture; make no mistake about that, this new *Hunchback of Notre Dame*."

—EDWIN SCHALLERT, *LOS ANGELES TIMES*

"The Music Hall is the last place in the world where we should expect to find a freak show, but *The Hunchback of Notre Dame* is that and little more. He belongs between the covers of his book or back in the simpler days of the movies; he's a bit too coarse for our tastes now."

—FRANK S. NUGENT, *THE NEW YORK TIMES*

GONE WITH THE WIND

LOS ANGELES PREMIERE DECEMBER 28, 1939

"Don't look back, Ashley. Don't look back. It'll drag at your heart until you can't do anything but look back."

THE STORY

A willful Southern belle hardens herself in order to survive the Civil War, and, as she changes, the rakish man who loves her looks within himself for new resources.

Left: Vivien Leigh and Clark Gable in a scene from Victor Fleming's *Gone With the Wind*

PRODUCTION HIGHLIGHTS

The climax of 1939's release schedule was also the crowning achievement of the studio system. On December 28, 1939, the Fox Carthay Circle Theatre presented the Hollywood premiere of *Gone With the Wind*, a Selznick International Picture directed by Victor Fleming. This film was based on a novel by an Atlanta journalist named Margaret Mitchell. Her Civil War saga had been published by the Macmillan Company on June 30, 1936. "This is beyond a doubt one of the most remarkable first novels ever produced by an American writer," wrote J. Donald Adams in the *New York Times*. Even such positive reviews could not affect what followed. Word of mouth did. Within twenty days *Gone With the Wind* had sold 176,000 copies.

Before *Gone With the Wind* was published, Macmillan had sent bound galleys to all the film companies, even independents like David O. Selznick. On May 20, he received a teletype from his story editor, Kay Brown. "I'm really steamed up about this book," said

213

Above: A portrait of Clark Gable made by Clarence Sinclair Bull for *Gone With the Wind*

While this activity was going on, Selznick worked with playwright Sidney Howard and production designer William Cameron Menzies to boil Mitchell's novel down to a series of photographable images. Once Howard had finished the script, he could not wait to get back to his Massachusetts farm. Selznick brought more writers in. And researchers. And consultants. Costs mounted, the clock ticked, and a start date was nowhere in sight. Meanwhile, Mitchell's book won a Pulitzer Prize. Where was the film?

Selznick was a compulsive gambler; he lost $60,000 in 1937 alone. Only a gambler would take on such a daunting, risky project. In August 1938, his hand was forced. He needed cash and he needed Gable. Louis B. Mayer, Selznick's father-in-law, offered the loan of his great star, plus $1.5 million. There was a catch. M-G-M would distribute the film. "To get Gable," recalled Marcella Rabwin, Selznick's executive assistant, "Mr. Selznick had to make this *enormous* concession." To accommodate Gable, *Gone With the Wind* needed to start in January 1939. Its release was planned for that December. Time was running out. And Selznick had yet to find his Scarlett O'Hara.

"If you have to get somebody by Wednesday," Selznick said later, "you take the best available, cross your fingers, and pray. The pressure on *Gone With the Wind* was severe, but I knew that seventy-five million people would want my scalp if I chose the wrong Scarlett." By December 1938, Selznick had narrowed the list of qualified actresses to Joan Bennett, Jean Arthur, and Paulette Goddard. Goddard could have eliminated the other two if she could prove that she and Charles Chaplin were legally married. "That's none of your goddamned business," she said. But Selznick could not cast this role with an

Brown. "I think that this is an absolutely magnificent story and it belongs to us." On July 30, Selznick bought the screen rights for $50,000. One year later year, 1.383 million copies had sold, and every reader had an opinion of whom Selznick should cast as Scarlett O'Hara and Rhett Butler, the main characters in the book. Selznick had not even finished a script. He knew that a great deal was at stake. His small company was less than two years old. The public might lose interest while he prepared the film. "I'm on trial with this," said Selznick. "If the picture fails, I'll lose everything."

Selznick's publicist, Russell Birdwell, found a way to buy time. He conducted a nationwide search for someone to play Scarlett. He interviewed 1,400 women. George Cukor, whom Selznick had chosen to direct the film, made screen tests of 59 studio actresses. These included Tallulah Bankhead, Lana Turner, Frances Dee, Jean Arthur, Susan Hayward, and Paulette Goddard. Bette Davis was not tested. "It was insanity that I was not to be given Scarlett," she wrote later. No men were tested for Rhett Butler, since fan mail unanimously favored Clark Gable.

actor whose private life was in question.

In December 1938, Laurence Olivier, of *Wuthering Heights* fame, had a visitor from London, an actress named Vivien Leigh. Selznick had looked at footage of her from two 1937 films and shown no interest. Leigh was a new client of Selznick's brother, Myron, Hollywood's most powerful agent.

On December 10, Selznick was shooting his first scene of *Gone With the Wind*. It would be the fiery destruction of the Atlanta munitions yard. As he was setting up the spectacular scene with Cukor and a small army of special-effects technicians, he got a call from Myron's office. "I'm looking at your Scarlett," said Myron slyly. He showed up at the staged inferno a few hours later with Leigh at his side, and they walked up behind David Selznick. The producer turned and saw her. "The dying flames were lighting up her face," said Selznick. "I took one look and knew that she was right. It's a look I'll never forget." Vivien Leigh was similarly struck by the moment. "The fantastic quality of that tremendous fire, the confusion I felt, and the feeling of loneliness in the midst of hundreds of people," she said. "They were all indicative of what was to come."

Leigh was signed to a Selznick contract, along with Olivia de Havilland and Leslie Howard, on January 13. Principal photography commenced on January 26, 1939, with Cukor directing Leigh. Gable did his first scene on January 31. Philip Scheuer was invited to observe. "The scene was a charity bazaar in Atlanta," wrote Scheuer in the *Los Angeles Times*. "A big raftered room hung with the Stars and Bars of the Confederacy and dominated by a picture of Jeff Davis. Hoopskirted beauties and soldiers in uniforms were whirling in a waltz to music from a playback horn. One couple was Scarlett

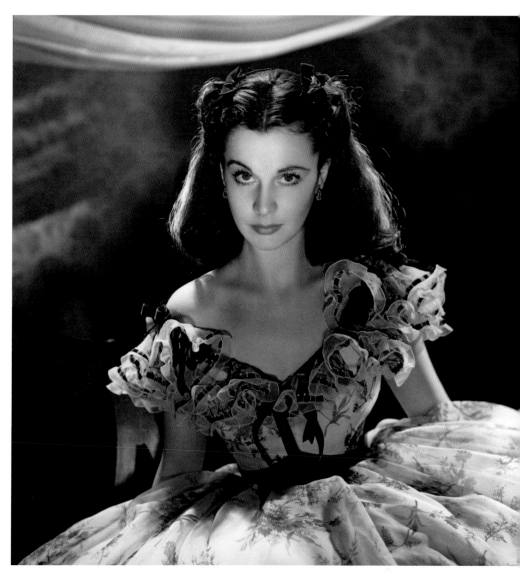

Above: A portrait of Vivien Leigh by Laszlo Willinger for *Gone With the Wind*

O'Hara (Vivien Leigh) and Rhett Butler (Clark Gable). Though she wore widow's weeds, Scarlett danced like the belle of the ball, pert nose tilted, eyes shining on Rhett. He returned the gaze with open amusement, but whether for her or for the disapproving glances of the other guests I could not tell. From what I could see, Vivien Leigh was, as the jitterbugs might quaintly put it, in the groove."

Cukor was doing his best to direct from an incomplete, constantly changing script; his best was not good enough for Selznick. On February 12 Cukor left the production, by mutual agreement. "The

principal reason I left was that Gable took too seriously my reputation as a good director of actresses," said Cukor later. "He was concerned that I was favoring Vivien in their scenes together." Cukor returned to M-G-M. Mayer put him on *The Women* and pulled Victor Fleming off *The Wizard of Oz* so that he could direct *Gone With the Wind*. Leigh and de Havilland were appalled at this and went in costume to Selznick's office to plead for Cukor, but to no avail. "With George and Victor, it's the same talent," Howard Hughes told de Havilland. "Only Victor's is strained through a coarser sieve."

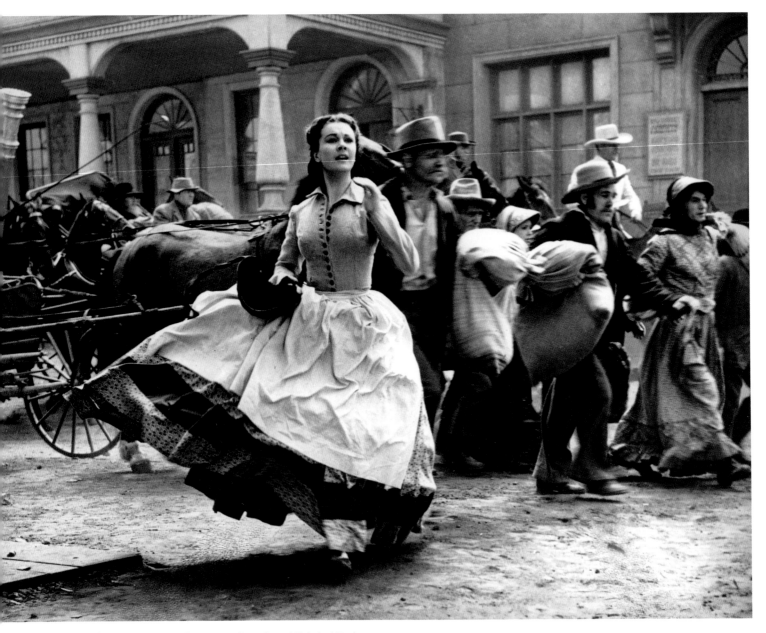

Above and opposite: Vivien Leigh in scenes from *Gone With the Wind*

Fleming insisted that Selznick shut down the production and finish the script, which was a shambles. More than ten writers had worked on it, all of whom withstood rewrites by Selznick himself. He may have known Mitchell's book intimately, but he was not a skilled screenwriter, as Fleming told him in pungent, unequivocal terms. An idled production would cost $10,000 a day. Selznick braved it and asked the fantastic Ben Hecht to do a whirlwind rewrite.

Hecht had not read Mitchell's book and did not plan to. Fleming and Selznick acted out the plot for him. "After each scene had been performed and discussed," said Hecht, "I sat down at the typewriter and wrote it out." This regimen went on for eighteen hours a day. "I'd catch a few winks on the couch," said Hecht. "David didn't sleep. He was the Dexedrine pioneer of Hollywood and was getting shots to keep him awake." On the fourth day Fleming burst a blood vessel in his right eye. On the fifth day Selznick passed out while eating a banana, the only food he had allowed himself. Hecht located the original Sidney Howard outline and finished the script from that in another week. (Selznick's tampering would bring Howard back to Hollywood from his farm for even more rewrites before the film was finished. Then Howard would return to his farm, only to be killed in an August tractor accident.)

Gone With the Wind was up and running on March 2. There were still six hundred shots to make. Cinematographer Lee Garmes was being replaced by

Ernest Haller because Selznick wanted more intense colors, but both artists' work would appear in the finished film, and both of them had pushed the new Technicolor film stock to the limit, creating a crisp, hard-edged look.

Gable was pleased to be working with Fleming, but Leigh and de Havilland consulted secretly (and separately) with Cukor, so his influence on their performances continued. Gable and Leigh were cordial, but not particularly friendly. Leigh disliked Fleming, who resented her reliance on the novel. "Put away that damned book," he would say. Leigh felt that Fleming was making Scarlett totally unsympathetic. "Vivien made no secret of her opinion of certain scenes," said Selznick. She demanded that a deleted line be restored. "I'm glad Mother's dead," says Scarlett. "I'm glad she's dead so she can't see me. *I've always wanted to be like her, calm and kind.*" Leigh felt that the line about Ellen's kindness was essential. "To me this was one of the finer points of Scarlett's character," said Leigh. "She did want to be like her mother, but the Civil War had made that impossible. She had to survive. It seemed a most important detail, indicating Scarlett's true nature."

Fleming was a taskmaster, but as tough as he was, Leigh was tougher on herself. "Before a scene," recalled Selznick, "she would be muttering deprecations under her breath and making small moans: the situation was stupid, the dialogue was silly, and nobody could possibly believe the whole scene. And then, at a word from Fleming, she would walk into the scene and do such a magnificent job that everybody on the set would be cheering." Still, tension rose between Leigh and Fleming: "Victor had the ability to conceal the iron hand in the velvet glove," said Selznick. As the

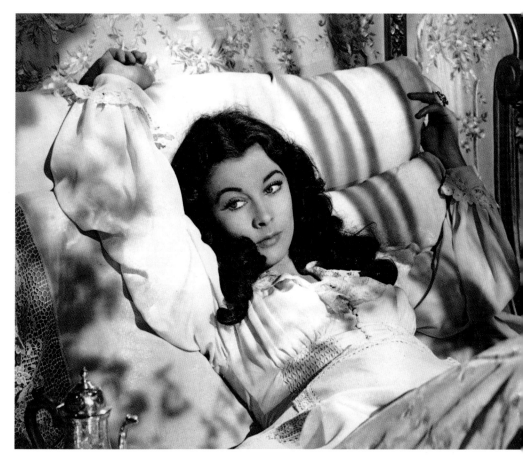

workdays lengthened to ten hours each, the iron became more apparent. Actors were playing in heavy costumes under arc lights. Tempers wore thin. On April 28, after Leigh refused to play Scarlett as a "bitch," Fleming threw his script at her and walked off the film.

"I'm a Scorpio," said Leigh. "We eat ourselves up and burn ourselves out." This was the energy that permeated the production. "I have never known so much hatred," recalled Rabwin. "Leigh hated Fleming. With a passion. Fleming hated her. He called her the vilest names. Gable hated David. Everybody hated David. The atmosphere was acrid. They burned themselves. And out of the ashes rose this phoenix of a picture." While these primal emotions were at play, Selznick was running out of money.

Sam Wood was brought in to continue shooting while Selznick looked for additional sources of funding. John Hay

Whitney, the millionaire sportsman, art patron, and chairman of the board of Selznick International, managed to secure a loan of $2.05 million from the Bank of America. "Not one hour was lost," said Selznick, "despite changes of director and Gable's time off to marry Carole Lombard. At one time both Wood and Fleming were shooting first units. One day five units were shooting." On June 27, Selznick cabled Whitney: "Sound the siren. Scarlett O'Hara completed her performance at noon today."

With the December deadline looming, Selznick's staff began the seemingly impossible task of completing post-production of a four-hour film in four months. Editing consisted of marathon day-and-night sessions, with Selznick apparently running on nothing more than nicotine and coffee but in fact on injections of Vitamin B-12, thyroid extract, and Benzedrine. Max Steiner composed

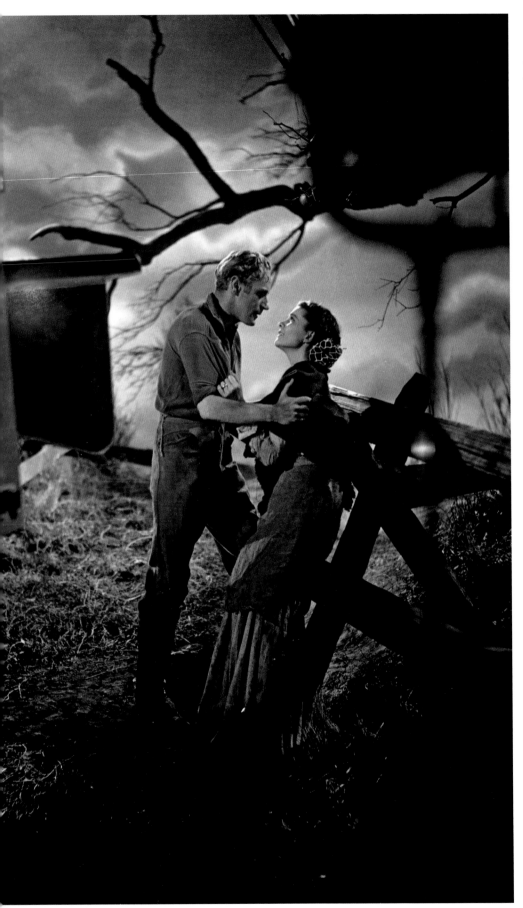

a superb musical score in record time by working twenty hours at a stretch.

The first preview was held on September 9 at the Golden Gate Theatre in Riverside, for an audience that was literally captive; the doors were locked. When the credits rolled, the building shook. "The people stood up and cheered and screamed," said film editor Hal Kern. "I never heard such a sound." The film ran four hours and twenty minutes. Preview card notations used one phrase over and over: "The greatest motion picture ever made." Still, Selznick was not sure. "I've staked my personal career, my company, millions of dollars of other people's money," he said. "I take full responsibility for the writing and reading of every line, for every prop, for every camera setup, for every inch of film."

By the time of its December 12 press preview at the Four Star Theatre in Los Angeles, *Gone With the Wind* ran three hours and forty minutes. Selznick had gambled either $3.957 million or $4.025 million, depending on who was asked the film's final cost. As it played to his industry peers, it appeared that his gamble would pay off. *Gone With the Wind* had its historic premiere on December 15, 1939, in Atlanta. It was followed by gala openings in New York and Los Angeles. The film justified its three-year buildup. It was longer, more expensive, more true to its source, and more technically innovative, than any film in the fifty-year history of projected cinema. In January 1940, *Gone With the Wind* went into a reserved-seat limited release at a dollar a ticket, playing more than four hundred theaters. By April, it had earned $17 million and become what is arguably the most popular film in Hollywood history.

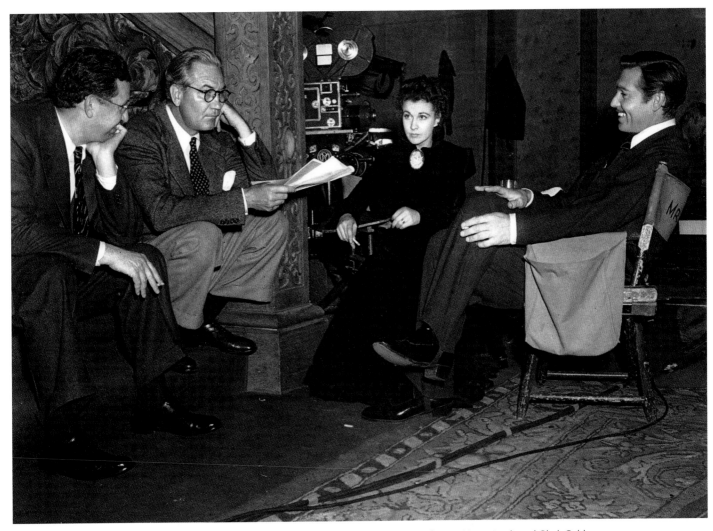

Opposite: Leslie Howard and Vivien Leigh on the paddock set *Above:* David O. Selznick, Victor Fleming, Vivien Leigh, and Clark Gable

Critical Reaction

"Leigh doesn't play Scarlett," reported Hedda Hopper. "She *is* Scarlett. Nothing can stop her. Gable brings more dignity to Rhett than he's ever shown before. Color makes the picture live. When Scarlett shoots that Yankee soldier, the smoke is blue and you realize it wasn't a blank cartridge. It was a bullet. The man's dead. Hollywood has been looking for someone to wear the mantle of Irving Thalberg. After seeing this, you can put it around the shoulders of David Selznick."—**HEDDA HOPPER**

"*Gone With the Wind* is the gargantuan Selznick edition of the Margaret Mitchell novel which swept the country like Charlie McCarthy, the "Music Goes 'Round" and similar inexplicable phenomena; which created the national emergency over the selection of a Scarlett O'Hara. Miss Leigh's Scarlett has vindicated the absurd talent quest that indirectly turned her up. She is so perfectly designed for the part by art and nature that any other actress in the role would be inconceivable.

Technicolor finds her beautiful, but Sidney Howard, who wrote the script, and Victor Fleming, who directed it, have found in her something more: the very embodiment of the selfish, hoydenish, slant-eyed miss who tackled life with both claws and a creamy complexion, asked no odds of anyone or anything—least of all her conscience— and faced at last a defeat which, by her very unconquerability, neither she nor we can recognize as final."

—**FRANK S. NUGENT,** *THE NEW YORK TIMES*

219

INDEX

MAJESTIC HOLLYWOOD

Johnson, Casey, 88-89, 90

Johnson, Nunnally, 16, 76

Johnson, Osa, 104

Jolson, Al, 75, 76-77, 158

Jones, Ray, 8-9, 194-195, 202-203, 204-205, 207

Jordan, Bobby, 20

Joslyn, Allyn, 78-79, 80-81

Joyce, Brenda, 138, 141

Juarez, 84-87, 130

K

Kanin, Garson, 101

Karloff, Boris, 8-9, 10, 11, 194, 197

Kaufman, George S., 199

Keaton, Buster, 156, 158

Kelly, Nancy, 17

Kendall, Read, 20

Kennedy, Joseph P., 165

Kern, Hal, 218

Keystone Cops, 158-159

Kilian, Victor, 78-79

King, Henry, 16-17, 104, 106-107, 140

Kingsley, Sidney, 20

Kipling, Rudyard, 27

Knight and the Lady, The, 192

Knowles, Patric, 90-91

Korda, Alexander, 28

Krasna, Norman, 100

Krims, Milton, 73

L

La Cava, Gregory, 144, 147

Lahr, Bert, 108-109, 113, 114-115, 116-117

Lamarr, Hedy, 41

Lanchester, Elsa, 210

Lanfield, Sidney, 119

Lang, Walter, 39, 40-41

Langley, Noel, 110, 155

Larkin, John, 76

Lasky, Jesse, 6, 69

Lasky, Jesse, Jr., 69-70

Last Train from Madrid, 84

Laughton, Charles, 208-210, 211

LeBaron, William, 93

Lederer, Francis, 44-45

Lee, Robert N., 194

Lee, Rowland V., 9, 10, 194

Leigh, Vivien, 4-5, 55, 149, 212-219

Leisen, Mitchell, 30, 43, 44-45

Lengyel, Melchior, 177, 179

Leni, Paul, 183

LeRoy, Mervyn, 39-40, 108, 110, 113, 114, 166, 168

Let Freedom Ring, 71

Life of Jimmy Dolan, The, 20

Lincoln, Abraham, 82-83

Lindström, Petter, 149

Lippman, Irving, 80

Little Lord Fauntleroy, 40

Little Princess, The, 38-41

Litvak, Anatole, 73, 85, 130

Livingstone, David, 104

Lombard, Carole, 102-103, 217

Longet, Gaston, 208-209, 210

Lord, Robert, 192

Lorre, Peter, 85

Lost Horizon, 28, 161

Love Affair, 50-53, 209

Love Match, 51

Loy, Myrna, 7, 106, 138, 140-141, 142-143

Lubitsch, Ernst, 177, 179

Luce, Clare Booth, 123, 129

Lugosi, Bela, 8-9, 11

Lukas, Paul, 72-73

Lunt, Alfred, 12, 83, 191

Lupino, Ida, 118-119, 120-121

Lusk, Norbert, 45

M

MacArthur, Charles, 27, 55, 56

MacDonald, Jeanette, 23

Mamoulian, Rouben, 134, 137

Mankiewicz, Herman, 110

Mann, Hank, 158-159

Marie Antoinette, 106, 141

Marshall, George, 30, 32, 202, 204

Marx, Chico, 166, 168-169

Marx, Groucho, 166-169

Marx, Harpo, 166, 168

Mayer, Edwin Justus, 43

Mayer, Louis B., 23, 39, 97, 106, 108, 110, 114, 125, 141, 152, 166, 214, 215

McCarey, Leo, 51, 53

McCarthy, Charlie, 32-33

McCrea, Joel, 70-71

McDaniel, Hattie, 24

McGowan, Jack, 155

McHugh, Frank, 170-171, 174-175

McLaglen, Victor, 26-27, 28

Meek, Donald, 34-35, 36-37

Menjou, Adolphe, 134-135, 137

Menzies, William Cameron, 214

Meredith, Burgess, 201

Merkel, Una, 204, 205, 207

M-G-M, 12-13, 23, 24, 39, 104, 108, 209, 214

M-G-M British, 97

Midnight, 42-45

Midsummer Night's Dream, A, 108

Milestone, Lewis, 199, 201

Milland, Ray, 92-93

Miller, Arthur, 40-41, 138, 140, 141

Miserables, Les, 63

Mitchell, Margaret, 213

Mitchell, Thomas, 34-35, 36-37, 78-79, 80-81

Modern Times, 183

Montgomery, Douglass, 183

Moore, Constance, 30-31, 32-33

Moore, Dennie, 127

Morgan, Frank, 108-109, 116-117

Morris, Chester, 88-89, 90-91

Motion Picture Producers and Distributors of America (MPPDA), 6

Mr. Deeds Goes to Town, 164

Mr. Smith Goes to Washington, 160-165

Muni, Paul, 84-85, 86

Murphy, M. F., 194, 197

N

Nash, Florence, 122-123, 125

Nash, Ogden, 110

Nelson, Harmon, 66

Nichols, Dudley, 36

Ninotchka, 176-181

Niven, David, 55, 56, 100-101

No More Ladies, 125

Norton, Edgar, 10-11

Nugent, Elliott, 183

Nugent, Frank S., 24, 33, 37, 49, 56, 77, 80, 83, 86, 90, 98, 101, 117, 129, 133, 137, 147, 150, 155, 158, 168, 179, 181, 184, 188, 197, 201, 207, 211, 219

O

Oberon, Merle, 54-57

Odets, Clifford, 134, 137

Of Mice and Men, 198-201

O'Hara, Maureen, 210, 211

Old Maid, The, 130-133, 192

Olivier, Laurence, 4-5, 54-57, 191, 215

O'Malley, Rex, 42-43, 44-45

Only Angels Have Wings, 78-81

Only Yesterday, 103

Otterson, Jack, 194

Our Gang, 20

Our Town, 134

Ouspenskaya, Maria, 53

P

Pan, Hermes, 46-47

Pape, Lionel, 44-45

Paramount Pictures, 23, 43, 84, 93

Parsons, Louella, 7

Pasternak, Joe, 202, 204

Payne, John, 60

Pepper, Barbara, 20

Perlberg, William, 134

Pickford, Mary, 40

Pigskin Parade, 40

Platt, Louise, 34-35, 36-37

Poor Little Rich Girl, 40

Povah, Phyllis, 122-123, 125

Power, Tyrone, 16-17, 18-19, 35, 41, 74-75, 76, 106, 138, 140, 143

Powolny, Frank, 19

Preston, Robert, 70-71, 92-93, 94-95

Price, Vincent, 192, 197

Private Lives of Elizabeth and Essex, The, 128, 190-193

Production Code Administration (PCA), 12, 5? 73, 84, 100, 161

Public Enemy, 93

Punsly, Bernard, 20

Q

Queen Christina, 55

R

Rabwin, Marcella, 214, 217

Rains, Claude, 160-161

Rains Came, The, 7, 106, 138-14?

Ramona, 63

222

ACKNOWLEDGMENTS

I can recite dialogue from *The Wizard of Oz, Gone With the Wind,* and many 1939 films, but I did not expect to find new information about them. Luckily, material existed that had never made its way into film histories. I thank Cindy De La Hoz and Running Press for giving me the opportunity to share it.

I thank these individuals for photographs: David Chierichetti and John McElwee.

For research help, I thank Mary Mallory; and I thank Christina Rice, the Acting Senior Librarian of the Los Angeles Public Library's Photo Collection.

I thank Erica Dorsey of Andrew Christian and Lester Lopez of Emillio O. Couture for computer help. I thank David Wills for PhotoShop help. For sustenance during writing and editing sessions, I thank my friends at Casita del Campo restaurant: Baldomero Mendoza; Omar Sandoval; Jay Richards; and Rigoberto Benitez. For guidance, I thank Jann Hoffman; the Rev. John McDaniels; Bryan Potok, L.C.O.; Ruben Alvarez, M.D.; the Rev. Ryan Steitz, the Rev. Shanna Steitz, and the Rev. Dr. R. Scott Colglazier of First Congregational Church of Los Angeles.

For supporting both me and the project, I thank: Darin Barnes; Frank Coiro and Roseanna Giordano; David Chierichetti; Howard Mandelbaum; Ben Carbonetto; Jonathan G. Quiej; P. R. Tooke; Bruce Paddock and Pete Cullinane; Marguerite Topping; Rob McKay; Andrew Montealegre and Marvin Bendana; Bill Pace; Paddy Calistro and Scott McAuley; Jim Schneeweis; Jack Tillmany; Vincent Estrada; Kenton Bymaster; Karie Bible; Suzanne McCormick; Matias Antonio Bombal; Daniel Mesones; Brad and Kim Hill; Fred Chico; Damon Devine; and Antonio Marroquin Guarchaj.

I thank my literary agent, Deborah Warren of East West Literary Agency, for her support and counsel. I thank my editor, Cindy De La Hoz, for suggesting this project.

For everything else, I thank my family: Beverly Ferreira Rivera; Joan Semas; Sue Costa; Dorothy Chambless; Michael Chambless; Lenore Griego; Matthew Griffiths; Janine and Steve Faelz; and Shannon and Guy Vieira.